DRAWING FASHION
ACCESSORIES

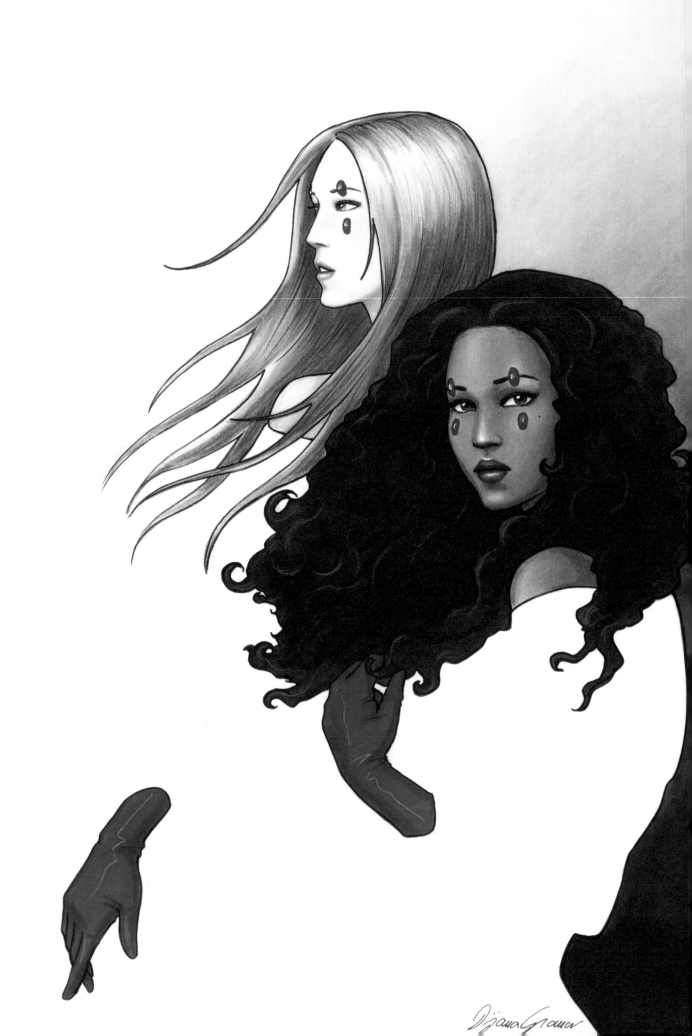

DRAWING FASHION ACCESSORIES

STEVEN THOMAS MILLER

LAURENCE KING

Published in 2012 by
Laurence King Publishing Ltd
361–373 City Road
London EC1V 1LR
Tel: +44 20 7841 6900
Fax: +44 20 7841 6910
e-mail: enquiries@laurenceking.com
www.laurenceking.com

A catalogue record for this book is available from the British Library.

ISBN: 978 1 85669 788 0

Design: Eleanor Ridsdale Design Limited

Printed in China

Dedicated to Janice, whose love makes my life and my art possible.

CONTENTS

INTRODUCTION

Illustrating fashion accessories can open doors into the fashion world you didn't even know existed, as well as providing an avenue for art and style you never imagined your work might travel. This book will help you learn a variety of studio techniques while also showing you the applications within the fashion marketplace where you can apply them. Some might argue that a designer does not need to know how to draw, but I have never known one who didn't go further and command more value because they invested time in learning the disciplines of illustrating their craft.

There will always be a need for editorial illustrations in print and fashion exhibitions. This is the type of imagery that grabs your attention and fires up your imagination about the styles or trends it is projecting, as shown with the alligator handbag in figure 1. It is art meant to inspire and attract with the sheer excitement of an idea. Then there is the ever-present need to sell that ready-to-wear accessory, as in figure 2, making it look as if it were the only couture piece made for that one special retail client. Fashion art used for commercial solutions has the ability to tell the truth about an item while still bringing an idealized fantasy to its character, stirring up the desires that make it a shopper's must-have. Of course, none of

this would be possible without a manufacturer bringing the designer's concept to reality. To accomplish that task with accuracy and specific individuality, a blueprint must first be made, as the flat drawing in figure 3 demonstrates. These three types of illustration each hold their own value in fashion and will always provide a way for a designer or retailer to bring uniqueness and identity to their particular accessory.

It is the artist's challenge to take a medium, a surface, add imagination and their personal flavour to the mix, and stir the viewer's desires to want the fashion they draw. With the media introduced and the step-by-step instructions in this book, our goal is to give you the tools necessary to become the illustrator you are longing to be, or challenge you to reach beyond your current skill level to master your art. This text will walk you through the basics of observing and styling fashion accessories so you can avoid common mistakes and possible rejection of your work. The step-by-step demonstrations will also instruct you in media choice and texture rendering. This book does not aim to teach you a style of art so much as help you develop in the direction of your own choosing and give you the foundational skills necessary to evolve your work alongside developing cultural trends.

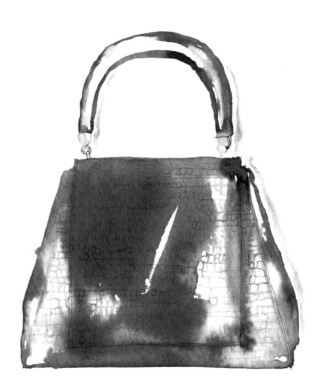

Figure 1: Editorial version. This is a loose, dynamic, suggestive interpretation.

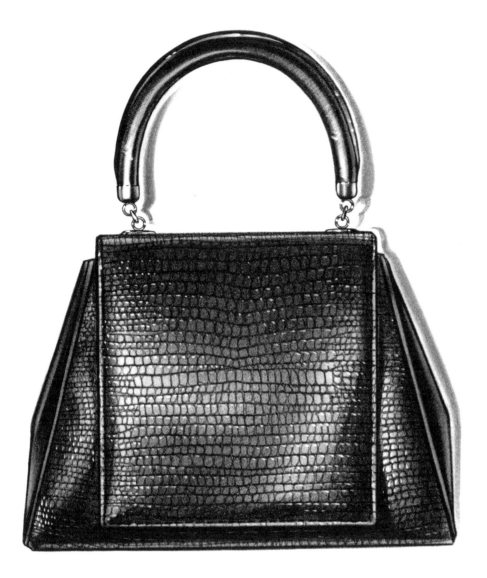

Figure 2: The retail version is a bold, idealized and stylized interpretation.

Figure 3: The manufacturing version. This drawing is clean, accurate, and descriptive.

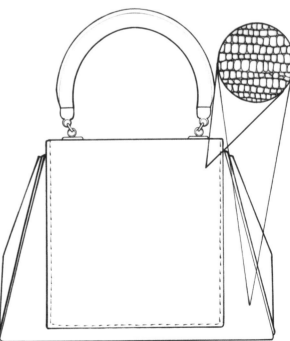

CHAPTER 1
USING DIFFERENT MEDIA AND TOOLS

This opening chapter will define the tools and media used throughout this book. It introduces you to some of the media available and their basic characteristics. Once you choose a style direction and technique to pursue, you will need to experiment and practise to achieve a quality of work that is both professional and consistent.

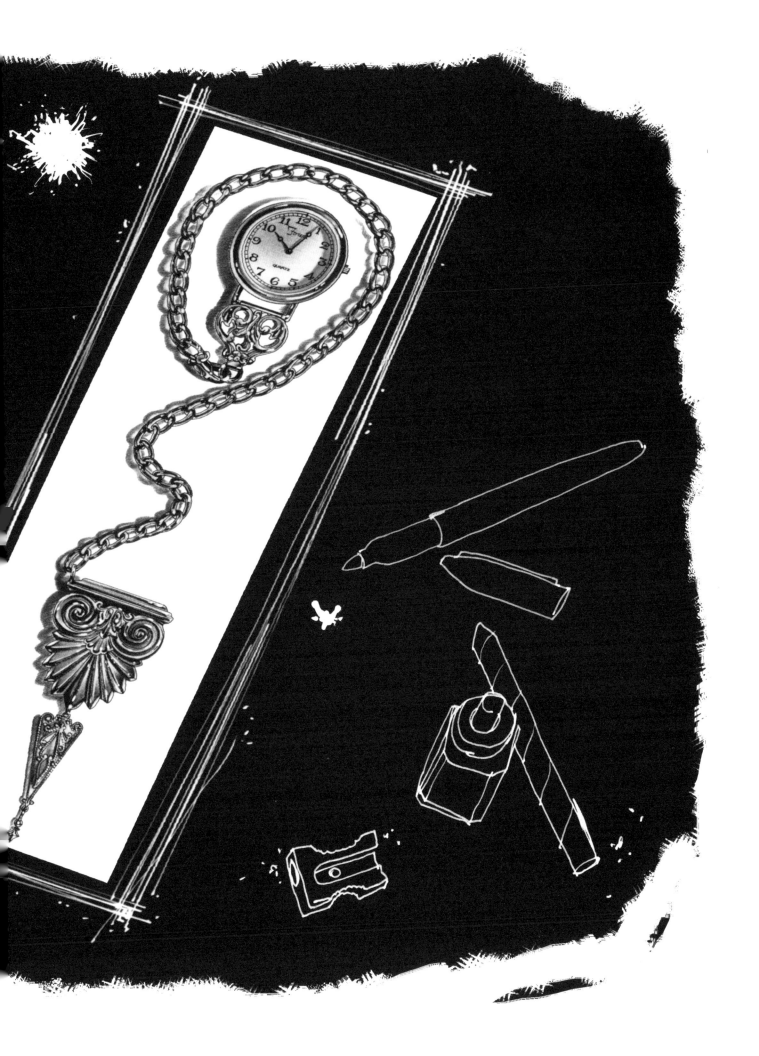

BASICS OF DRY MEDIA

Dry media such as charcoal, graphite, coloured pencils and pastels are the most common and readily available media with which to draw. Because fashion accessories come in such a vast range of textures and surfaces, you should look for a medium that best describes the finish and fabrication of the object as simply as possible.

CHARCOAL

This is the blackest and most traditional of the dry media. It can be somewhat difficult to control for detailed drawings and challenging to keep clean, but there is nothing more rich and expressive than a charcoal line. Charcoal comes in various grades and forms that progress from very hard, typically 2H, to very soft, such as 6B. It is better to use softer grades because you can always lessen your hand pressure for lighter tones, whereas a hard pencil can never be darker than its grade.

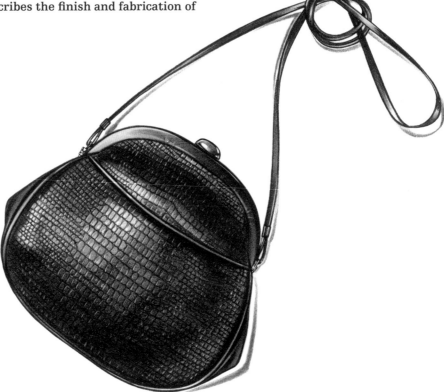

The alligator handbag was drawn with charcoal pencil and used for a retail advertisement.

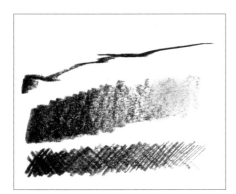

CHARCOAL PENCILS

Charcoal pencils are wood- or paper-wrapped covered sticks of charcoal that can be sharpened in a pencil sharpener or with a knife. They are used for expressive lines and general drawing.

VINE CHARCOAL

Vine or willow charcoal has a soft grey tone. It is more fragile than regular charcoal and can be easily rubbed or erased away.

COMPRESSED CHARCOAL

Compressed charcoal comes in short blocks or stick form. Its deep black colour makes it excellent for laying down large areas of tone or for smearing.

POWDERED CHARCOAL

Powdered charcoal is charcoal in powder form that can be padded or rubbed down with a foam pad or chamois. It is also used for pattern and stencil work.

GRAPHITE

Graphite is a grey-coloured medium enhanced by its shiny surface. It is very controllable and erases easily as long as you do not press too hard into the paper. It comes in a wide assortment of grades from 9H, the hardest, to 9B, the softest. It is also available in a variety of forms.

Graphite pencils allow maximum control when rendering textured surfaces, as with this nylon boot.

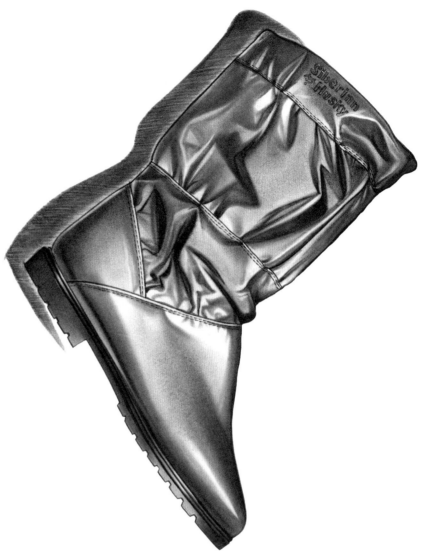

GRAPHITE PENCILS

Graphite pencils are wood-cased graphite cores that can easily be sharpened in a pencil sharpener or with a knife. They can be used for everything from fast sketching to the finest detailed work.

WOODLESS GRAPHITE

Woodless graphite consists of cylinders of graphite covered with a thin layer of plastic that can be sharpened in a sharpener or by hand. This is excellent for emotional linework, as well as for laying down large areas of tone.

GRAPHITE STICKS OR BLOCKS

Graphite sticks or blocks are larger rectangles of graphite that are good for covering large areas with tone or making texture rubbings.

GRAPHITE LEADS

Graphite leads can be purchased in thin, woodless sticks that can be inserted into a metal or plastic mechanical lead holder. These are typically used for extra-fine detail and drafting.

POWDERED GRAPHITE

Powdered graphite comes in a jar; it can be rubbed down to create a solid dark grey tone or applied with a soft cloth or pad to create subtle toning.

WATER-SOLUBLE GRAPHITE

Water-soluble graphite can be used to draw in a conventional manner but also turns into a grey wash when applied with water and a soft brush.

PASTELS

Pastels are pure pigment held together with a binder. They come in endless colour options and can be used for line drawing, value lay-down or colour fills. They are made in a variety of sizes, from pencils to large sticks. Their quality can also vary, from finer portrait pastels to sidewalk chalk. Pastels can be applied with your fingers, sponges, bristle brushes or chamois.

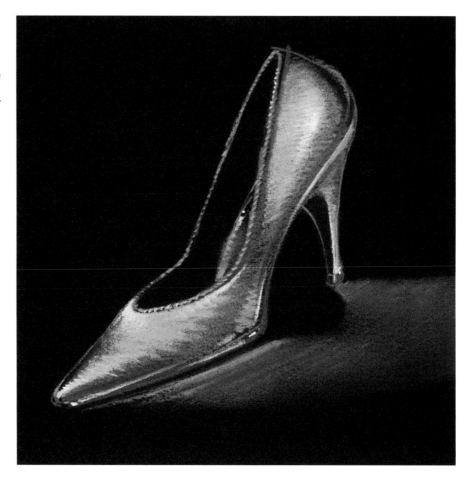

This green satin pump on black paper was drawn using a hatching technique.

SOFT PASTELS

Soft pastels are the most common pastels and have multiple uses. They cover easily and blend well to achieve realistic light gradations and colour variation. They tend to be dusty and can be hard to use for fine detail.

SEMI-HARD PASTELS

Semi-hard pastels have more binder in them and are usually baked. They are good for linework as well as detailing. Some brands are so hard that they can be used as blocks of paint like watercolours and can be applied with a soft, wet brush.

OIL PASTELS

Oil pastels contain an oil base that makes them dustless when they are applied. They are harder to control for detail, but can be used with solvents to turn them into a more painterly medium.

COLOURED PENCILS

Coloured pencils are a popular medium because they can be controlled easily and work well when used with other media. Coloured pencils come in different quality grades; it is important to use a professional grade when executing serious art. Coloured pencils are easy to overlay and can be used in linear styles or smooth blended finishes.

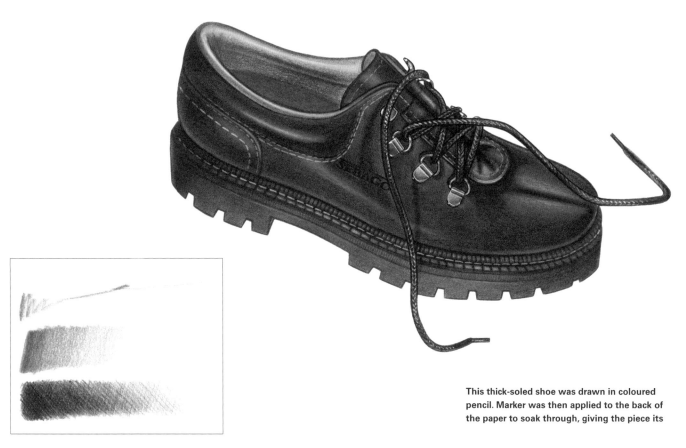

This thick-soled shoe was drawn in coloured pencil. Marker was then applied to the back of the paper to soak through, giving the piece its

STUDIO OR THICK-CORE COLOURED PENCILS

These are best used for drawing line and filling in. They come in a variety of colours and are fairly easy to erase if you have not scored the paper with too much pressure.

BLENDER COLOUR PENCIL

A blender pencil is a colourless coloured pencil. It is a stick of the pigment binder with no pigment, designed for smoothing and blending coloured pencils together once they are applied to paper.

COLOURED PENCIL STICKS

These are the core of a coloured pencil with no outside casing surrounding them. They are great for laying down large areas of colour or stippling big areas.

SEMI-HARD COLOURED PENCILS

These are insoluble, harder-core colours that are best for fine line and detail work. They work best on semi-smooth paper.

BASICS OF WET MEDIA

Wet media can offer some of the most stunning visual results, but can also be the most difficult to control and the least forgiving to work with because of their transparent nature. You therefore need to consider the extra time needed to master their beauty and unpredictable character. The cheaper the supplies you buy, the more difficult they will be to work with.

WATERCOLOUR

You will need a good watercolour brush, a decent quality of paint, and the right paper, depending on how you like to work. Brushes can be limp or springy in nature. Paint can be applied in controlled, layered washes or bold, loose brushstrokes, and paper can be absorbent or resistant to the paint depending on the amount of 'sizing' in it (see Watercolour paper, page 20). Try a few different combinations until you find what works for you. Watercolour comes in various forms and each has its advantages and disadvantages.

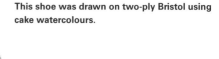

This shoe was drawn on two-ply Bristol using cake watercolours.

WATERCOLOUR TUBE PAINT

Watercolour tube paint is a semi-liquid form. The medium is ready to use; all you need is some water to achieve the right consistency for your choice of style. These paints can be difficult to mix accurately when a specific colour story is required, but they are the easiest with which to achieve consistent colour when applied.

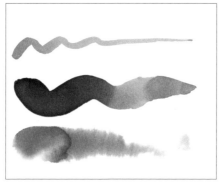

CONCENTRATED WATERCOLOUR

Concentrated watercolours are 100% liquid paints with a chemical or extra-fine pigment base. They are typically brighter than tube or cake forms, and are easy to mix with the eye dropper with which many brands are supplied. They are less permanent and will bleed into each other if you overlay them. You can also use them directly in drawing pens and airbrushes. They are known for sometimes separating into slight colour variations, as in the swatch above.

WATERCOLOUR CAKES OR BLOCKS

Watercolour cakes or blocks are the most common form of the medium. The cakes are basically the tube form dried into a block shape. The paint can be easily revived with water and mixed for colour matching. This is not the easiest way to work if colour matching is important. Dry paint can also be picked up with a damp brush.

WATERCOLOUR PENCILS

Watercolour pencils have become a popular way of using the medium in the past few years and the quality of the pigment in them has increased dramatically. They are easy to control, but it can be hard to achieve deep colour values. They can also leave you with a slight hatch line from the drawing process that may not dissolve completely. The best results seem to be when they are scribbled down on a separate sheet similar to a palette and used in the same manner as cake watercolours.

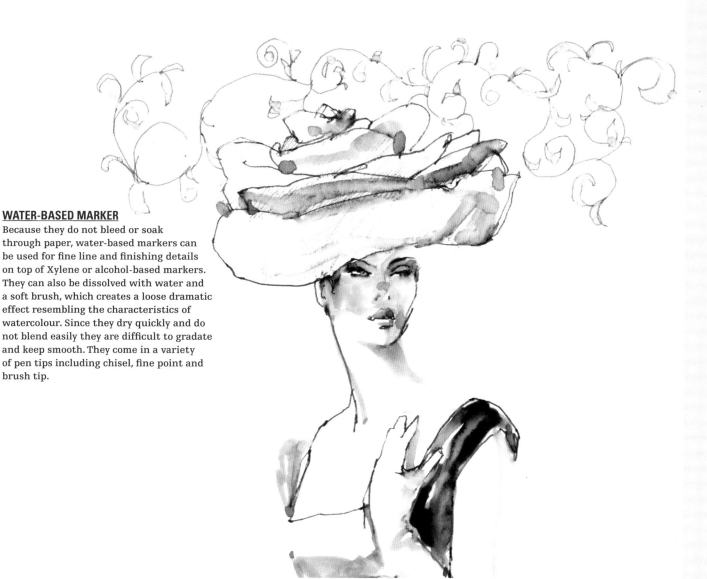

WATER-BASED MARKER

Because they do not bleed or soak through paper, water-based markers can be used for fine line and finishing details on top of Xylene or alcohol-based markers. They can also be dissolved with water and a soft brush, which creates a loose dramatic effect resembling the characteristics of watercolour. Since they dry quickly and do not blend easily they are difficult to gradate and keep smooth. They come in a variety of pen tips including chisel, fine point and brush tip.

This large rose hat was drawn with water-based pens; a soft watercolour brush was then used to dissolve the line and give it a loose, washed effect.

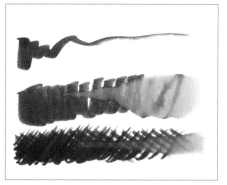

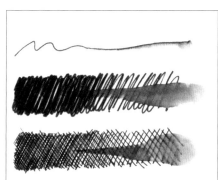

The swatches above offer a basic example of a water-based brush tip pen and a fine-line marker, both when laid down directly and when dissolved with water.

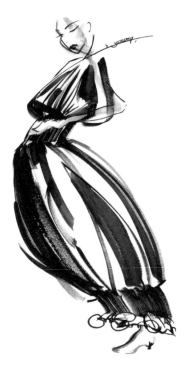

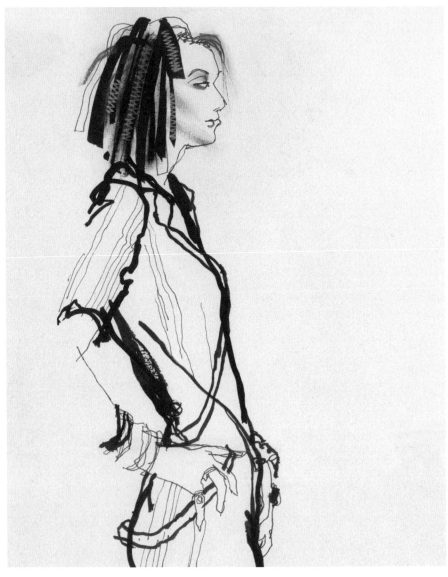

Above: This brush and ink drawing by Young Kim demonstrates the drama and gesture available through this traditional medium.

Right: This black ink drawing on yellow paper demonstrates the dramatic line qualities you can achieve with a solid black line.

INK

India ink is an intense black ink that offers a dramatic and classic look to art. It can be used with drawing pen points, calligraphy nibs, brushes or sticks. It can be cross-hatched or used in wash form to add tone or form to an object. Inks also come in a variety of colours that are usually permanent and can be airbrushed without thinning.

There are also pigment-based ink pens that give transparent coloured lines. These are excellent for detailed work and technical drawings.

Ink pen

Pigment ink pen

This drawing was done with ballpoint pen on hot press bristle board and accented with charcoal pencil and transparent markers.

BALLPOINT PEN

Usually thought of as an office supply, a ballpoint pen will offer a wide variety of line as well as subtle hatching.

Gouache

GOUACHE

Gouache is opaque water-based paint. It was the standard medium for coloured illustration work during the golden era of illustration in the 1940s, '50s and '60s. It is still popular in some design fields and as a fine art medium because of its extreme matt finish. Because it mars and chips easily, it is no longer widely used for commercial work. It is good for laying down flat areas of pure colour, and when used in a washed style it produces a modeled-looking texture. It can be airbrushed or applied with a soft hair brush. To create form on an object, simply use some watered-down paint and lightly brush over, or hatch on, the undercoat colour, tinting it to the desired tone.

The cyber smoker was painted on illustration board using soft brushes for the figure work and an airbrush for the smoking heart.

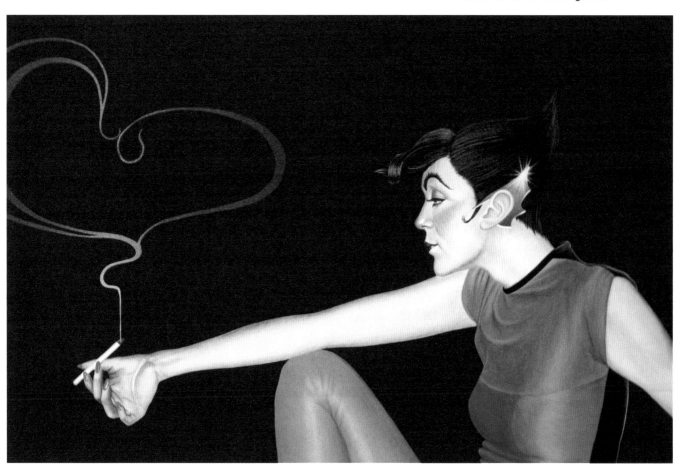

The featured figure piece demonstrates a faster line drawing style that communicates the clothing while leaving room for the fantasy of fashion.

This highly stylized illustration by Diana Garrett is drawn with alcohol marker and pigment fine-line pens on Bristol board.

SOLVENT-BASED MARKERS

Art markers come in two popular solvents: alcohol and Xylene. There is no real difference between the two except that Xylene tends to offer a slightly slower drying time together with a more intense smell, which many artists prefer not to suffer through. Markers can be purchased in a multitude of colours, which makes them a popular medium for commercial artists. They dry quickly and are easily transported for in-house freelance work. They can be combined with dry media and can offer both loose and tightly rendered art styles. They work best on marker paper that is specially made to take markers and enhance their transparent beauty.

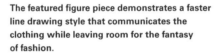

These swatches demonstrate different ways of gradating with markers.

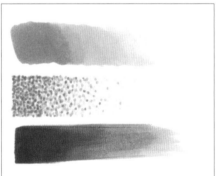

The gold swatch was gradated using a colourless blender marker to draw out the tone. The stippling technique below it uses three different tones, light, medium and dark blue. The deep orange swatch was created using three different values of marker beginning with a pale flesh, then medium orange, then finally burgundy. All swatches were applied wet onto wet.

ACRYLIC PAINT

Acrylic paint has taken off where gouache could not go. It is a durable water-based paint that dries quickly and does not mar easily. It can be used as flat colour, for overlapping washes or in thick painterly styles. It can be sprayed through an airbrush or applied with nylon brushes. It is easy to correct because it can be used in an opaque manner to cover mistakes.

The swatches above demonstrate the traditional painterly quality of acrylic as well as the dimensional illusion created by airbrushing.

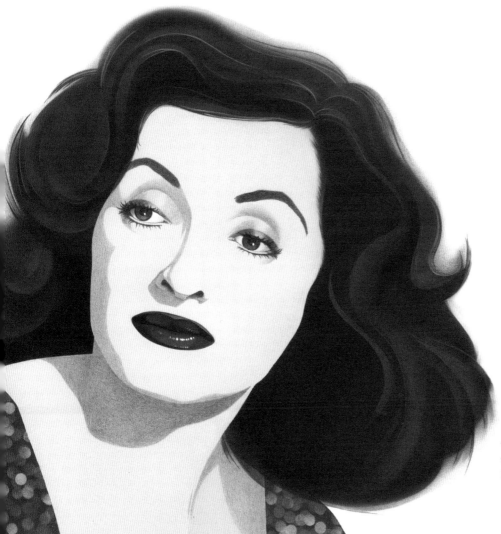

This celebrity portrait of Bette Davis was painted with an airbrush using acrylic paint. Graphite pencil was then used for the face details.

PAPERS

There is a large variety of papers for artists to choose from. You will need to try different manufacturers as well as different kinds of papers to make the right choice for your specific medium and style direction. Most media have papers that are made especially for their particular characteristics, such as pastel, charcoal, markers and watercolour; however, don't be afraid to experiment to find something that is unique to you. Most papers come in single sheets, pads or rolls, in a vast array of colours from tainted whites to solid black. You will also find some papers described as 'archival'. This means that they are museum-quality and will not deteriorate over time. Archival papers are preferable if you are planning to make fine art pieces that will need to last permanently.

There are two basic criteria to consider when choosing a paper: surface texture and paper weight.

Watercolour paper with concentrated watercolour

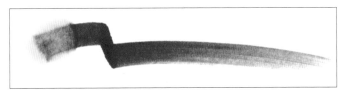

Marker paper with alcohol marker and blender marker

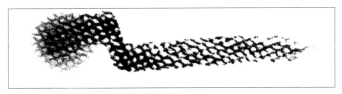

Rough paper with compressed charcoal

SURFACE TEXTURE DEFINITION

Vellum or cold press finishes are slightly textured or have a 'tooth' to them. They are excellent for working in dry media such as pencil, charcoal, pastel or some paint media.

Plate or hot press finishes are smooth and work best for ink, pen line or any style requiring a clean, smooth edge to a finished line.

Some papers refer to their surfaces as 'rough' finish – as with certain watercolour papers. Try not to use a paper so rough that it creates texture where you do not want it, or that changes the surface character of the item being illustrated. Rough textures also tend to allow media to settle into their 'pits', which can look grainy and change the texture of an accessory.

PAPER WEIGHTS

Papers come in different weights that affect their stiffness, transparency and brightness. You will need to try a few brands to see what works best for your needs. First read the covers of the pads to understand if they are for wet or dry media only. A paper that is too thin will buckle with wet media. If you work on a very translucent paper you will need to mount your illustrations to another paper or board when finished so the correct values are displayed and your piece does not appear too flimsy to handle.

WATERCOLOUR PAPER

Watercolour paper is specifically meant for heavy water use, so the weights are much heavier than regular drawing paper. It also contains 'sizing', which affects how the paper absorbs or resists water. It can be purchased in single sheets, pads, rolls or block form. A block is a pre-stretched pad of papers mounted on a backing board and sealed on all four sides with a rubber or plastic border. Stretched papers are necessary when working with a lot of water in your style so your work will not buckle while painting. Try not to work in anything lighter than a 300gsm (140lb) weight unless you stretch your paper first.

TRACING OR PARCHMENT PAPER

Tracing paper, also referred to as 'onionskin', comes in pads or roll forms. It is a translucent paper with various surface textures that is used mostly for underdrawings, overlays and conceptual planning. There are some artists who have developed finished styles using tracing paper because of the unique way that it takes various media.

SKETCHING, DRAWING AND BOND PAPERS

These papers are used for most basic drawing needs. They are the kind of papers used in most sketchbooks and come in a wide range of pad sizes, weights, textures and colours.

MARKER PAPER

There are different types of marker paper. Many are slick with lots of sizing in them and are made so the marker floats on the top surface. Most of the pieces shown in this book were drawn on Bienfang Graphics 360 marker paper, which is a 100% cotton paper. When using Graphics 360 marker paper, colouring can be done on the back of the paper, which has less sizing than the front and is therefore more absorbent, helping achieve a smooth, even tone. Other papers may work like this too, so experiment with what is available to you.

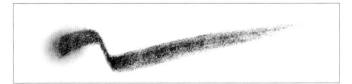

Tracing paper with graphite stick

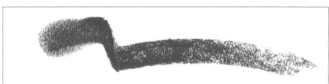

Sketch-bond paper with chalk pastel

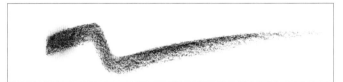

Bristol board with coloured pencil

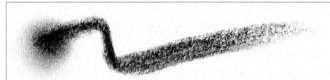

Newsprint with charcoal pencil

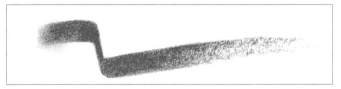

Hot press paper with coloured pencil stick

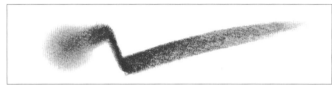

Vellum with pastel pencil

BRISTOL BOARD

Bristol is a thicker drawing paper that commonly comes in 2-, 3- and 4-ply weights. It also comes in both vellum and smooth textures and, because of its sturdiness, it works well for both dry and wet media. It is also excellent for mounting finished illustrations done on thinner paper for presentation purposes.

NEWSPRINT

Newsprint is usually the most economical type of paper to work on, as it is typically made from recycled materials. It is not archival and will turn yellow within a few months of use. For this reason, it is not usually suitable for finished, professional work.

ACETATE OR CLEAR FILM

Acetate or clear film is a completely transparent sheet or roll of cellulose used for protecting finished art, stencilling or masking for airbrush work, or for adding overlays to finished drawings. It also comes in a frosted version that can take ink, paint or marker without crawling. It comes in a range of weights from very thin (.001) to extra-heavy (.020).

COVER STOCK OR CARDSTOCK

Cover stock or cardstock is a thicker paper (200gsm/80lb or more) that comes in many colours and can be used for dry or wet media.

DECORATIVE PAPERS

Decorative papers are either made by hand or have unique characteristics such as a print, fiber content or texture. They may even have organic materials such as flower petals or leaves pressed within them.

FOAMBOARD

Foamboard is a sheet of polystyrene (3–13mm/⅛–½in thick) laminated on both sides with drawing stock paper. It is excellent for mounting presentation drawings.

POSTER BOARD

Poster board is a cheap, thick paper stock for mounting art.

TRANSFER PAPER

Transfer paper comes in various colours and is used for transferring preliminary drawings onto your final paper stock when the paper is too thick to see through.

TOOLS

Many of these tools are used to create the techniques shown throughout this book.

BRUSHES

When choosing a brush, make sure you consider what medium you will be using and what size is necessary for the work to be done. For the detailing or highlight work demonstrated throughout this book, you will need a round-ferrule pointed hair brush. Use a #1 or #0 for finer details, although you can go smaller if necessary. For painting with watercolour, try a round-ferrule pointed hair brush that is between #6 and #10. Find a brush that you are comfortable with, but remember that the smaller the brush, the more stroking you will have to do to fill an area; this can cause a watercolour, for example, to become overworked.

MECHANICAL PENCILS

Mechanical pencils are hollow, lead-holding pencil shafts that allow you to use your choice of lead hardness and to change them quickly.

PENS AND FINE-LINE PENS

Drawing pens come in several point sizes and nib shapes. There are fine points, chisel, broad tip and brush pens.

CHAMOIS

Chamois is a soft, pliable piece of animal skin excellent for blending, smudging or laying down tone on a drawing.

ERASERS

There are many erasers to choose from. A kneaded eraser allows you to 'blot' or adjust the values of a drawing without having to remove a line or tone completely. You may also choose to invest in an electric eraser that allows you to remove large areas of tone or extensive linework easily. Make sure before you use it that your eraser's consistency will not destroy your paper's surface.

TORTILLONS OR STUMPS

Tortillons or stumps are spiral-wound soft paper tools used for blending charcoal, graphite and pastels. They come in different hardnesses and sizes and can be sharpened with an artist's knife.

FRENCH CURVES

There are various shapes and sizes of French curve. They give a solid smooth-drawn edge to curved shapes.

TRIANGLES

Triangles are angled, straight-edged tools that come in two standard shapes: 45/90 degrees, and 30/60/90 degrees.

CIRCLE TEMPLATES AND ELLIPSE GUIDES

Circle templates and ellipse guides are thin plastic stencils used for drawing accurate, clean-edged circles and ellipses.

TEMPLATES FOR JEWELLERY

Start with a centre line on which to position the template. Then use a medium black pen line to outline the stone's silhouette. Use a finer pen line for the inside facets, focusing towardss the centre line.

HIGHLIGHT PAINT

White paint can be used for highlights. It provides the strong contrast desirable for most commercial work. For opaque highlights, you can use white gouache, Pro White paint or Dr. Ph. Martin's Bleedproof White. All of these paints are water-based and can be thinned for various tones. Dr. Ph. Martin's is popular because it helps prevent any colour underneath from bleeding through.

SPRAY ADHESIVE

Spray adhesive is a spray-on glue that allows you to mount a drawing onto a presentation board without your work wrinkling.

WORKABLE FIXATIVE

Workable fixative is a spray-on coating used to seal finished illustrations; it allows you to go back and make corrections if necessary because of the slight tooth it leaves behind.

LIGHT TABLE OR BOX

This is a flat drawing surface illuminated from below that allows you to transfer an underdrawing onto a thicker paper.

SOFTWARE

The diversity of user-friendly software programs available for today's computers have made them one of the most common and usable tools for any artist. Although the techniques in this book primarily involve hands-on studio skills, you will find a variety of computer applications mentioned that were used to tweak or enhance the illustrated images. This tutorial is a very basic explanation of some of the most common tool terms found in all image-editing programs. The technology changes daily, so try to find your own special combination of software and apps to make your art as individual as you are.

SHAPES AND OBJECTS

In a photo-editing program, use a masking tool to create basic shapes (indicated with dotted lines), then turn the shapes into 'objects'. Once the objects are enclosed, they can be filled using a fill tool. You can fill an object with solid colour or a variety of gradations, as well as prints or textures. Gradations with colours come in 'steps'. The lower the number of steps, the more lines you will see in the tone; the more steps, the smoother the gradation will look. A common dpi setting for a printable image is 300dpi.

LAYERS

You can overlap or layer as many shapes or objects as needed. You can also order shapes to the front or drop shapes behind others. This makes it easy to keep a clean edge. Here, intense light and dark tones were used to capture the reflective facets of this jewel. Smaller facets were added to enhance the prism feel of the crystal.

TRANSPARENCY, COPY AND PASTE

You can use 'transparency' to adjust white surface reflections to 50 or 70%. This will give the gem depth and sparkle. Use 'copy' and 'paste' to make repetitive patterns. For the gold frame studding, one finished dome was created and then 'copy' and 'paste' were used to create one horizontal and one vertical solid line of domes. Once completed, those lines were copied and pasted to the other side.

OTHER EFFECTS

A brush tool set on 'spray' effect can be used to spray some white glow over some of the white highlights. You can also add a quasar or two for added sparkle effect. The front surface reflection is a solid white shape with its transparency altered so it appears as if you are looking down into the gem.

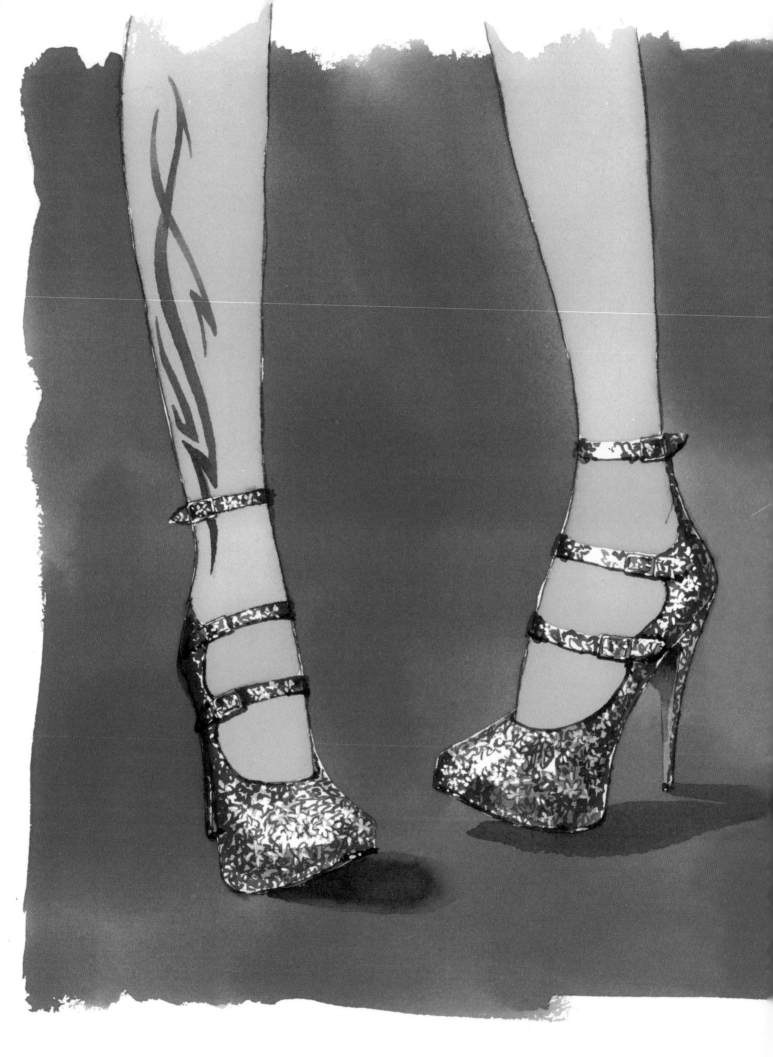

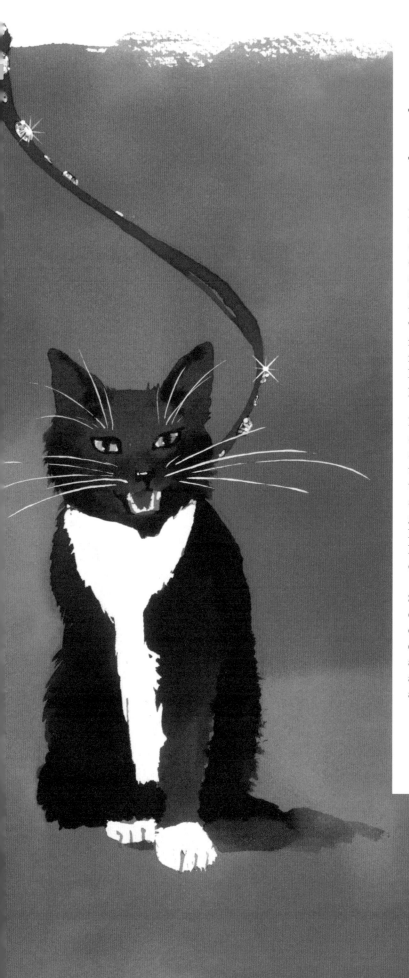

CHAPTER 2
FOOTWEAR

Perhaps the most exciting arena of fashion accessorizing comes by way of the cobbler. Shoe design and construction dates back to the beginning of feet, but in recent decades it has moved light years away from utilitarian needs to footwear theory and sculpture. There will always be an aspect of a shoe that is functional even while it expresses fantasy. The aim of this chapter is to give you an appreciation for the art and expression of how beautiful a shod foot can be, and to arm you with the techniques to go beyond the everyday illustration and use your own personal expression.

Footwear illustration has many challenges as well as applications. A good shoe illustration can move a practical pump to a level of powerful seduction through the medium of designer sketches, industry technical drawings and illustrations for retail sales and couture clients. The purpose of this chapter is to give you the drawing and rendering foundations to head towardss any area of the footwear industry and know with confidence that you understand the needs of the business and have the skills to achieve them.

Shown here are many of the actual drawing challenges you might encounter. Although the outcome of your particular rendering may not be exactly the same, the principles should guide you to a personal and satisfying style. The glossary contains a vocabulary of terms to help you explain your work and also a visual library for silhouette identification.

INTRODUCTION TO DRAWING FOOTWEAR

When illustrating footwear, whether for manufacturers or for the retail market, it is necessary to capture and enhance the uniqueness of the designer's vision while also making the necessary adjustments to the shoe's visual perspective to express its wearability as a functional fashion item.

The first thing to realize about shoes is that they are not flat. They curve around the foot from toe to heel and also rise up slightly from the ball of the foot to the toe tip. The three most common mistakes to watch for in drawing shoes are: getting the perspective wrong; drawing the centre front off-centre; and making the shape and perspective of the heel incorrect. We will start by looking at how to address these basic problems and will then work our way through to rendering exciting finishes and textures.

The two most important features of footwear to capture are the toe shape and the heel treatment; these reveal the uniqueness of the design. These features are typically illustrated with three views: a straight-on side view together with a top toe view detail (see p. 29), or a three-quarter view (see p. 28) that shows enough of the top of the toe while still giving an adequate view of the heel to show its specific design characteristics. It is also important, whenever possible, to draw your footwear from the 'outside of the foot' view. This shows the optimum design elements while avoiding the distortion and awkwardness of drawing the inside arch shape, which can appear to warp the shoe and make it look uncomfortable to wear. You should always draw a shoe with the understanding of a foot slipping comfortably into it, and with newness to the texture and structure (not as though the shoe has been worn previously).

The use of the illustration should also be considered when choosing a style to work in. If the illustration is being used for manufacturing purposes – for production or pattern drafting – the illustration will have to be much more proportional and realistic to the actual finished shoe. If the finished drawing will be used for retail or editorial applications, then whatever the client desires can be your goal. If you are the designer, you should develop your style enough to explain your concept at first glance. If your drawing creates more questions than it answers, you will need to develop a tighter style.

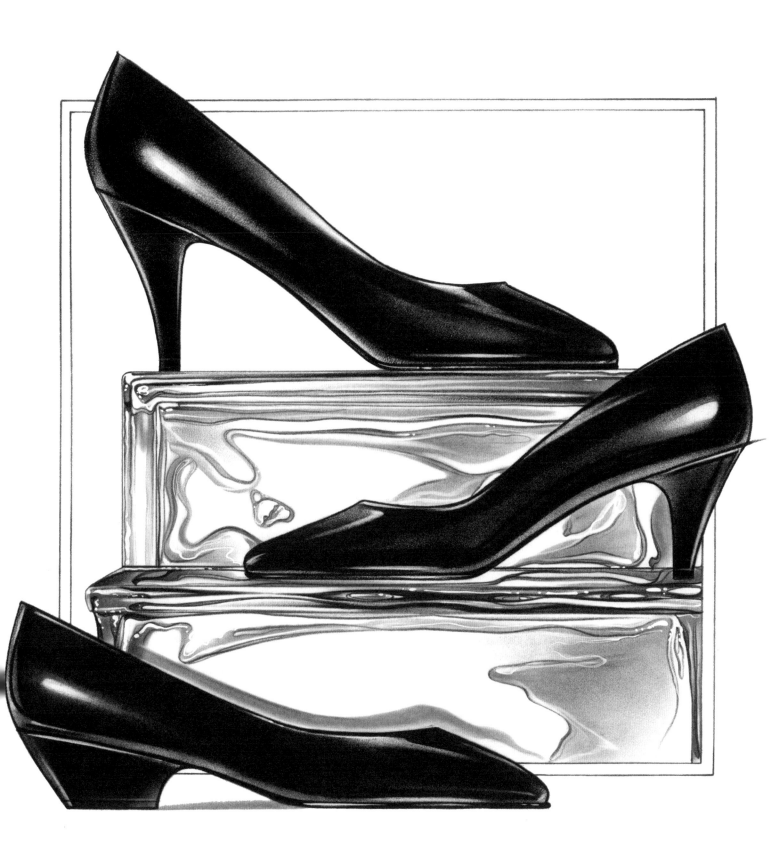

These black pumps were drawn in rich, dark charcoal to illustrate clearly their different heel heights.

THE THREE-QUARTER VIEW

The most popular, and probably the most productive, position for drawing footwear is the three-quarter view. It has a slight downward stepping angle that allows for both the heel and the toe shape detail to be viewed simultaneously. It is the most common view used by footwear designers. This Vivienne Westwood plaid shoe was illustrated using liquid watercolours. The plaid was painted last using a small brush and thin paint that overlapped to make the darker shade.

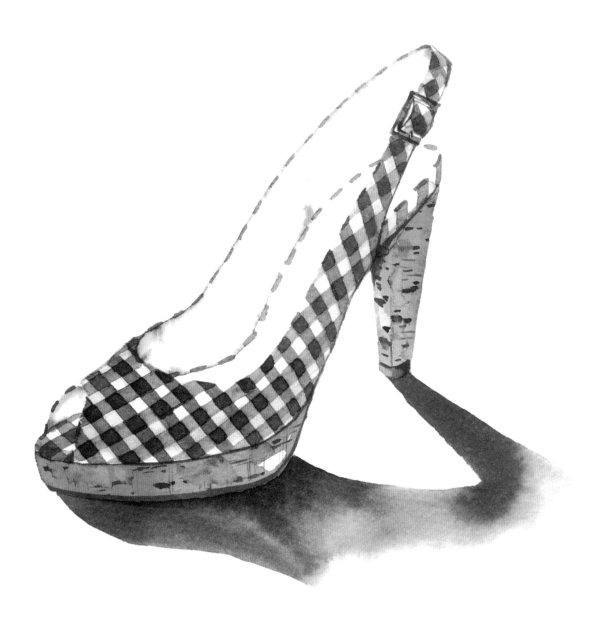

THE SIDE AND TOP VIEW

Another popular way of illustrating footwear is to draw a side view along with a top view toe detail. These views are particularly useful when drawing or designing a unique heel that needs to be featured while also needing to show the toe shape or some unique top embellishment. It is also a useful perspective when a shoe design is asymmetrical. It is not necessary to draw the entire top of the shoe if the novelty is primarily on the toe section. The examples shown here were done in graphite pencil along with black pen line for the studding to make them separate from the shoe surface. The hatch lines in this drawing were added at the end to give it a looser feel. Also notice how the background adds motion without overpowering the featured items.

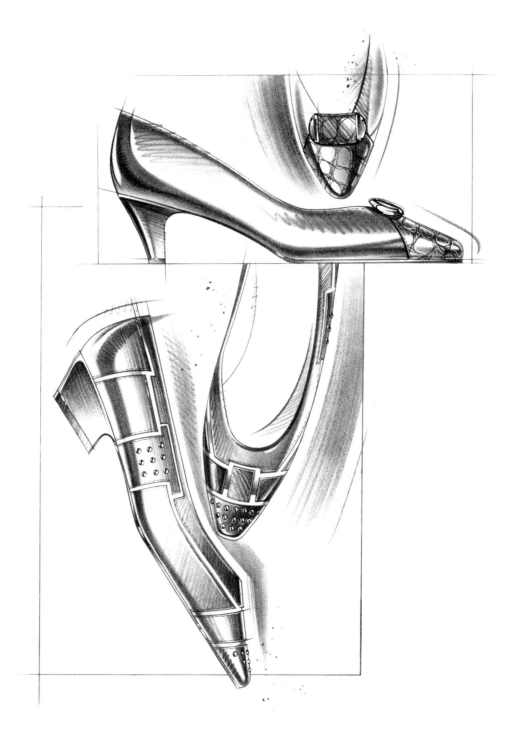

DRAWING THE THREE-QUARTER VIEW

This step-by-step demonstrates the process for developing a three-quarter-view shoe drawn in a tight, clear style. The illustration could be used for showing to a manufacturer or in a retail/advertising venue.

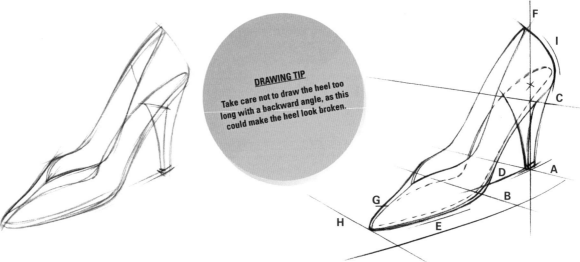

DRAWING TIP
Take care not to draw the heel too long with a backward angle, as this could make the heel look broken.

STEP 1

Begin with a loose sketch on tracing paper. If you have the shoe, place it in front of you. Set the shoe to have a slight downward step, allowing you to see the toe top, heel and toe sides. You may be able to see a bit of the inside sole, or the inside of the upper if more heel definition outside is necessary.

STEP 2

Place your initial sketch under another piece of tracing paper and refine the drawing. The inside heel angle (A) is parallel to the inside back of the shoe (B). The cross-section perspective should follow the same line (C). The centre of the heel lines up with the centre of the back so the heel appears to sit a bit higher than the sole (D). The outside of the heel runs along the same line as the outside of the shoe (E). The centre of the heel lines up vertically with the heel of the foot (F). Check the centre line of the toe (G) and the front toe perspective (H). The heel hugs the back of the foot (I).

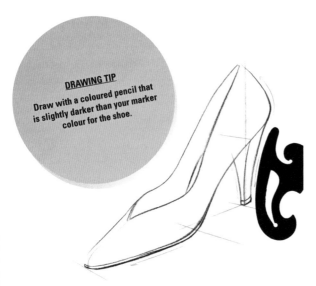

DRAWING TIP
Draw with a coloured pencil that is slightly darker than your marker colour for the shoe.

STEP 3

Place your underdrawing under a sheet of translucent marker paper. Begin to draw the outline of the shoe with a coloured pencil. Use a different colour pencil for every different colour on the shoe (sole, upper, heel) and follow your perspective lines. Use a French curve if your hand is not steady enough to make smooth, clean lines.

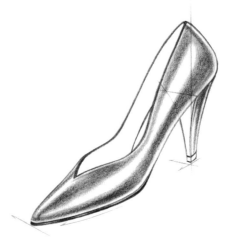

STEP 4

Now begin to draw the shadow patterns. Light the shoe with your desk light if possible. All shoes have a similar shadow pattern, as they all have to wrap around a foot. Keep in mind that you are only drawing the shadow tones – you do not need to fill in the whole shoe with colour. Make sure your rendering is darker than the marker colour you will be using, otherwise the marker will wash away all of your shadow tone drawing.

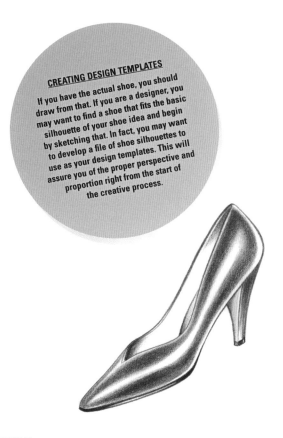
Materials:
Tracing paper
Bienfang Graphics 360 marker paper
or another 100% rag paper
Coloured pencils
Alcohol or Xylene markers
Pro White paint or white gouache

STEP 5

Use a blender pencil to develop a richer colour or to smooth out the texture of the coloured pencil. This will darken your pencil work and will also smooth out the gradation areas from shadow to lights. There is only a minimum amount of colour used on the inside of the shoe because the outside of the shoe is where you want people's attention. If the inside is over-rendered, it can distort the silhouette of the shoe and make it appear wider.

STEP 6

To apply the marker, flip your paper over and begin to marker at one end of the shoe. Do not draw an outline around the shoe with the marker – that will cause a dark outline on your finished piece. Start markering at one end and move slowly towardss the other. Aim to saturate the paper with the marker. Use a circular motion, or straight lines going back and forth. Make sure you overlap your colouring enough to saturate the paper and avoid streaks and blotches.

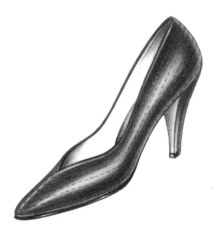

STEP 7

When you are finished markering, flip the paper back over and the local colour of the shoe will be complete. Now you are ready to add highlights and reflective lights. Notice the orange colour (reflective light) added on the back of the heel for interest. The highlights were made with a white coloured pencil and give a soft glowing highlight that is appropriate for the leather finish of this shoe.

STEP 8

Finish your shoe by adding some specific (or hot) highlights with some Pro White paint or white gouache. This is also a good time to add any top-stitching or pattern because your shadow drawing is now partially sealed into the paper by the marker soaking through the paper and gripping it. You can also use your white paint medium to clean up any edge bleeding from the markers or straighten up any perspective angles that have been skewed.

DRAWING THE SIDE VIEW

When drawing a side view of a hard-soled shoe, keep the bottom front toe flat to the floor. Do not draw the natural up curve that most shoes have. This will show the shoe the way we think shoes look on our feet. The only exceptions to this rule are athletic shoes, thick-soled boots or platform shoes; these will look awkward if they do not have a slight up curve to the toes (see pp. 36, 38–39, and 40). This is a tighter style that could be used for retail or a presentation venue.

Materials:
Tracing paper
Marker paper
Coloured pencils
Markers
Pro White paint

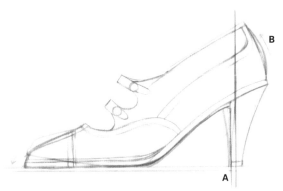

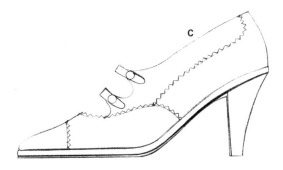

STEP 1
Begin by sketching the shoe silhouette on tracing paper, ensuring you bring the front toe down flat to the floor. Adjust for the natural curvature of the shoe by drawing the toe from a straight-on side view, then turn the shoe slightly to see the straight-on view of the heel. Draw these two design elements without distortion. Make sure your inside heel is at a right angle to the sole (A). Softly curve the back of the heel comfortably over the heel of the foot (B).

STEP 2
After refining the underdrawing on another piece of tracing paper, place it under a piece of marker paper and draw your outline with a darker-coloured pencil than your finished marker. If you have difficulty controlling the smoothness of your line, use a French curve for your edges. Make sure you do not draw the inside upper of the shoe (C). (It is not possible to show the inside of a flat-soled shoe because it will appear warped.)

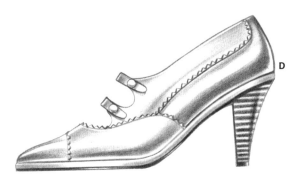

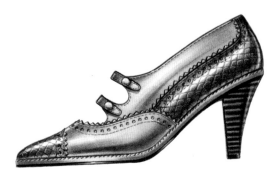

STEP 3
Fill in your shadows following the natural flow of the foot using a darker-coloured pencil than the local colour of the leather. By drawing a dark core shadow and leaving a lighter reflective light pattern down the side of the shoe, you will add form and separate the upper from the sole (D).

STEP 4
Finish by markering on the back of the paper. Then turn the illustration over and detail the necessary textures or patterns. Here, the snakeskin and wingtip pattern were drawn with a harder HB graphite pencil. This allows for maximum control and sharpness. Notice the reflected blue light coming up from the floor on the side of the shoe. Again, the large white highlights were left out while markering and the snakeskin was highlighted with a white coloured pencil and accentuated with Pro White paint.

DRAWING THE TOP VIEW

For the top or toe section of the shoe, you need to draw from straight above the toe tip, then add a bit of length to the shoe to make up for the foreshortening that takes place as the shoe rises up from the arch of the foot to the heel. The higher the heel, the more length you will need to add. It is not usually necessary to draw the whole shoe when drawing a toe detail (see p. 29), but if you do, make sure the back heel curves comfortably around.

Materials:
Tracing paper
Marker paper
Coloured pencils
Markers

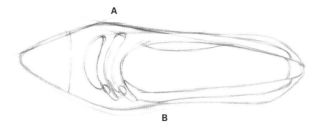

STEP 1
Begin by sketching the top of the shoe on a piece of tracing paper. Notice the harder angle on the arch side of the foot (A) and the smoother curve of the outside view (B). The arch-side bulge will be slightly lower than the bulge on the outside of the foot.

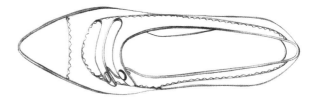

STEP 2
After refining the underdrawing, place it under a piece of marker paper and begin to draw the outline of the shoe with a darker-coloured pencil than the finished local colour of marker. Keep in mind the symmetrical nature of most footwear and keep the perspective straight.

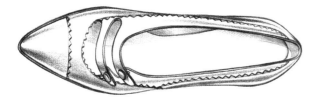

STEP 3
Start to lay in your shadow tones. Light your shoe from a single light source. Notice how the light and dark patterns follow the side structure of the foot. Keeping to this form will make your shoes easy to read and look structurally sound. The more reflective the surface, the higher the contrasts between lights and darks. Keep the inside sole of the shoe lighter than the outside upper so the inside does not distract from the design and allows the silhouette of the shoe to dominate.

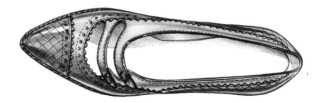

STEP 4
Finish the illustration by markering the local colour on the back of the drawing and then adding the design details to the front (snakeskin and highlights). In this illustration, the highlight on the toe was created by missing out that area when marker colour was applied.

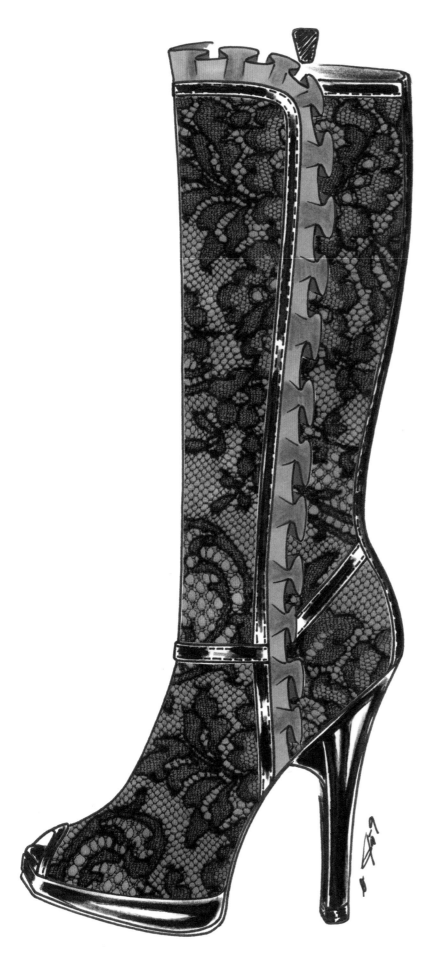

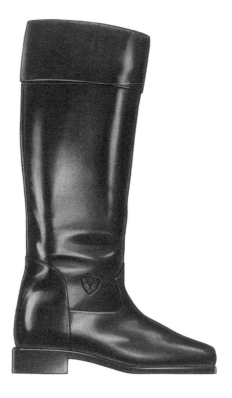

This riding boot was drawn on marker paper using charcoal and a 40% cool grey marker was added from the back of the paper. Highlights were added using white coloured pencil.

This lace boot by Raymond Serna was drawn with black ink and grey marker. A copy of black lace, tinted green with marker, was collaged into place from the back side of the paper.

DRAWING HIGH BOOTS

When drawing high boots such as riding or knee-highs, there are a couple of perspective rules that should be followed. The following rendering examples explain how to achieve the proper perspective. This is a tighter rendering style using 4B and 6B graphite pencils.

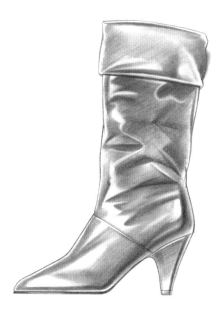
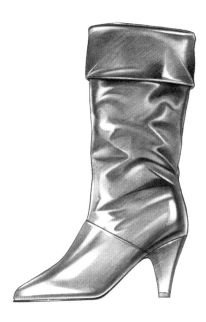

STEP 1
Begin with a preliminary sketch or underdrawing. Curved edges, like the top opening, will increase in arch as they move away from eye level (see top green curved line). If you draw the bottom of the boot looking straight on, you should also draw the top looking straight on, to ensure you do not get an extreme curve at the top. Bring the natural toe spring flat to the floor (see green line). Lay in shadow patterns at this point.

STEP 2
Using a 4B graphite pencil, draw in a more defined and solid outline. Start to lay in your shadow patterns with a 6B or softer graphite pencil, observing how the leather bends and relaxes as it forms the boot. Use your finger to smooth out some of the hatch lines.

STEP 3
To finish the drawing, increase the value contrast and rub out most of the texture using a blending tortillon or drawing stump. Note that no marker tone was applied behind the drawing, so the natural white of the paper becomes the highlights for the finish. Darken the shadows and erase some of the highlights. Add a 40% cool grey Xylene marker behind the rendering to add more contrast. Add some highlights with a white coloured pencil and add details using a fine hair brush with Pro White paint.

DRAWING WORK OR HIKING BOOTS

When drawing any thick-soled boots such as work, hiking or platform boots, it is necessary to draw them with the toe spring visible. The looser rendered examples below show how to achieve the proper perspective in a three-quarter view. This style of drawing is appropriate for editorial illustration or can add interest in trend forecasting media.

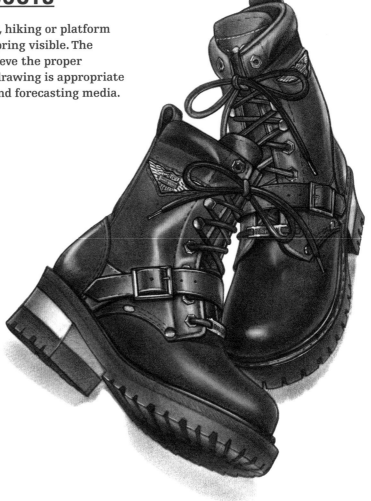

The tighter rendering style of these Dr. Martens boots was achieved using 4B and 6B graphite

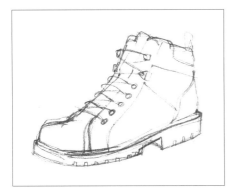

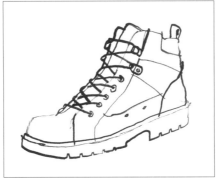

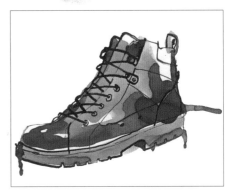

STEP 1

Begin with a preliminary sketch or underdrawing of the boot. Watch for the soft, upward turn of the front toe spring. Also watch the perspective of the boot lacing. Work out the crossing over that occurs in lacing and also the symmetrical quality of the eyelets. Keep the sole divots equal in size and correct in number to maintain the right design proportion.

STEP 2

Place your preliminary drawing under your piece of finish paper. Using a bamboo stick or sharpened popsicle stick, draw around your shoe shape. Do not be overly concerned with accuracy. Some flaws in the drawing will add to the artistic nature this style demands. By getting a wide variety of line quality – everything from wet and bold to dry and scratchy – you will end up with a more interesting art piece.

STEP 3

Finish the drawing with concentrated watercolour, which gives you a bright and completely transparent colour finish with no sediment from pigments. Turn the paper as you work and use an excessive amount of water to create the dripping effect. Start with lighter colours first then add darker tones for the shadows, even mixing the paint right on the paper, wet into wet.

DRAWING SANDALS

When drawing any kind of sandal it is usually necessary to draw the straps as though a foot were in the shoe. Make sure the straps are symmetrical from side to side as they connect with the sole. This image (bottom) of a Jimmy Choo patent leather strappy represents an illustration style that could be used in any magazine or editorial article. It was drawn by hand using a brush-point pen and was then scanned into Photoshop and rendered using colour fills for a clean graphic look.

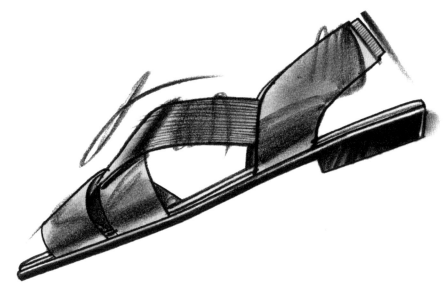

This loose, black and white flat sandal was drawn with charcoal pencil on marker paper with cool grey marker applied to the back for the local colour tone.

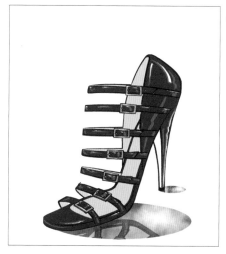

STEP 1
Begin with an underdrawing with the straps drawn in their formed position. Notice the foot shape (in blue), which helps to form the straps. Note the perspective lines (in red) that help keep the straps in perspective from side to side. Keep your viewpoint consistent and keep the curve of the straps similar to your view. Use a centre front line (green) to keep the three-quarter perspective correct.

STEP 2
Place your preliminary drawing under the finish paper of choice. To achieve an expressive yet slick line drawing, use a black brush-point pen. The clean black line will also make the drawing easy to scan and provide well-defined shapes to capture with a masking tool.

STEP 3
Draw highlight lines on another copy of the original shoe and scan. Colour-by-colour grab each individual shape with a masking tool such as the masking wand. After creating a mask, make a shape and fill it using the fill tool. Grab the line drawing and fill it with black to ensure it is solid and rich with colour. After adding the middle tones and highlights, clean up some of the lines and colour shapes using a brush tool. Add bright white highlight spots to exaggerate the feel of patent leather.

DRAWING PLATFORMS

Platforms, like any thick-soled boot, need to be drawn with the toe spring visible. The purpose of the toe spring is for the shoe to have a rocking motion as the foot steps forward, otherwise there would be a hard, sharp edge to stumble over. The Vivienne Westwood extreme platform shown below is rendered using a cut paper technique. This fun, graphic style works well for editorial illustration or trend forecasting spot illustrations.

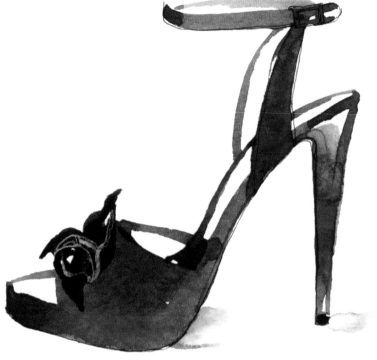

This loose watercolour drawing shows the natural lift in the toe and is typical of a faster designer sketch in a wet medium to show a concept idea. Black line was drawn over the finish to add some clarity to the details.

STEP 1
Begin with a preliminary sketch of your shoe shape on paper or go right to cutting the shape out if you feel confident enough. Use a sharp razor knife such as an X-Acto knife, and cut your basic shapes first. Note the toe spring rising up from the ball of the sole. Keep the laces soft and alive.

STEP 2
Cut your secondary shapes: middle tones, highlights and some darker shadow shapes if necessary. Plan on three tones to make a solid form. Focus on the basic shape a colour makes and be sensitive to thicks, thins and curves – do not get too generic or your shoe can look clunky and boring. Cut thin strips of black paper for the sole edge. These strips curve well if the paper is not too thick. Glue your paper shapes in place.

STEP 3
To finish the illustration, add some background elements to give a feeling of depth and to enhance the theme of the design. As a finishing detail, draw an alligator texture overlay and scan it in Photoshop. Scan the collage and add the overlay. This could also be accomplished by using an alligator print or textured paper. See the collage boot on p. 34.

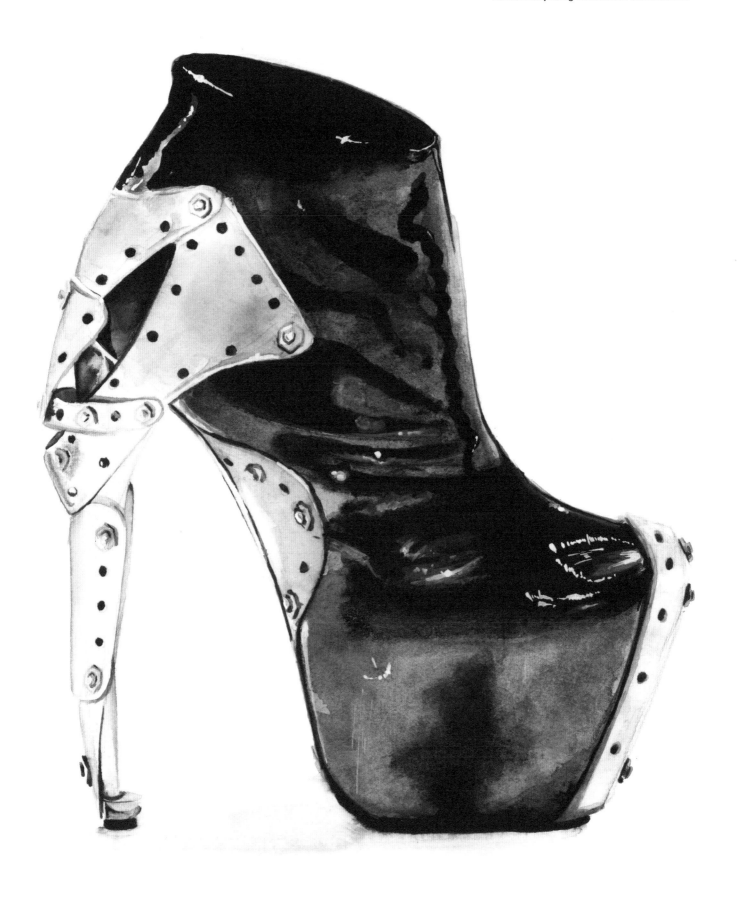

DRAWING ATHLETIC FOOTWEAR

When drawing athletic footwear or specifically soft-soled shoes, it is necessary to draw the soles with a soft toe spring. If you force the toe flat to the ground it will make the shoe seem too hard and will not visually fit the 'comfort' aspect of a sports shoe. The high-top below was drawn in a looser style to communicate a younger, more editorial, style.

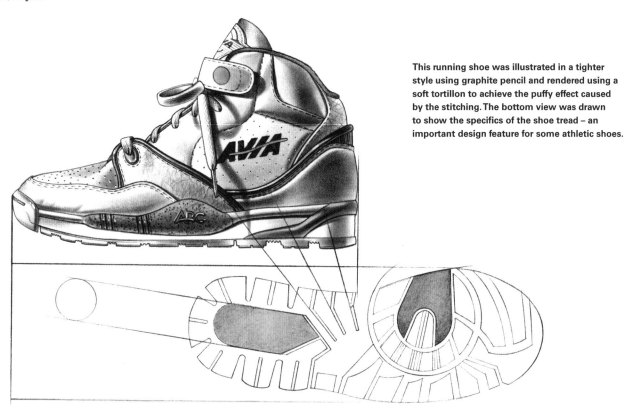

This running shoe was illustrated in a tighter style using graphite pencil and rendered using a soft tortillon to achieve the puffy effect caused by the stitching. The bottom view was drawn to show the specifics of the shoe tread – an important design feature for some athletic shoes.

STEP 1

Begin with a light preliminary sketch using a hard (2H–4H) graphite pencil. A three-quarter view makes it easy to show the softer toe curve. Then cover the areas you want to leave white with a masking fluid or liquid frisket. This makes it easy to be expressive with your paint without having to worry about bleeding or slipping over lines with your brush.

STEP 2

Using concentrated watercolours for a brighter, more tie-dyed, look, begin to paint your shoe. Use a lot of water on the painted areas, allowing the colour to bleed without too much control. Add the background tone to separate the white laces from the background. When the paint is dry, remove the masking fluid by peeling or rubbing it using a soft eraser.

STEP 3

To finish the drawing, draw around some of the edges using black India ink and a sharpened lollipop stick. This adds definition and detail without tightening up the drawing. Add the type with a fine-line pen for product identification.

DRAWING ESPADRILLES

Espadrilles are a type of slip-on shoe found in most cultures. Sometimes it is necessary to draw them with laces that extend up the leg. When drawing these you will need to draw them as if they are actually tied around a leg. Keep an elegant foot shape in mind and visualize the way the laces wrap. The drawings below are examples of a designer drawing or concept sketch. They are drawn quickly using art markers for the rendering. Remember that even with a faster sketch the purpose is always to show the item with form – not flat – so consider your light source and shadows. This fast style is ideal for production ideas and for communicating a concept quickly to your client.

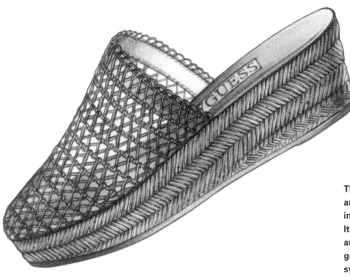

This tightly rendered shoe was used for a black and white newspaper advert; it was rendered in graphite with art marker behind the drawing. It was necessary to break the weave pattern and the sole stitching down into a simple graphic pattern, and then repeat the pattern systematically across the surface. Always flatten or reduce the pattern as it moves around and over the shoe surface for a foreshortened effect.

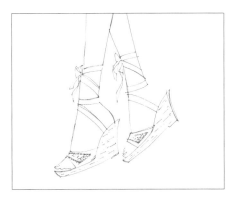

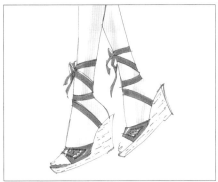

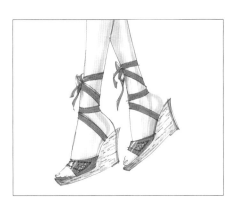

STEP 1
Begin with a preliminary sketch or underdrawing. Work out your foot shape and the lacing up the leg. Then slip the preliminary sketch under a piece of marker paper and draw the outline using a black fine-line pen. The pen ink needs to be either water-based ink or a pigment ink, otherwise the finishing art markers will smear the lines.

STEP 2
Begin markering with the lighter tones of each colour. It is faster to leave the highlights out by drawing around them. Notice that it can add interest and even a softer feel to have some edges drawn with only the marker colour without the black line around them. Misregistration of colour and edge is also interesting and acceptable.

STEP 3
To finish the drawing, use a darker marker of the same colour family to add shadow and form. If you do not have a darker marker, use the same marker again, giving a double dose of the same colour. Wait until the first layer dries before adding another. Notice the highlight lines drawn with white coloured pencil on the upper – you may need to add some highlights on the lacing ribbons, too.

DRAWING VARIOUS VIEWS

The ability to draw footwear from various angles is not only important for shoe illustration but also to ensure that the figure looks stable and able to move. When drawing the feet in perspective, it is important to watch for the foreshortening that will always occur with body movement. Here are some common views together with some guidelines to check your drawings for solid movement from any view.

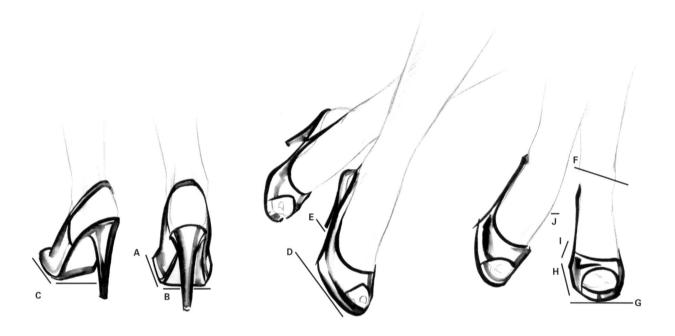

BACK VIEW

When drawing shoes from the rear position, watch for the foreshortening that takes place with these two main perspective points: from ground level (B) towardss the front of the shoe there is an upward angle that shows the thickness of the foot/shoe (A). With a turned foot there is also a slight upward angle as the foot moves away from you (C). Take note that the heel is slightly lower then the instep line.

CROSSED ANKLE VIEW

When crossing ankles or drawing the foot moving forward on its side, watch for the curve of the outside edge (D) and also the heel length (E), which will appear to be centred back behind the ball of the foot.

FRONT STRAIGHT-ON

When drawing a straight-on foot, notice that the inside ankle (tibia bone – F) is higher than the outside (fibula). The narrowest part of the ankle is right above the ankle bones. When drawing the shoe, look for the width (G), the height (H) and the depth of the instep (I). It is not necessary to draw all the toes in detail – remember, you want people looking at the shoes, not the feet. Also notice the soft curve of the top arch on the forward lifted foot. Keep your arch high in placement, not centred on the foot (J).

THREE-QUARTER BACK VIEW

In the three-quarter back view, watch for the upward perspective of the shoe as it moves away from you (A). Also make sure the heel is centred in the back of the instep and lower than the instep base line (B). Usually the heel of the shoe curves underneath the heel of the foot to centre the weight of the foot over the heel. Watch the curving of the heel seat as it wraps around the heel of the foot (C).

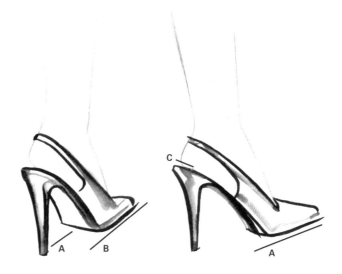

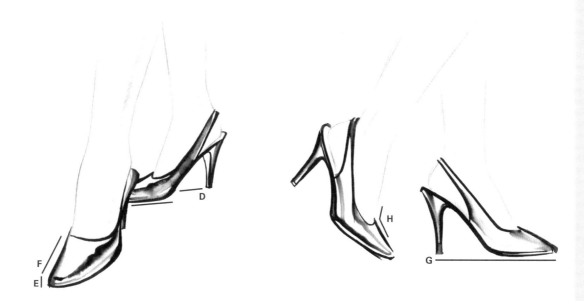

THREE-QUARTER FRONT VIEW

When drawing a front three-quarter view, watch your heel height (D). The heel of the shoe should appear to be set back and slightly under the heel of the foot. When drawing the toe section, make sure you draw the height (E) and the depth (F) of the toes so your shoes do not look flat.

SIDE VIEW ON

Watch that you keep the side view shoe flat to the ground as you would without a foot in it (G). Notice that the heel is set slightly higher than the instep. Also make sure that you do not shorten the toes on a walking gesture. A clean angle from the arch to the toes (H) will keep your shoe structure looking proportional and strong.

RENDERING BUFFED LEATHER

Buffed leather is one of the simpler surfaces to render. It has soft shadows and reflections that can be easily achieved with coloured pencil or pastel.

Materials:
Coloured pencil
Colourless blender pencil
Marker pen
White pencil

DRAWING TIP
To keep the rendering smooth you can use your finger, soft tortillon, chamois or tissue.

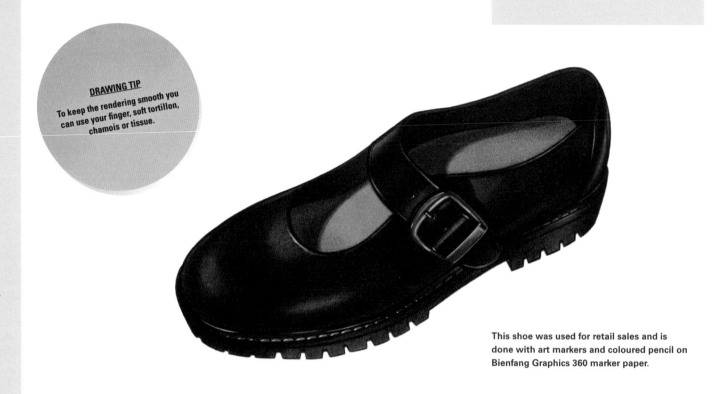

This shoe was used for retail sales and is done with art markers and coloured pencil on Bienfang Graphics 360 marker paper.

STEP 1
Begin with a smooth-edge outline with a coloured pencil. Lay in your shadow form, keeping the rendering smooth. Use a colourless blender pencil to get rid of unwanted texture and blend the shadow colours together.

STEP 2
Now add marker on the back of the paper.

STEP 3
Finish up by adding some soft white highlights with a white coloured pencil. This will make the surface of the object glow.

RENDERING SATIN

Satin has smooth, flowing, liquid-like reflections that glow with soft edges. Because it is highly reflective you must consider the dark reflections as well as the light reflections.

Materials:
Coloured pencil
Colourless blending pencil
Art marker
White pencil
Pro White paint

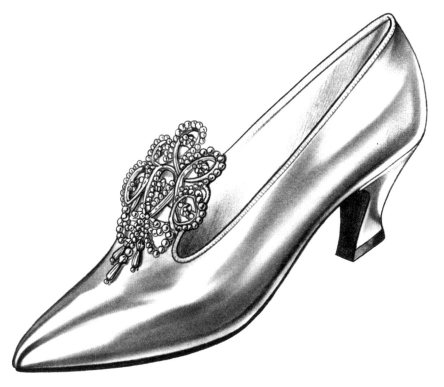

This satin shoe was used in an advertisement for bridalwear. Graphite pencil was used for the shoe rendering and a fine-line black pen for the bead outlines. (See the beading step-by-step on page 51.)

STEP 1
Begin with a smooth-edge line. Lay in your shadows, keeping the shapes fluid. Smooth out some of the texture with a colourless blending pencil (optional) and darken the shadow forms, keeping edges smooth.

STEP 2
Apply art marker on the back of the paper.

STEP 3
Now add your highlights with a white coloured pencil, keeping the texture smooth and the shape fluid. You can add a small amount of Pro White paint if necessary to make the highlights more intense.

RENDERING PATENT LEATHER

Patent leather is strong, clean and reflective. Keep your contrasts extreme. You should use solid black (or whatever the colour may be of the leather) to a pure white highlight. Gradations are good to show surface movement, but keep your texture very smooth.

Materials:
Coloured pencils or charcoal
Marker
Bleedproof White paint
Beinfang Graphics 360 marker
paper

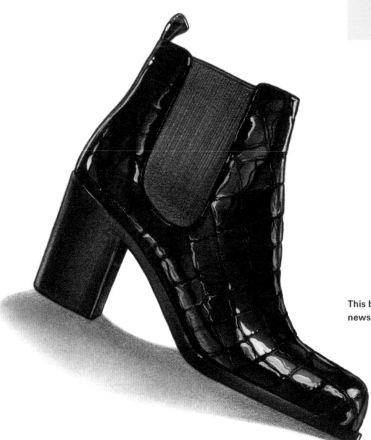

This boot was used for a black and white newspaper advertisement.

STEP 1
Begin with a smooth-edge line and lay in your shadow patterns. Fill in the reflections with a full range of contrast. Use a blender pencil to smooth out any excess texture.

STEP 2
Apply marker to the back of the marker paper. Use a 50–80% grey marker, not 100% black.

STEP 3
Add highlights with white paint to give a look of high-gloss finish to the surface. Use a white coloured pencil for softer white reflections or to soften the hot highlights.

RENDERING SUEDE

Suede is soft, fuzzy and dull, and is one of the easier textures to render. The most important thing is to not overwork it.

Materials:
Coloured pencil
Marker
White pencil
Bienfang Graphics 360 marker
paper

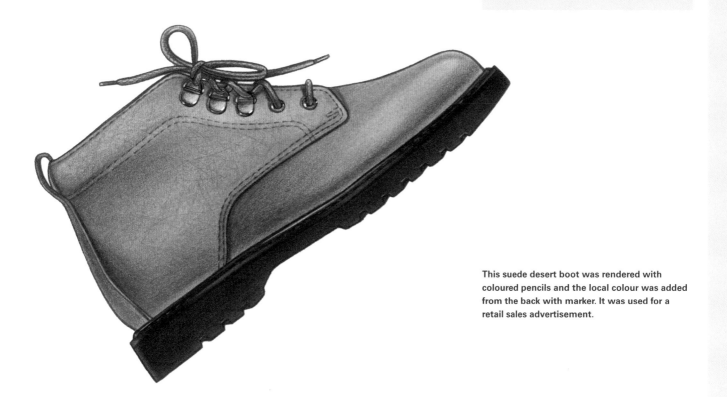

This suede desert boot was rendered with coloured pencils and the local colour was added from the back with marker. It was used for a retail sales advertisement.

STEP 1
Draw a soft edge on your object. Lay in your shadow areas using the side of your pencil for maximum texture. Darken your shadows and add texture over all open areas.

STEP 2
Apply marker on the back, leaving no areas unfilled.

STEP 3
Add white or light coloured pencil onto highlight areas to create more form, using the side of your pencil for optimum texture. Use a colour to add interest to the dullness of the suede.

RENDERING WOVEN FABRICS

The easiest way to draw a woven fabric is to break it down into a graphic grid and draw it with a repetition of both shadow and reflection.

Materials:
Coloured pencils or charcoal
Marker
Pro White paint
Beinfang Graphic 360 marker paper

DRAWING TIP
To speed up the drawing process, use a repetitive method. Draw all the same sides on each section of a woven pattern, for example, then draw all the next sides on each section.

This shoe illustration was made for retail store advertising.

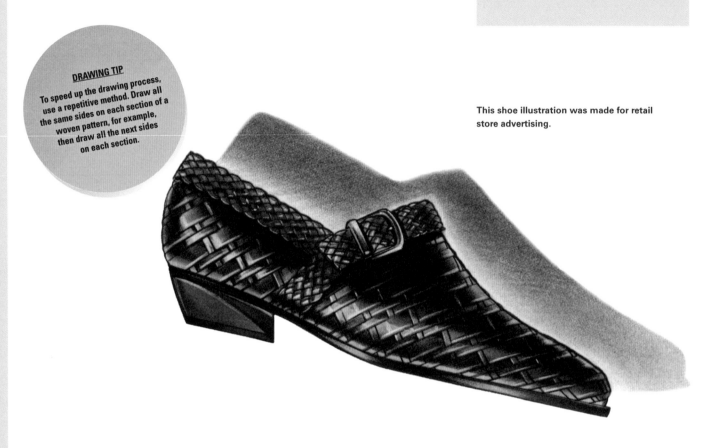

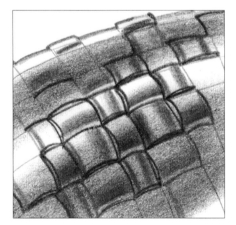

STEP 1
Begin with a smooth edge in coloured pencil. Lay down your base shadow tones with coloured pencil. Add a grid of the weave pattern with a hard graphite pencil. Outline and colour the individual sections with a darker-coloured pencil. Darken the shadows on the individual sections.

STEP 2
Add marker to the back of the marker paper.

STEP 3
Finish up by using a small amount of Pro White paint for highlights on the highlight side edges of each section, and a white coloured pencil for softer highlights.

RENDERING CANVAS OR TWEED

Canvas or tweed textures are found in both dress and casual shoes. The simpler or tighter the weave, the less texture you should show.

Materials:
Coloured pencils
Marker
Pro White paint

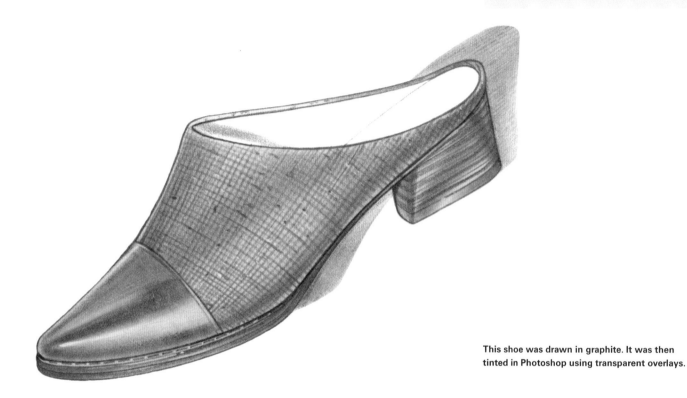

This shoe was drawn in graphite. It was then tinted in Photoshop using transparent overlays.

STEP 1
Begin with a smooth edge in coloured pencil. Roughly lay in your shadows. Using a sharp coloured pencil, add cross-hatching lines following the grain of the fabric. Do this in the lighter areas only and fade it into the shadows to avoid over-rendering. Avoid fat lines. Add some nubs by tapping the pencil down around the surface.

STEP 2
Apply marker colour on the back of the paper if applicable.

STEP 3
Finish by adding highlights with Pro White paint and a small brush. Keep the strokes thin and in the same direction as the drawn lines. Add a few white nubs for added texture.

RENDERING FUR

When fur is used in footwear it usually has a short nap, unless it is a mukluk-type boot. The important thing to capture is the soft quality both on the edge and on the upper.

Materials:
Coloured pencils
Marker pens
Pro White paint
White pencil

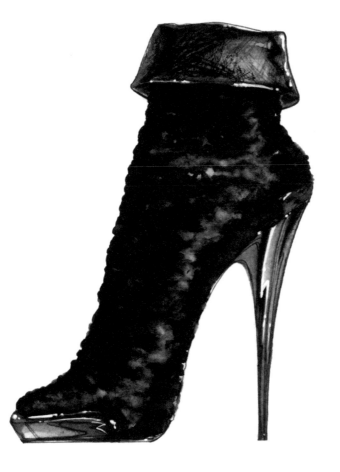

This Vivienne Westwood boot was done in watercolour as a style direction sample.

STEP 1
Begin with a textured edge in coloured pencil capturing the feel of the fur. Lay in your shadow form, keeping the rendering rough. Begin to outline and colour in individual spots, keeping them soft with a hair edge.

STEP 2
Add marker on the back of the paper, using two colours if appropriate.

STEP 3
Finish by using Pro White paint for highlights on the guard hairs (if applicable) or a white coloured pencil for softer highlights on the high points. Exaggerate the edge texture with a few longer hairs.

RENDERING BEADING

Beading is popular for wedding and evening shoes. The illustrated beads should look dimensional, not simply like a flat pattern.

Materials:
Coloured pencils
Marker
Pro White paint

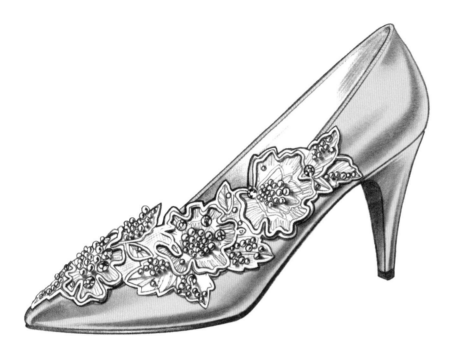

The shoe featured was drawn in graphite. It was then coloured in Photoshop by adding a transparent colour shape over the shoe silhouette created by masking out the beading and lining shapes. This image was drawn for a bridal footwear sale.

STEP 1

Begin with a smooth-edge drawing with a hard pencil. Roughly lay in your shadows with graphite pencil, drawing guidelines with an extra-hard pencil to line up the beads. Using a fine-line black marker and a shape template, draw the outline of the beads. Begin to render the dark, reflective shadows on the beads using repetition.

STEP 2

Apply marker colour or scan the completed value drawing onto your computer for colorizing.

STEP 3

Finish by adding highlights with Pro White paint on the highlight side of the beads using repetition to communicate a strong light reflection. Add a few quasars (star-shaped reflections) for added emphasis or glitz.

RENDERING SEQUINS

When rendering sequins or any kind of embellishment on footwear, it is important to keep the separation of the bangle from the shoe façade and also to give it a sense of surface when it comes to the sparkle.

Materials:
Coloured pencils
Marker
Pro White paint or gouache
Marker paper

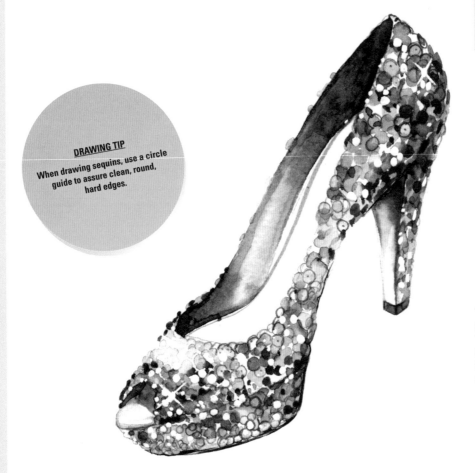

DRAWING TIP
When drawing sequins, use a circle guide to assure clean, round, hard edges.

The bejeweled shoe here was rendered in graphite, coloured pen line and watercolour. The beads and sequins were drawn in pen line to hold their edge and stand out from the shoe. (See also the beading step-by-step on p. 51.)

STEP 1
Begin by drawing your edge line with coloured pencil. This line should represent the shape and size of the sequins. Lay in your shadow forms, and begin to draw the sequins in colour. Keep the shapes round on the front surfaces and ellipse the sequins that wrap around the edges. Try to represent three values: dark (the reflective darks), medium (the sequin's local colour) and light (the reflective lights).

STEP 2
Add marker on the back of the paper.

STEP 3
Use Pro White paint or gouache for highlights; grouping the highlights together adds to the effect of the lighting. Keep a stronger focus of highlight on the high points or light area. Add a couple of quasars for added expression.

RENDERING LACE

When rendering lace on a shoe or garment the two most important elements are the proportion of the design to the item it is embellishing, and the theme or type of pattern the lace represents; for example, is it floral, geometric or architectural?

Materials:
Hard graphite pencil
Medium-hard pencil (HB–2B)
Watercolours
2-ply Bristol board

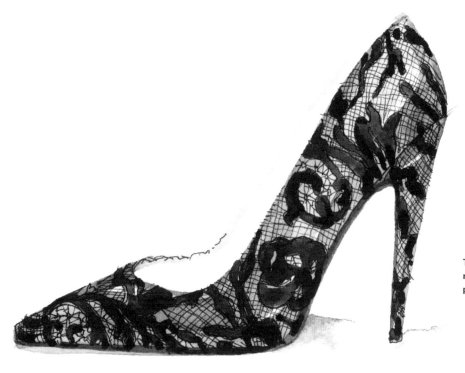

DRAWING TIP
If the pencil is too soft, the graphite will pick up in your watercolour and make your rendering appear dirty.

This shoe, featuring a floral-type lace, was rendered in watercolour with a fine-line black pen for the details.

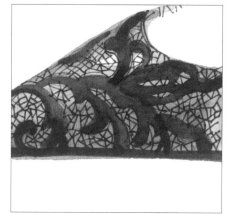

STEP 1
Begin with a simple line drawing with a hard pencil to give you a shape to follow. Wet your paper inside the shoe shape first if you want a smooth, soft, blended look, or paint directly on the dry paper if you want a harder-edged finish (used here).

STEP 2
When dry, draw the lace pattern on the surface using a medium-hard pencil (HB–2B). Don't press too hard, so you can erase your lines later for a cleaner look. Begin to lay in the larger shapes of your lace pattern using watercolour. Make sure you thin out the design on the sides to indicate the perspective change as the lace wraps around the edges.

STEP 3
Finish your lace by adding the lacing threads or webbing in between the large shapes. The smaller the illustrations, the simpler and more suggestive you can keep this. I used a forest green watercolour for the shoe and a warm black for the lace webbing.

RENDERING ALLIGATOR

When rendering reptile skin, the most important thing is to stay true to the characteristics of that particular skin. The two most constant differences are the shape and proportion of the scales.

Materials:
Coloured pencils
Hard graphite pencil
Art markers
Pro White paint
Bienfang Graphics 360 marker
paper

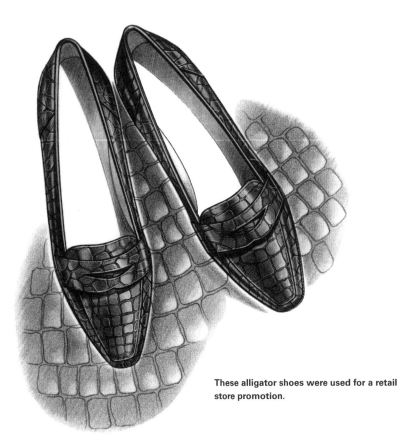

These alligator shoes were used for a retail store promotion.

Opposite: This alligator platform by Don Yoshida was rendered entirely in Photoshop using a flat pattern fill, to which shadow and highlights were added using a brush tool. Notice the subtle reflection below the shoe created by duplicating the original image and flipping it upside down.

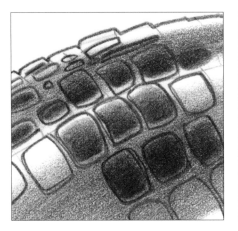

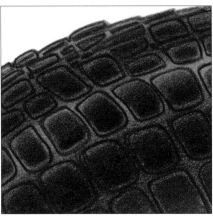

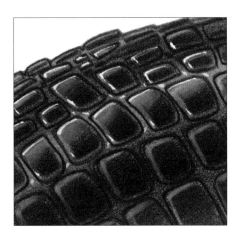

STEP 1

Begin with a textured edge in coloured pencil capturing the feel of the scales. Lay in the shadows. Draw in the scale sections using a hard graphite pencil. Outline and colour in individual scales, gradating them from one side to the other.

STEP 2

Finish colouring the scales, making sure the edges are thinner so they appear to curve over the edge of the shoe. Lay in a local colour using art marker on the back of the paper.

STEP 3

Finish up by using Pro White paint on the highlight side edges and white coloured pencil for softer highlights in the scales.

RENDERING SNAKESKIN

Snakeskin and lizard skin are very similar to render. Snakeskin usually has more of a spotted appearance, whereas lizard is more consistent in its colour and scale size.

Materials:
Coloured pencils
Hard graphite pencil
Art markers
Pro White paint
Bienfang Graphics 360 marker paper

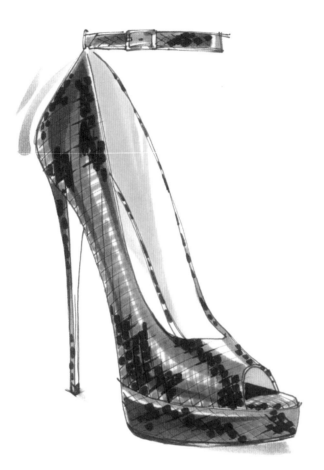

This loosely rendered image of a blue snakeskin pump is characteristic of a designer concept sketch. It was drawn with a black water-based pen and then markered on the top with alcohol-based markers, using cerulean blue for the local colour and leaving the highlights untouched. Ultramarine blue was then applied for the shadow and dark blue brush-point pen for the scale spots. This style of sketch is a fast way of getting an idea ready to present to a client.

STEP 1
Begin with a rough edge to capture the scale size and feel. Roughly lay in the shadows in coloured pencil. Add a grid with a hard graphite pencil for the scales. For a spotted skin, lay in the spot pattern using a contrasting colour pencil. Darken your shadow forms.

STEP 2
Apply art marker on the back of the paper for a local colour.

STEP 3
Finish by adding highlights with Pro White paint on the highlight side of the scales in the light areas.

RENDERING ACRYLIC

When rendering acrylic or any glossy transparent material, it is important to remember two things. The first is to keep your edges crisp, as the more reflective a material, the more harshly it will contrast darks and lights. The second is to try to find an edge that overlaps to show the transparency of the material through layering.

Materials:
Black pen
Graphite
Markers
Pro White paint
Marker paper

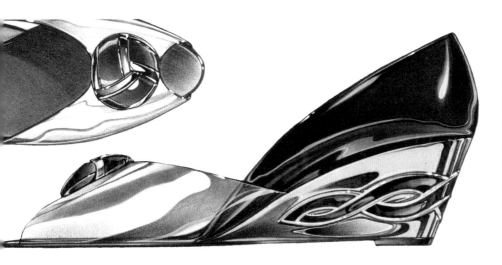

In the acrylic shoes shown here, you can see the liquid, crisp flow of the reflections as well as the full range of values from dark to light. Gradation is also used within some of the reflective shapes to give a feeling of atmosphere and depth. The soles are a combination of black patent leather and gold metal inlay; note where the acrylic overlaps them. This tighter rendering style was used for a retail advertising campaign using a fine-line black pen, hard and soft graphite pencils, a 20% cool grey marker and Pro White paint for the highlights.

STEP 1
Begin with a smooth outline in black pen to help create a strong edge. Lay in the shadows, keeping the rendering smooth. Use the pen to bring some strong line and movement into the object. Erase some white lines out of your rendered areas for added depth.

STEP 2
Add marker into some of the shapes to give a solid, clean reflection. The grey in the lower right corner adds a feeling of transparent layers. Keep the rendering fairly light to suggest the clear acrylic.

STEP 3
Finish by adding some clean, flowing white highlights to make the surface of the object pop forward and add more depth by layering. Note the transparent effect in the lower right corner when the white crosses over the grey.

RENDERING METALLIC LEATHER

For rendering a metallic leather finish, the darks and lights should be in high contrast but typically softer in transition than glossy textures.

Materials:
Coloured pencils
Blender pencil
Art markers
Pro White paint
Marker paper

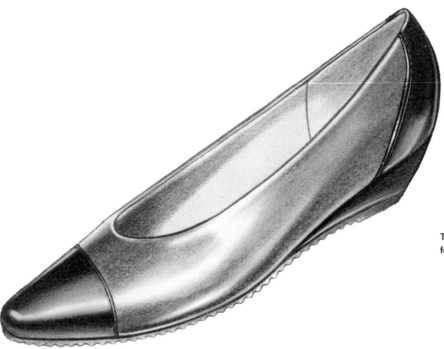

The style of illustration for this shoe is suitable for full-colour magazine promotion.

STEP 1
Begin with a soft yet clean-edge line. Roughly lay in your shadows in darker coloured pencil. Smooth out some of the texture with a blender pencil (optional) and darken shadow forms.

STEP 2
Apply art marker on the back of the paper for local colour and unity.

STEP 3
Now add your highlights using white paint in a stippling technique. Metallic leather has more of a sparkle to its reflection.

DRAWING CHILDREN'S SHOES

Children's footwear offers a wide variety of shapes, textures and styles, all on a smaller scale. Because a child's feet are not the same proportions as an adult's, there is the danger of their shoes looking deformed or awkward – their feet are thicker and shorter when it comes to sizing. A good way to help communicate their size and shape is to put a common object in the illustration with them for scale comparison, as demonstrated with the baseball in this feature image.

These shoes were drawn in graphite pencil with art marker tones for a black and white retail advert. To make them more interesting for a colour spread or magazine, you could apply different computer filters after scanning them. The amount of abstraction you allow should depend upon the purpose of the publication.

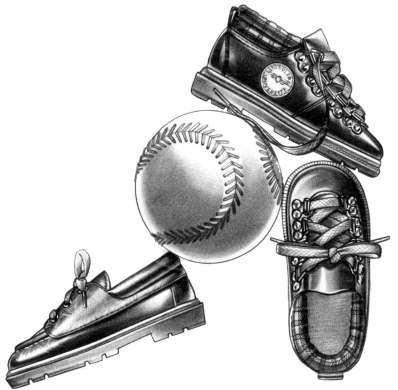

PSYCHEDELIC ART
This is a software filter that will become more or less dramatic with your particular settings.

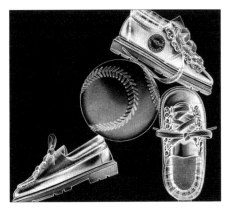

LAYERING
The shoe image was converted into two different colour palettes that were then layered over each other with different transparency percentages.

COLOUR INTENSITY
The black and white art was converted into one solid colour, in this case magenta. This keeps the graphite rendering feel while adding colour impact.

INVERTED
This filter takes the image and reverses the values to the opposite degree, similar to a negative photo effect.

FLAT DRAWINGS FOR PRODUCTION

Shoes, like any garment, require flat drawings for production. The following flats were drawn by Raymond Serna, Women's Footwear Design Director for such companies as Tommy Hilfiger, Nine West and Coach Footwear. Footwear flats can be drawn with top and side views or a three-quarter view, depending on the need to show specific details. The illustrator must keep in mind that these technical drawings are used for development and sample production and, therefore, need to be accurate in dimension and proportion. Every aspect of a shoe's design must be shown clearly so the developer or pattern-maker can understand the shoe's individual features.

These flats were sketched on Bristol paper using a graphite pencil to a woman's size 4 shoe proportion. Once the pencil sketch is complete, a permanent black pen line is added to make the lines clean and easy to read in three distinct line weights: bold is used for the outside silhouette (which keeps the shape strong), medium for construction detailing (which is the main purpose of the drawings) and a fine line for adding texture, reflection or shadowing. Use straight edges and French curves to ensure smooth linework. Once the ink line is dry, the pencil line is erased, leaving a sharp, graphic image. Typically colour or soft rendering is not used on flat drawings. Think of them as an architectural drawing for an object.

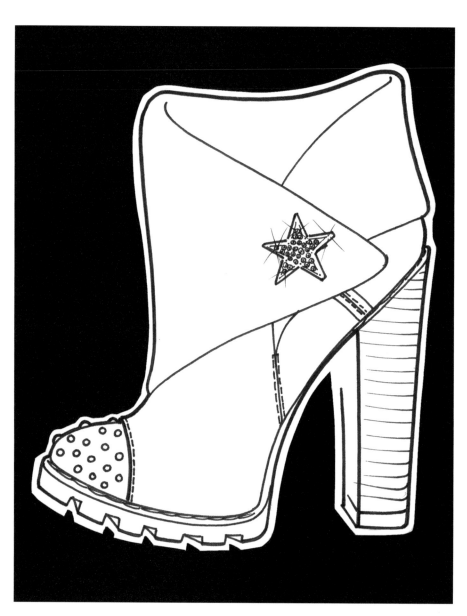

ANKLE BOOT

The thick structured sole has a raised toe curve. The fold-down flap is accomplished by curving and not connecting the inside flap lines with the outer edge lines at the top, showing the thickness of the leather. The studding is shown by raised shapes on the outside edge.

TALL BOOT

The leg extension leans forward. All stitching is straight and spaced evenly with a consistent size dash. Thin lines on the upper show softness in the structure. The heel lines indicate a layered wood or leather heel.

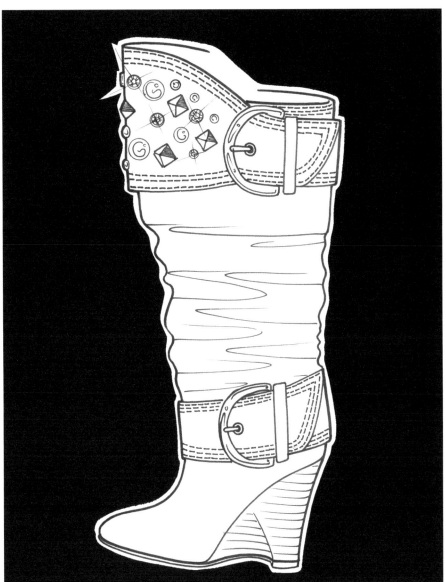

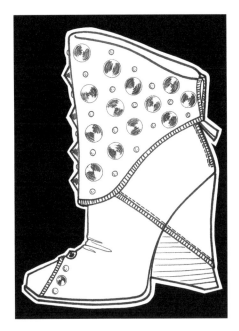

SHORT BOOT

This boot features a square toe, shown by the perspective across the front angle. For the cone-shaped studs, the half-circle progressive lines make the metal feel both reflective and brushed. The boot itself is not rendered.

OXFORD FLAT

This shoe features cut-outs. They are not shown on the inside since the outside is the feature design. Notice the slight cut depth on the upper back edge of the tear shapes and the raised centre front seam.

MARY JANE

This flat shows the height of the rhinestones as well as their facets and reflections, including black quasars. In contrast, the studs have a swirling shape to indicate their reflection and smooth nature.

GLOSSARY OF SHOE TERMINOLOGY

This glossary will help you become familiar with some of the basic terms used in constructing and designing footwear. Some terms describe parts common to every shoe – such as the sole, upper and heel – whereas other terms are specific to a particular type or style of shoe. Not all of the terms are illustrated on the example shoes.

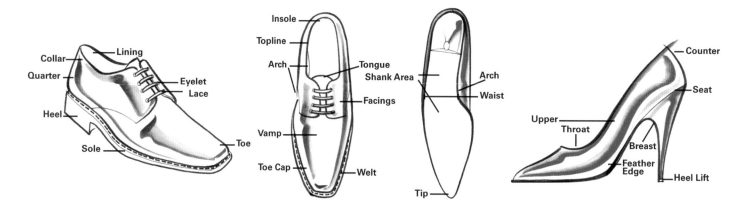

ARCH: The curved, narrow, midsection of the shoe that the arch of the foot curves over.

BREAST: The forward-facing top of the heel found under the arch of the foot.

COLLAR OR TOGGLE: A piece or stitched area surrounding the foot opening or topline – similar to a shirt collar surrounding the neckhole. Usually found on lace-up shoes.

COUNTER: A piece of stiff material or leather positioned on the back of the upper around the collar. It can either be a hidden piece inside between the upper and the lining or an overlapping piece of leather on the outside, usually in a contrasting colour. It is meant to add strength and help maintain shoe shape.

EYELETS: The holes that are punched through the facings, upper or vamp for threading laces through.

FACING(S): A layer of material (usually two) covering the front top vamp, having laces or some kind of closures to bring them together across the top of the foot.

FEATHER EDGE: The place where the upper's edge and the sole meet.

FOXING: An outside panel covering the back of the heel and wrapping around onto the quarter.

HEEL: The heel is found at the rear of the shoe and is the part of the sole raising the back of the shoe in relation to the front. Heels come in various heights and are usually named after their shape or the person who made them fashionable. They can be made out of various

materials including wood, cork, synthetics and stacked leather.

HEEL LIFT: The finishing piece on a spiked heel that comes into contact with the ground.

INSOLE: The layer of material between the sole and the wearer's foot. It adds comfort as well as hiding the construction seams of the upper and sole.

LACES: Made of string, rope, leather or synthetics, laces are used to fasten a shoe to the foot of the wearer.

LINING: Most shoes have a lining that covers the inside of the vamp and quarter. Linings improve comfort, can add warmth, and extend the life of the footwear.

PUFF: A lightweight reinforcement in the upper that gives the shoe its shape and support. Similar to an inside toe cap.

QUARTER: The rear part of the upper that covers the heel forward to the vamp. It is actually an area of the shoe and can be part of a continuous piece of material that includes the vamp.

SEAT: This is the concave area of the heel that sits into the rear of the sole.

SHANK: A hidden piece of support material inserted between the sole and the insole to give strength to the shoe as well as support to the wearer.

SOLE: The bottom piece of the shoe that sits below the wearer's foot and comes into contact with the ground.

THROAT: The front top of the vamp above the toe cap.

TIP: The very end of the toe.

TOE: The area at the forward front upper of the shoe. Toes come in various forms and are a major factor in style differences.

TOE CAP: A covering stitched over the toe for decorative effect or to strengthen the toe. It can also be used for protection as in steel-toe boots for dangerous work areas.

TONGUE: The leather insert or extension of the vamp that covers the top of the wearer's foot and adds comfort for lacing as well as protection from weather conditions.

TOP PIECE: The part of the heel that comes into contact with the ground. It is called the 'top' piece because shoes are made upside down, making the bottom of the heel actually the top.

TOPLINE: The top edge of the upper that may have a border or edging technique.

UPPER: The entire part of the shoe that covers the foot. The upper consists of two main parts: the vamp and the quarter.

VAMP: The front section of the upper, which covers the front of the foot. The vamp extends back to the joint of the big toe.

WAIST: The part of the shoe or last that relates to the instep and arch of the foot.

WELT: The strip of material that joins the upper to the sole of the shoe.

GLOSSARY OF CONSTRUCTION TERMINOLOGY

The beginning of a shoe starts with the 'last'. The last is a hard, moulded, shoe-shaped form usually made of wood or plastic. Lasts come in a variety of toe shapes and heel heights, depending upon the latest fashions. The heel height of a last is made specifically for a particular shoe design and cannot be changed during construction. The toe shape is also very specific and determines what the final shoe will look like. A shoe last is used to stretch the leather over to form the shoe. Although you can create many different shoes from the same last, each heel height has to have a different last, as does each shoe size and width. The fit of a shoe will be determined by the shape and volume of the last. Lasts have a hinge in the middle so they can be collapsed and removed from the finished shoe without causing any damage.

BACKPART: The rear part of the last from the heel to the ball girth.

BALL GIRTH: The measurement of the last around the ball of the foot.

CENTRE BACK: The centre of the heel to which you line up the back seam and heel.

CENTRE FRONT: The centre front line of the last is where you line up the pattern for a proper fit and symmetry.

CONE: The upper instep of the last.

FOREPART: The front part of the last from the toe to the ball girth.

HEEL HEIGHT: The distance between the bottom of the last heel and the floor.

LAST: The solid, foundational form around which the shoe materials are stretched to construct and mould the shoe. It defines the final shape of the shoe.

SEAT: The rear bottom of the last to which the heel will fit.

TOE SPRING: The angle at the front of the last that will allow the foot to rock forward from the ball of the foot.

WAIST: The narrow midsection of the last that corresponds to the arch and instep of the foot. It is also where the joint of the last is typically located for bending the last for easy removal.

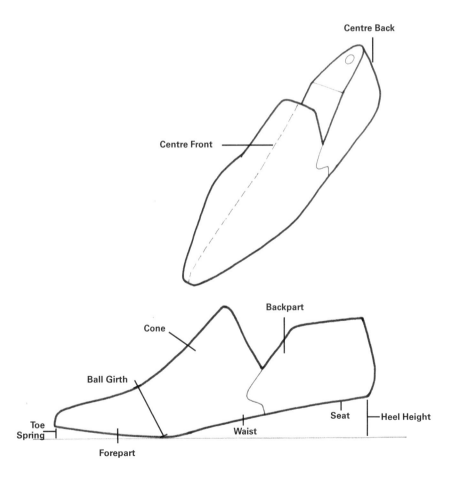

GLOSSARY OF TOE SHAPES

The most manipulated and trendsetting part of any shoe is the toe cap or tip. A shoe often becomes known for, or even named after, the toe shape. The greatest difference between the expressiveness allowed in the design of a toe and that of a heel is that the toe must always conform to its purpose – surrounding the toes of the foot. Here is a very basic vocabulary of toe shape variations that have set trends and become the mainstays of footwear design. It is only a foundation of names – the options are endless. These toe shapes were illustrated using water-based, fine-line black pen for the outline, to which watercolour was added with a soft brush. The brush was allowed to touch the outline, dissolving the ink slightly so that it bled into the paint, creating a feeling of shadow and curve on the edges while leaving the highlights untouched.

SIDE VIEW **TOP VIEW**

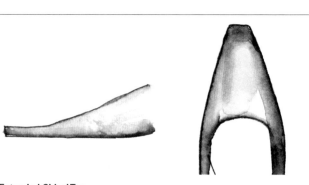

Bubble Toe

Clam Toe

Extended Chisel Toe

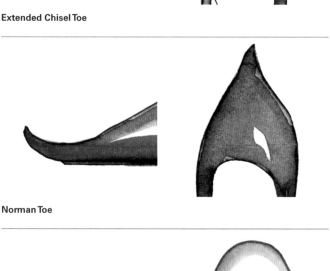

Norman Toe

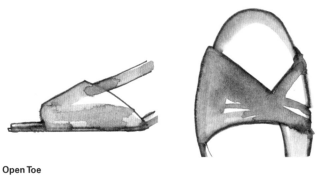

Open Toe

SIDE VIEW	**TOP VIEW**

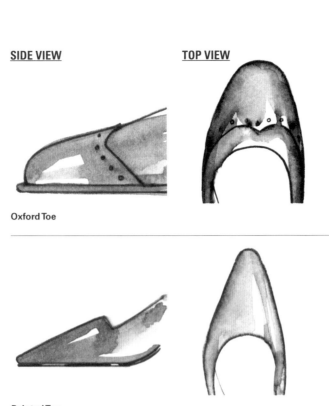

Oxford Toe

Pointed Toe

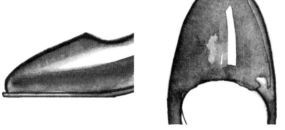

Round Toe

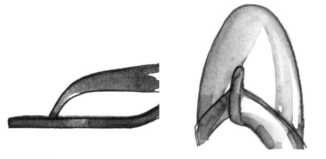

Sandal Toe

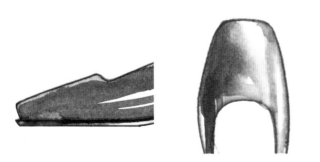

Square Toe

GLOSSARY OF HEEL SHAPES

The other major definer of a shoe silhouette, besides the toe, is the heel. The heel can be the most unique and personalized part of the shoe because it is not confined by the shape of the foot. This is a very basic vocabulary of heel shapes that can be exaggerated and manipulated to their extremes. These heels were drawn with a black outline using a water-based Tombow pen, which was then dissolved with water using a soft watercolour brush.

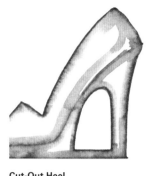

Ball Heel

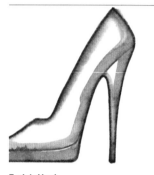

Cut-Out Heel

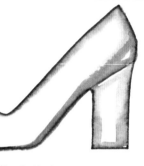

Chunky Heel

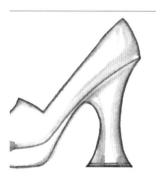

Fetish Heel

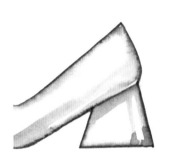

Chunky Low Heel

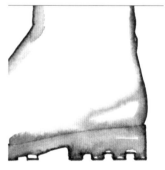

Flared Heel

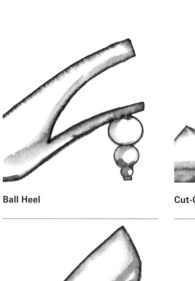

Cleated Boot Heel

Flat Heel

Cowboy Boot Heel

Granny / Victorian Heel

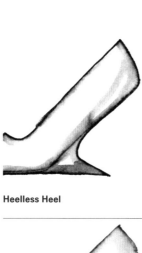

Heelless Heel

Stiletto High Heel

High Heel

Triangle Heel

Kitten Heel

Vivier Heel

Low Cuban Heel

Wedge Heel

Low Heel Boot

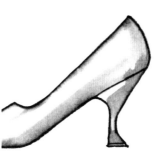

Waisted Medium Heel

GLOSSARY OF SHOE SILHOUETTES

This glossary of shoe silhouettes is designed to give you some of the basic names of the most common shoe designs. There are many variations and even combinations of some names. Also included are alternative names for some styles. These shoes were illustrated using liquid concentrated watercolours with the highlights drawn out with a wet brush after the base coat dried. Finally, a black fine-point pen was used for the outlines.

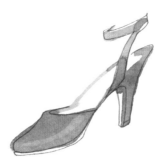

Ankle Strap

Espadrille

Blucher / Oxford

Flat

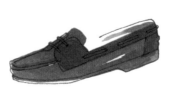

Boater / Deck Shoe

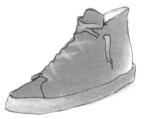

High-Top

Clog

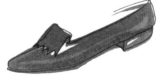

Kiltie

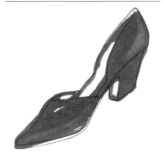

D'Orsay

Moccasin / Loafer

Mule

Skater Sneaker

Thong / Flip-Flop

 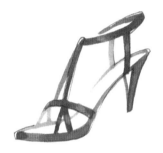 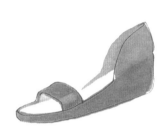

Open Toe / Peep-Toe

Slingback

Wedge

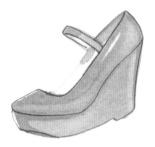

Platform W-Bar Strap

Strappy Sandal

 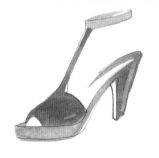

Pump

Spectator

Saddle Oxford

T-Strap

GLOSSARY OF BOOT SILHOUETTES

This glossary of boot silhouettes will provide you with some of the more common boot heel shapes and heights used in the footwear industry. There are many subtle variations for boot heights, but the basic names remain the same. These boots were illustrated using liquid concentrated watercolours on watercolour paper. On some boots a wet brush was used to pull out some subtle details after the base coat had dried.

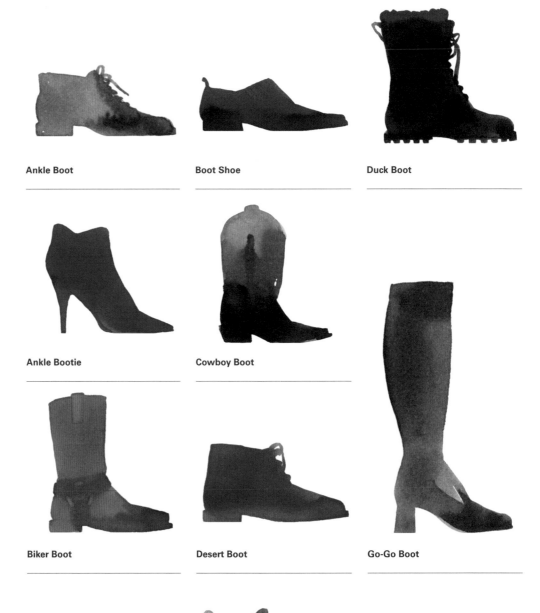

Ankle Boot

Boot Shoe

Duck Boot

Ankle Bootie

Cowboy Boot

Biker Boot

Desert Boot

Go-Go Boot

Dr. Martens Boot

Granny Boot

Hiking Boot

Paddock Boot

Platform Boot

Thigh-High Boot

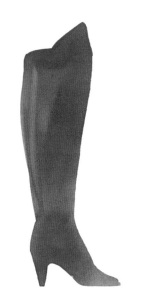

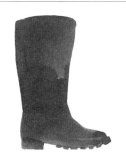

Knee-High Boot

Rain Boot

Ugg Boot

Mukluk Boot

Riding Boot

Work Boot

CHAPTER 3
MILLINERY

Through the centuries, headdresses have not only served a utilitarian need for warmth and protection but have also been a social statement for establishing an individual's status and position. It was not uncommon, for example, to have a variety of hats that could transform the same garment into a multitude of looks for different occasions. Today, headwear has evolved into a form of sculptural ornamentation that can communicate the highest level of fashion expression and personal character. This chapter explores both the basics of illustrating practical head attire as well as the fantasy of couture headwear.

INTRODUCTION TO DRAWING THE HAT ON THE HEAD

When drawing any hat, it is essential to keep in mind the head with which it is interacting. Proportion, angle and symmetry are all important factors to consider for expressing a hat at its best. Since the same hat can be worn at different angles, think about the 'attitude' the person you are illustrating is projecting with their chapeau.

In a front view of a hat, the inside brim, or base of the crown, should come straight up off the sides of the skull (red line) and fit across the forehead above the eyebrow line (blue line). For a straight-on head view, make sure you keep the face and hat symmetrical. In some cases you will need to make allowances for the volume of hair (consider about five millimetres in actual size proportion for hair on both sides). In a side view drawing, keep the crown flat to the forehead and coming straight up off the lower skull in the back (red line). Attention to this fit factor will keep your hats from looking as though they are hovering around the head. Also pay attention to the back angle of your hat. Hats typically sit close to the eyebrows and angle back above the ears to the base of the skull (blue line).

Make sure you draw enough height on the crown of the hat to clear the top of the head (magenta line). Keep in mind also that any dent or angle in the crown must not dip down into what would be the top of the skull. On large-brim hats, keep your brims continuous as they wrap around the head and neck (yellow line). It is a good idea when drawing your preliminary drawing to draw the brim right through the head as one unbroken line – then only draw the visible brim for your finished illustration. Make sure your brim ends curve to avoid a flat or sharp awkwardness to the perspective.

In a three-quarter view, the most important thing to watch for is keeping the centre front of your hat in line with the centre front of the face (green line). Be careful to divide your brim at the correct breaking point.

Front View

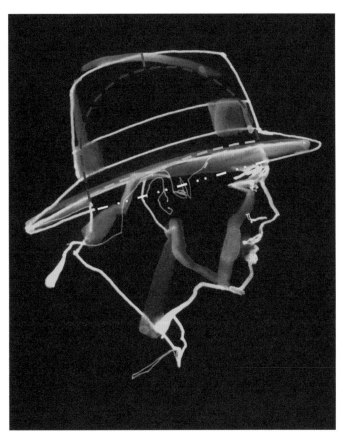

Side View

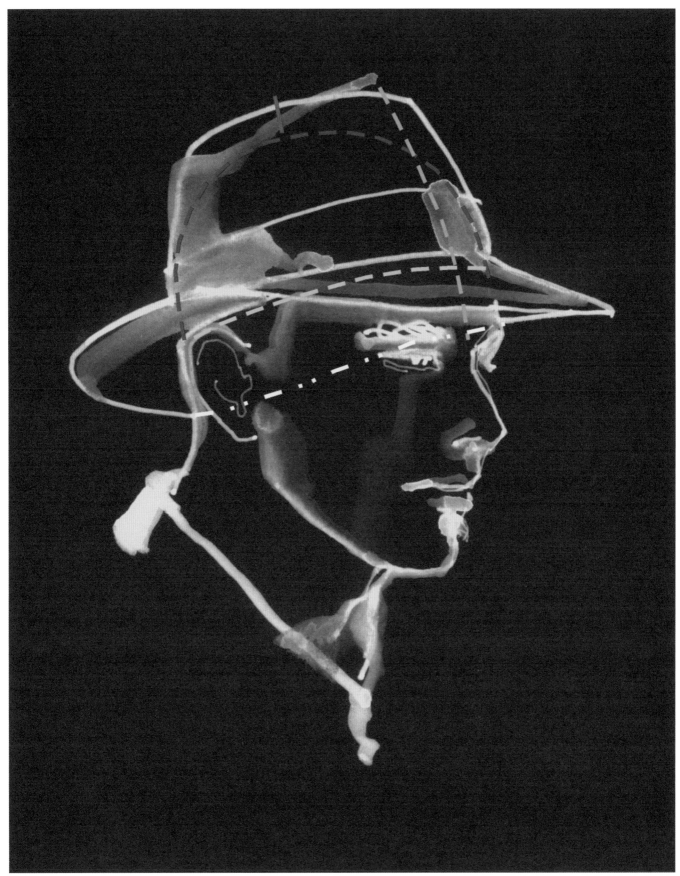

Three-Quarter View

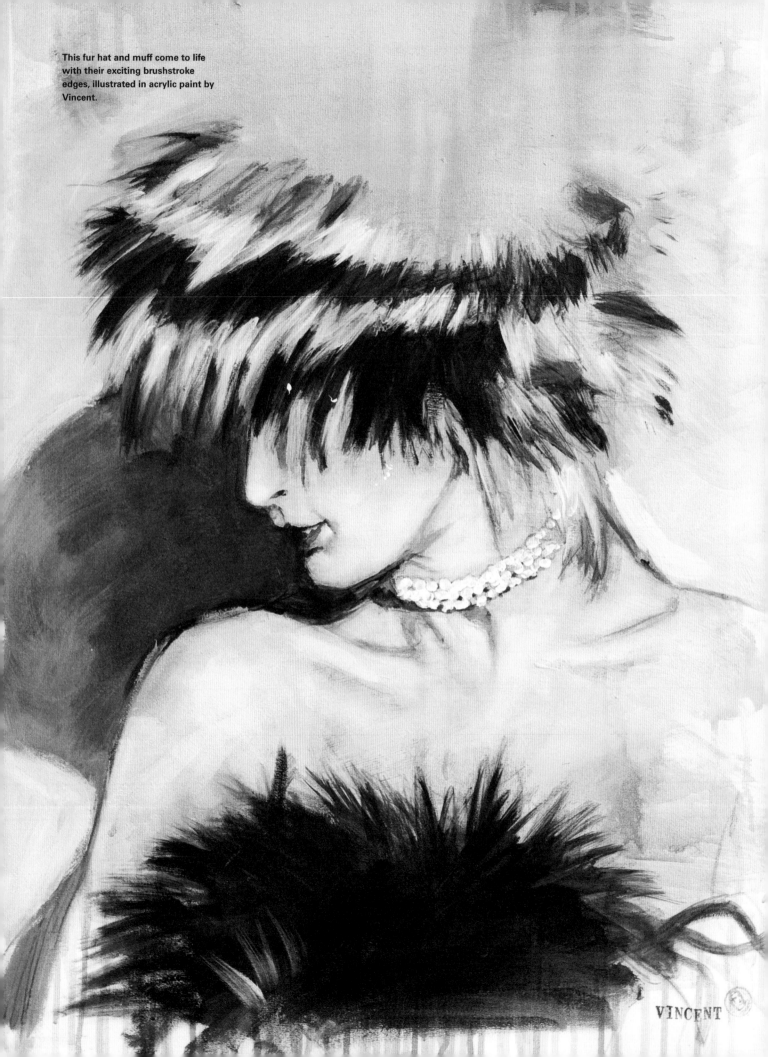

This fur hat and muff come to life with their exciting brushstroke edges, illustrated in acrylic paint by Vincent.

VINCENT

TEMPLATES FOR DIFFERENT VIEWS OF THE HEAD

The head templates shown are provided for you as a base on which to sketch your hat designs. The guidelines have been added to help solve some of the more common perspective problems.

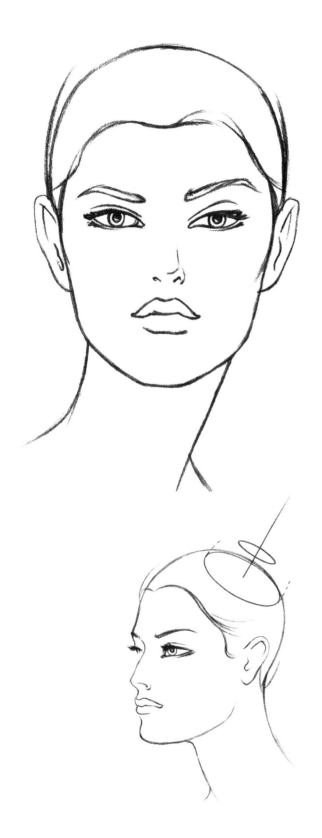

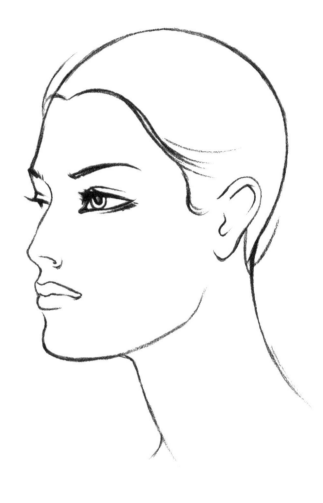

THREE-QUARTER FRONT VIEW RIGHT

This head has the foundation for a fascinator or smaller crown-size hat. The red guidelines show the centre line for the hat crown to follow. Keep in mind that as an ellipse moves away from your eye line it will increase in circumference. Also keep in mind that even pulled-back hair will add about 12 millimetres of thickness to the head.

TEMPLATES FOR MEN'S HATS

These male head templates feature the two most common poses for displaying men's headwear. The side view features the guidelines (in red) for measuring head size. Notice that both views have perspective to their brims even though the heads appear very straight-on. Also note the curve of the hat band on the front view. This curve will increase as the crown moves away from the head (that is, as it gets higher).

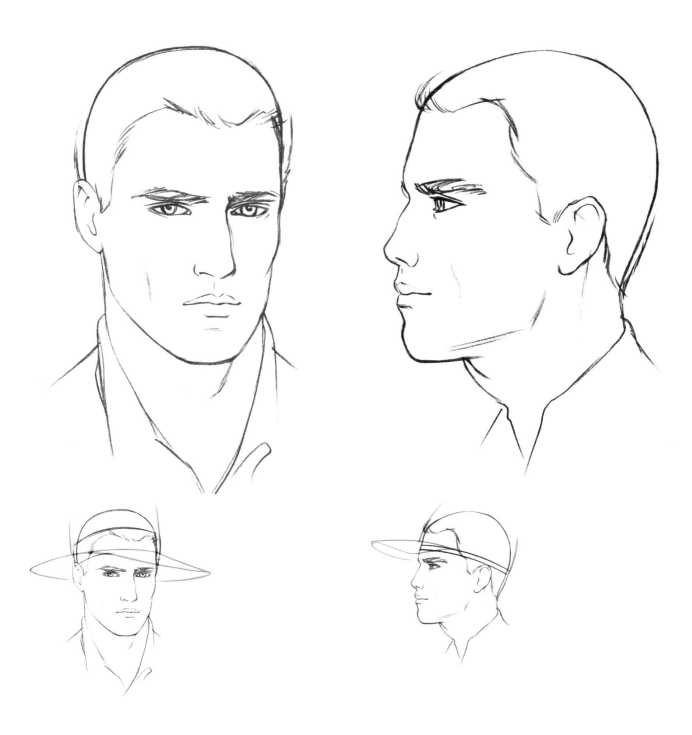

Hoodies are popular headwear. Watch that you leave enough room for a full-size head inside the hood. but also make sure that the hood lies on the top of the head and does not hover around it like a helmet.

RENDERING FABRIC TEXTURES

Hats can be made from a vast array of materials. The following examples include some of the more common materials and textures you will come across.

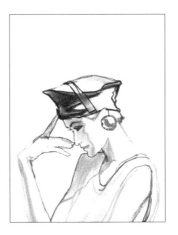

LEATHER
This leather cap is more indicative of the fabric finish. The stiff look of the material and the thicker, consistent line quality give the feel of leather. The hat has both soft and bright highlights, which is characteristic of leather.

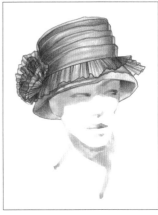

SHEER CLOCHE
The sheer cloche was rendered with coloured pencil; marker was then applied to the back of the paper. The transparent quality of sheer fabrics is best shown off on the edges. A transparent medium, like marker or watercolour, shows different layers.

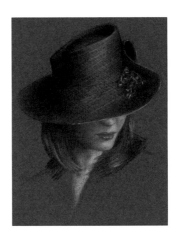

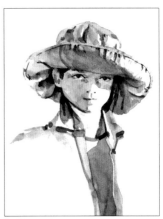

TWEED
This tweed cap in watercolour focuses on the spotty, rough feel of a woven fabric. Notice the seam line indicating a sewn cap. The white (highlight) area was left unrendered so the hat would not feel overworked and appear flat.

SINAMAY
Sinamay is a straw-like material that comes in a variety of textures, weave sizes and colours. It is commonly used for hats because of its excellent malleability. This classic pastel drawing shows a tighter weave with flower accents.

COTTON
This cotton rain hat was rendered in watercolour, leaving the light side white to show form. The seam 'puckers' indicate the hat's soft, floppy nature without it looking limp.

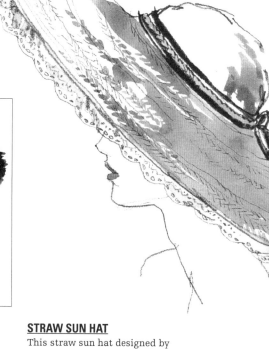

FUR

This fur toque was drawn with compressed charcoal to achieve the soft, blurred texture. Capturing the texture on the outside silhouette edge is more important than the inside. The gradating tone inside this hat gives a feeling of density and form.

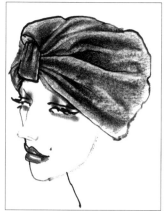

KNIT CAP

This knit cap is drawn with watercolour and a soft pointed brush. The inside cable and knit patterns were drawn after the hat and face. Shadows were added to the deepest parts of the knit to give form. For the fur trim, watercolour was put into a wet area and allowed to bleed.

STRAW SUN HAT

This straw sun hat designed by Eia Radosavljevic was drawn with a graphite pencil; a light watercolour wash was then applied to give some punch. You only have to draw enough pattern to give an idea of the straw.

WOOL

This wool beret was drawn with a combination of watercolour and coloured pencil. After the loose, initial colour was laid down using paint, the pencil line was added to define edges and add texture.

VELVET TURBAN

This velvet turban was first drawn with India ink and a stick to give it a quirky feeling. A layer of chalk pastel gives it texture. Pastel pencil was used to add darks for better form.

DRAWING BLOCKED AND SEWN HATS

BLOCKED HATS

Blocked hats are hats that have been formed using a hat block (see Glossary of Hat Terminology, p. 92). Felt, straw and sinamay are some of the most common blocking materials. The unique feature of a blocked hat is that it has no seams. The fabric is stretched over the block and then pinned, nailed or compressed in place by a reversing mould shape. The hat is then steamed, dampened or pressed until dry. This process allows for the creation of some very unorthodox shapes.

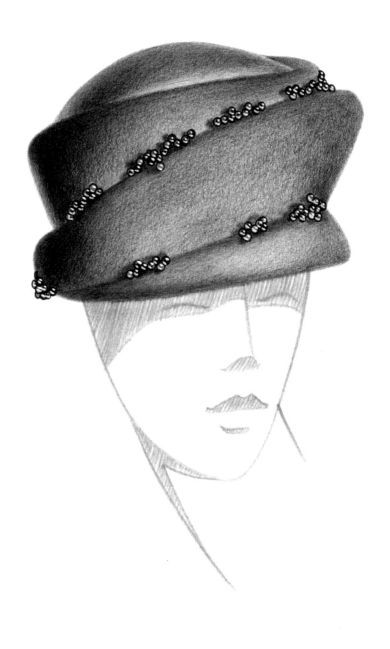

This example of a blocked felt hat with small glass beads, designed by Eia Radosavljevic, was drawn using soft graphite pencils on Canson marker paper. A minimum of rubbing with a finger was used so the texture of the felt would remain obvious. The beads were outlined using a black, fine-line permanent pen; then some intense darks were added with pencil, together with spot colouring with a 40% and 60% grey marker to add depth to the glass. Finally, a dot of white paint was added to show reflection and add surface to the glass. The face is stylized and simple to keep the hat as the main focus.

SEWN HATS

Sewn hats are constructed using pattern pieces, just like a garment. The obvious difference between blocked and sewn hats is that sewn hats have seams. It is important to show, or at least suggest, the seaming so a designer's construction can be understood and also to clarify for the client what kind of hat it is.

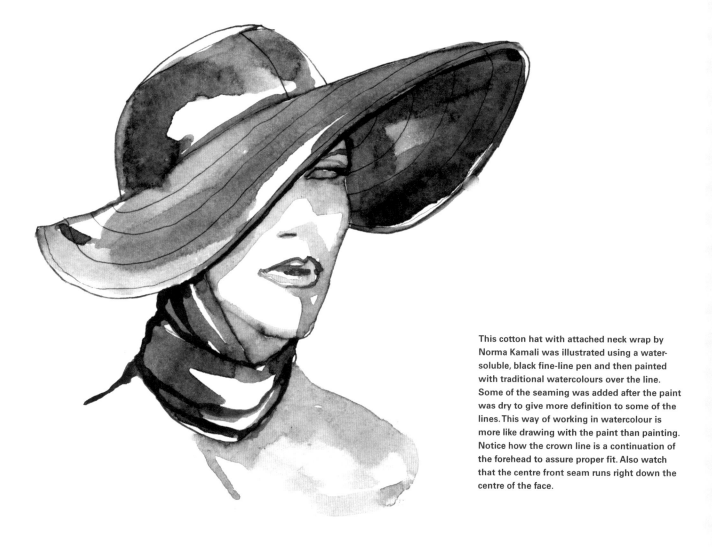

This cotton hat with attached neck wrap by Norma Kamali was illustrated using a water-soluble, black fine-line pen and then painted with traditional watercolours over the line. Some of the seaming was added after the paint was dry to give more definition to some of the lines. This way of working in watercolour is more like drawing with the paint than painting. Notice how the crown line is a continuation of the forehead to assure proper fit. Also watch that the centre front seam runs right down the centre of the face.

RENDERING FEATHERS

Feathers are probably the most common embellishment used in millinery, and offer a wide variety of uncommon textures and colours. The greatest challenge when drawing plumage is to make sure that it does not look like fur. You will need to carefully study the vein of the feather you are rendering and get a good feel for the silhouette. The ostrich feather hat featured in the black and white ink drawing here looks and feels very different from a pheasant or peacock feather. Represented here are some different approaches to rendering feathers that all show the details necessary to define their particular character.

This ostrich feather hat designed by milliner Eia Radosavljevic captures the thick and wispy fronds of the feather while also keeping the sense of proportion to the hat and figure. It was drawn with black India ink and a round pointed watercolour brush. Notice there are areas within the feathers that are only defined by shape and no detail. This technique helps keep the drawing bold without looking overworked.

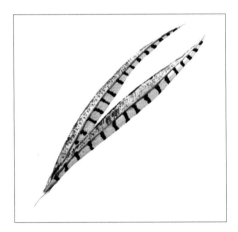

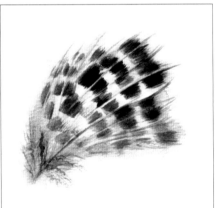

PHEASANT FEATHERS

These pheasant feathers were painted with watercolour and rendered in a tight, clean manner for maximum detail.

VINTAGE PLUME

This grouping of feathers was drawn with black pastel. After the initial shapes were laid in, the edges were refined and frond details added using a 4B charcoal pencil. This technique is useful if you are drawing softer plumes because it gives you a soft fluff for the feather while allowing you to control the shapes. The blue and magenta colours were added as reflected colours so the black would not look dead.

WILD BIRD PLUME

This plume of feathers was rendered by applying watercolour onto a wet area on the paper. Then, after the first layer of paint dried, more contrast was added with darker colours keeping the bone or stem of the feather obvious for structure. After the initial painting dried, the area was wet again with a large brush and clean water to soften the edges. Notice that some of the flues are detailed at the base of the feather to give a softer, fluffy feel to the group.

RENDERING BOWS

Bows can be an embellishment for any fashion accessory. No matter what garment piece you illustrate them on, it is important that they have 'life'.

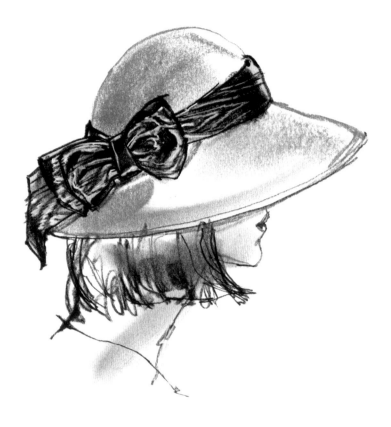

This grey felt hat features a black moiré ribbon and bow. The hat was drawn with grey pastel and the bow was drawn with a 4B charcoal pencil, compressed charcoal and a 40% warm grey marker. The marker helps separate the ribbon/bow from the hat and makes it the feature of the chapeau.

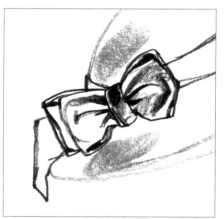

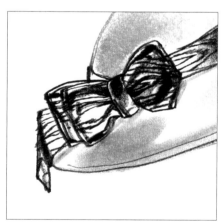

STEP 1

Begin with an underdrawing, keeping the bow plump and rounded on the ends. Notice the twist that happens when a bow is pulled. This allows you to see the inside of one top and one bottom on opposite sides of the bow. Also make sure to show a 'pinch' in the bow sides; this will help give it a gathered effect.

STEP 2

Drawing the outside shape using various line qualities will help give 'life' to your bow. Rough in the shadow and reflection patterns keeping your darker values reserved for the gathered and inside areas of the bow. Make sure the pinched areas of the bow sides are centred and obvious.

STEP 3

Draw in the pattern or texture. The moiré, watermark pattern of this ribbon reflects both dark and light. Once the marker was applied to the back of the paper, a hard white stick of pastel was used to add some highlights to give it even more form. The felt texture of the hat was achieved by leaving most of the natural texture of the pastel on the paper untouched except for a slight smearing.

RENDERING RIBBONS

When rendering ribbons or hat bands, try to keep as much life in them as possible. Limp, dull or rigid ribbons will not inspire.

The featured trilby was drawn with chalk pastel on black paper. The base colour was smeared on first by finger; black charcoal was then used to draw over it, and pastel pencils were used for detail. This makes a vivid drawing suitable for editorial illustration or a less specific design style. Notice that the hat band curve increases as it moves away from the eye line of the viewer. This is true whether curves go up or down from the eye line – they will always increase as they move away from you.

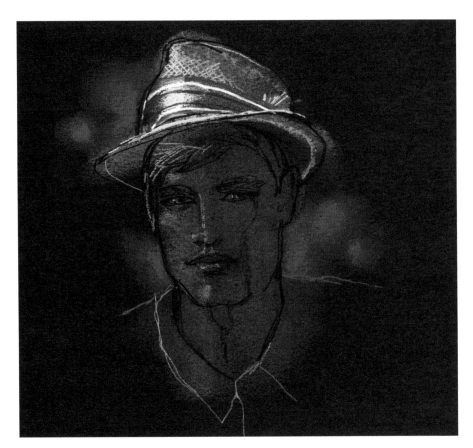

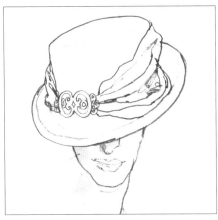

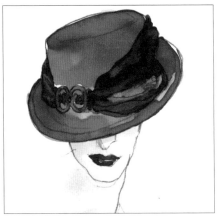

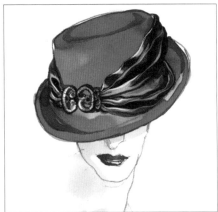

STEP 1
In this very traditional line drawing, the ribbon was thick, plush satin, which added a feeling of bulk to the brim. The focus here is on line quality to add interest and emotion to the ribbon and head. A shadow across the face will add depth to your illustration. Make sure to keep the curve of the ribbon consistent with the brim and not flat.

STEP 2
Using concentrated watercolour, the main colours of the hat and ribbon were painted in, pushing the darks for depth.

STEP 3
Once the paint was completely dry, a small brush was used to punch the shadows to strengthen the form of the hat. Pro White paint was used to add highlights to the ribbon and embroidery detail, building the highlights with thicker paint. This is a simple and quick technique for illustrating a presentation to a client.

RENDERING NOVELTIES, FRUIT AND FLOWERS

When rendering a novelty hat such as a hat with fruit, flowers or some unique appliqué, you should keep the object of focus obvious. Whatever the novelty object is, make sure you keep it full of gesture and life.

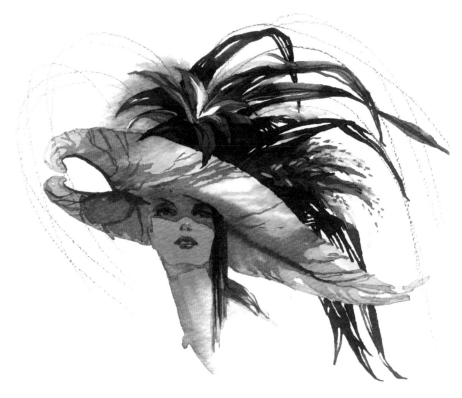

This illustration shows a fantasy design to be made entirely of organic materials. Concentrated watercolours were used to render the finish to keep it bright and loose in detail.

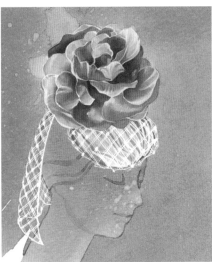

STEP 1
The drawing for this oversized floral chapeau by Eia Radosavljevic began with a light line drawing and the background colour. The aim was to keep the hat as the main feature and not include a detailed face.

STEP 2
After the background dried, a soft colour was laid over the face. When the face was dry, some clear water was spattered on the piece to get a textured, water spot effect. A damp brush was used to remove some colour in the flower to begin to establish some form.

STEP 3
Once the painting was dry, the final colours were laid down, starting with the darker colours, putting an intense drop in the deepest points of the flower, and then blending them with clear water. Highlights were added with Bleedproof White paint and blended in with a soft damp brush, as with the darks. When the piece was completely dry, guidelines were softly laid in with a 6B graphite pencil for the netting and painted in using a #0 pointed watercolour brush.

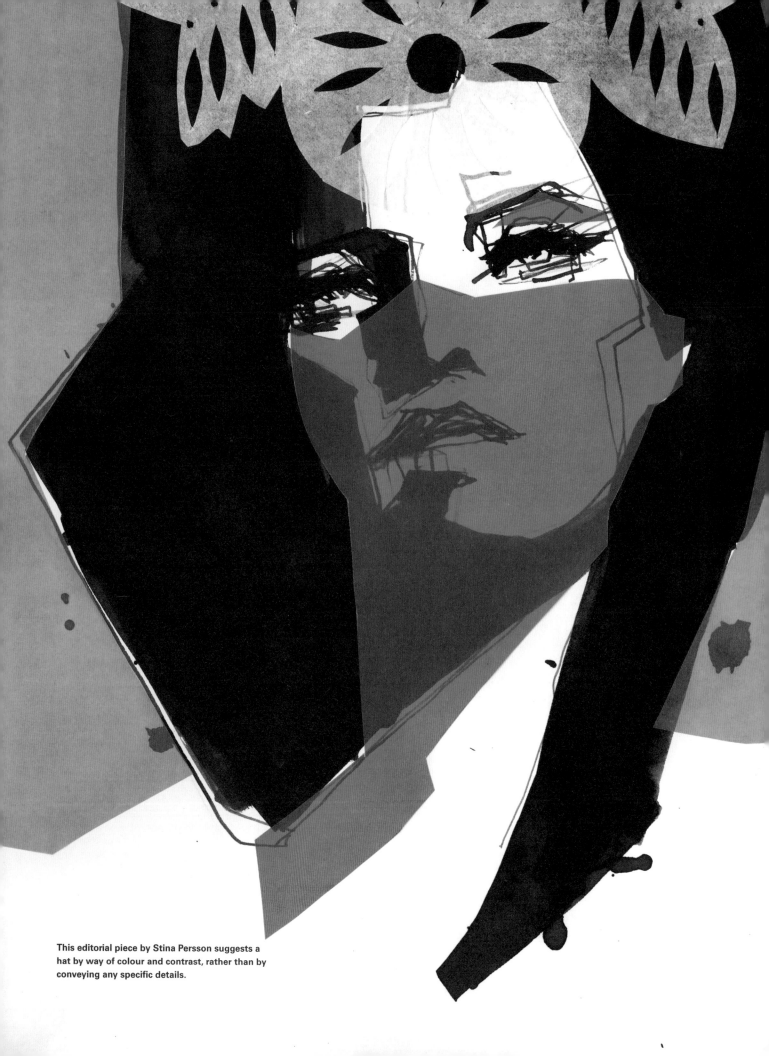

This editorial piece by Stina Persson suggests a hat by way of colour and contrast, rather than by conveying any specific details.

RENDERING NETTING

Netting or veils add mystery to any headdress. They can range from a small chic puff on a cocktail fascinator to full-face mosquito net coverings, or from large open nets to the fine silk tulle used in wedding veils. The important thing to capture is the character of the netting. It should always have a fragile, if not soft, body to it.

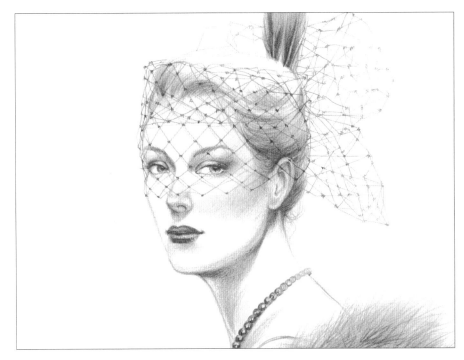

This illustration was drawn with a Sanguine pencil on a vellum-finish Bristol board. Not all the overlapping netting was drawn, as it would have made the covering feel too dense. This original drawing was large so the angle and sizing of the netting could be drawn accurately without having an underdrawing.

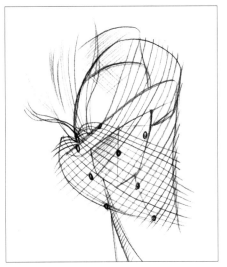

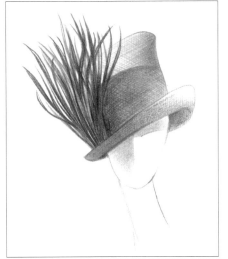

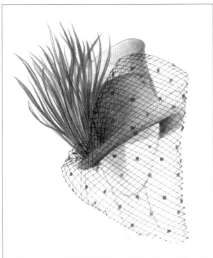

STEP 1

Start with a sketch to establish the proportion and balance of the hat, then lay in your netting angles. Indicate where the netting bunches up or gathers together, but do not concern yourself with the accuracy of every angle. This hat, by Eia Radosavljevic, has two different nettings on it: the fine orange horsehair mesh that surrounds the crown of the hat, and the black netting covering the face (also known as a 'birdcage').

STEP 2

Draw in all of the hat details. This rendering was completed entirely in coloured pencil. Different values of pencils were used to bring depth to the shadows quickly without having to labour the medium too much. Notice how the hat edges are parallel to the edges of the head – this ensures a comfortable-looking fit. The rendering was faded a bit in the highlights to keep the form of the hat obvious when the veil is covering it.

STEP 3

Once the hat is finished, lay in your netting. This netting had a stiffer feel, in high contrast to the hat. For a softer look, try to draw the netting with a fine-line coloured marker or a sharp, hard coloured pencil. After completing the netting, a soft coloured pencil was used to apply the felt dots, taking care to keep them symmetrical and evenly spaced. For lighter-coloured or softer-flowing netting, use a hard graphite pencil and a broken line to create a wispy feeling.

GLOSSARY OF HAT TERMINOLOGY

The terminology for headwear is very basic. For the most part, the elements for all hats are the same. There are a few terms that are more commonly used only in men's hats, and these have been noted below. It is the names of hats that make them particular to their individual uses. You will find many of the more popular names in the next few pages.

DRAWING TIP
The very top of the crown is usually a separate piece of material in stitched hats.

BILL: The front projection of a hat overhanging the face.

BLOCKS OR HAT BLOCK: A carved wooden, plastic or polystyrene form used to mould the crown and brim. The material of choice is stretched and/or starched over the block shape. A good selling hat shape will make the block very expensive.

BREAK: (men's) The connection point of the crown edge with the brim edge.

BRIM: The flat projection of the hat usually encircling the entire hat.

CREASE: (men's) The fold found at the top of the crown running through the tip.

CROWN: The top section of the hat that rises above the head.

DENT: (men's) The pressed in areas that run along the outside of the crease.

EDGE BINDING: A strip of fabric or leather that runs along the outer edge of the brim.

EYELET: A hole or group of holes surrounding the crown for ventilation.

FRONT DIP: The height difference between the break and the front edge of the brim.

HAT BAND: A band or ribbon, usually decorative in nature, that runs around the base of the crown at the break.

LINER: The fabric or interfacing that covers the inside of the crown.

PANEL / SECTION: The pattern pieces of a stitched hat (such as a baseball cap).

ROLL: The curve or bow of the hat from one side to the other. Particularly seen in cowboy hats or large floppy hats.

SWEATBAND (men's) or **HEAD SIZE RIBBON** (women's): A piece of leather, cloth or ribbon that runs around the break on the inside of the hat. It helps keep head oil as well as sweat from seeping into the hat brim. The head size ribbon also adds comfort at the seam connection at the crown and brim.

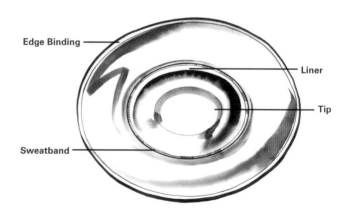

Wooden Hat Blocks

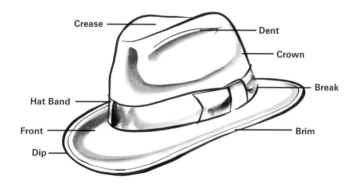

GLOSSARY OF HAT SILHOUETTES

The hat silhouettes in this section provide you with some of the more common 'family' names and shapes in headdresses. There are endless variations and embellishments that can modify each shape, and some hats are known by more than one name; here the more common historical names are listed. They are almost all unisex and trans-seasonal. Some hats cross over to more then one category, such is the case of fascinators and the fantasy hat shown here. Very different shapes can fit into all these categories.

These silhouettes were illustrated using liquid concentrated watercolour on cold press watercolour paper, working wet into wet with different colours. Regular household bleach was then used with a small pointed brush to remove the colour where more clarification was necessary for a brim or texture.

See how far you can push the basics, as headwear is an area of accessories that offers the illustrator endless sculptural possibilities.

BABUSHKA: A babushka is basically a square-shaped handkerchief or bandana tied around the head and knotted at the back.

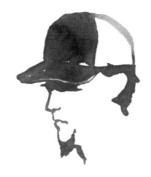

BASEBALL CAP: Baseball caps can have a hard high crown (such as a trucker hat) or a soft, low crown, illustrated on p. 95 by the hunter or crew cap.

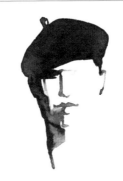

BERET: Berets can be worn flat or puffed up, pulled down straight over the head, resting on top or set on a slant.

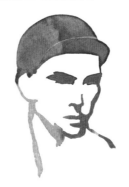

BIKE CAP: The bike cap or sports cap typically has a short brim that is easily flipped up out of the way.

BIRDCAGE: 'Birdcage' is a term used for any hat with a veil or netting that wraps around the face and head.

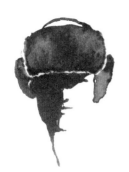

BOMBER OR PILOT CAP: Bomber or pilot caps have flaps on the sides that can be let down in colder weather. The fur flaps are up on this example.

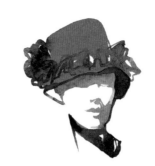

CLOCHE: The cloche is any bell-shaped hat that comes down over the crown of the head.

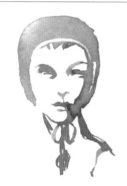

BONNET: The bonnet encompasses a large variation of shapes. It can have a large brim or be open at the back. It is best known as a hat that wraps around the head and ties under the chin.

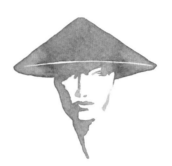

COOLIE: A coolie is any angled, pyramid-shaped hat. The crown and brim are continual.

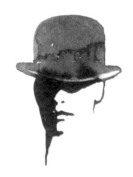

BOWLER: Bowlers have numerous subtle shapes and heights, but all come from the same basic idea of a round, hard crown with a brim.

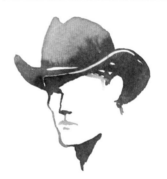

COWBOY HAT: The cowboy hat category contains numerous variations that include the ten gallon hat, which is tall and rounded on the crown, and the low-crown gambler style.

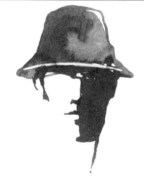

BUCKET OR FISHING HAT: The bucket or fishing hat is a common casual shape for both men and women.

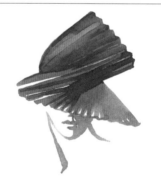

FANTASY HAT: Fantasy hats are the 'anything goes' category – as long as you can wear it on your head.

CAP OR MOD CAP: The cap or mod cap shown here represents a large category of women's hats with a crown and frontal brim.

FASCINATOR: Fascinators are headpieces with a unique shape or embellishment. They are smaller in size, but can have extensive attachments.

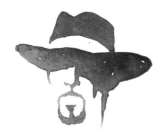

FEDORA: A fedora is possibly the most commonly worn men's hat. It is typically a soft felt hat with a curled brim and a dented crown.

KNIT CAP: The knit cap is also akin to the cloche. It has an upturned brim and is made by knitting or crochet.

FEZ: A fez is basically a straight crown with no brim. The tassel is optional.

MAD HATTER: The 'Mad Hatter' is a style noted by its mushrooming crown.

FLAPPER: The flapper is also a cloche, which encompasses the head of the wearer.

MONGOLIAN: The Mongolian has a fur-trimmed crown.

HOODIE: A hoodie could be any garment with a hood attached. The example here has the hood up on the head. Note the vertical drop of the sides, keeping the hood close to the head so it does not appear to be floating around the head like a space helmet.

OFFICER'S CAP: The officer's cap has many variations, mostly indicated by the height of the crown.

HUNTER or CREW CAP: This cap is softer in the front crown than a baseball cap.

PILL BOX : Pill-box shapes can be soft or squared on the edges.

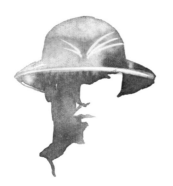

PITH HELMET or SAFARI HAT:
The pith helmet or safari hat is noted for its wide rounded crown, covered with fabric, and its angled brim.

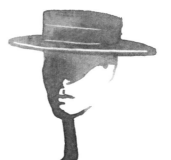

STRAW HAT OR BOATER:
The straw or boater hat is typified by its flat top crown and flat wide brim.

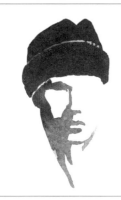

RUSSIAN HAT: Russian hats can be a smaller military wedge shape or larger versions of the bomber cap. They are characteristically made in fur.

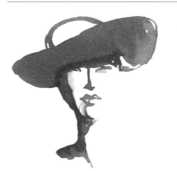

SUN HAT: Sun hats are large-brimmed hats with the purpose of shading the face. Note that the brims can go up or down.

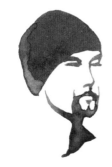

SKULL CAP: Skull caps can be any tight-fitting hat formed to the shape of the head.

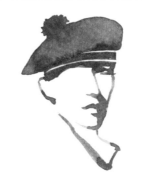

TAM O' SHANTER: The Tam o' Shanter or tam is similar to a beret except it typically has a headband and pom-pom on top.

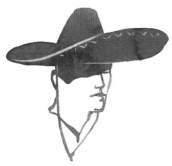

SOMBRERO: Sombreros are typically large-brimmed hats with high crowns.

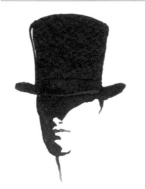

TOP HAT: Top hats can be short or extremely tall, crowned with either soft or sharp edges.

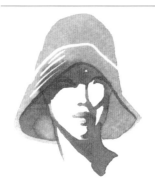

SOU'WESTER: The sou'wester is basically a large, soft-brimmed rain hat.

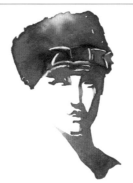

TOQUE: The toque is a straight tall crown that fits the circumference of the head. It can be shorter, like this fur toque with a bow, or a taller pillar, as with a chef's hat (not illustrated).

TRI-CORNER: The tri-corner gets its name from having three corners on its upturned brim.

TRILBY: A trilby is similar in crown design to a fedora, but has a much slimmer brim and sits more on top of the head.

TURBAN: Turbans can be wrapped or draped and sewn for the effect. Some have tails that hang down at the back.

VISOR: Visors can be short or long as well as flat or curved.

WEDDING VEIL: Wedding veils can be traditional, long and full-head covering, or short and suggestive of a covering. They are usually based on a crown or headpiece of some kind. The netting can be fine, such as tulle, or large and open.

CHAPTER 4
BAGS, PURSES
AND BELTS

The category of leather goods is by no means limited
to snakeskin or cowhide. Today, skin coverings
are still used for purses and wallets, but their use
has expanded to include everything from mobile
phone covers to iPod protectors, with many other
materials in use, too, including woven textiles and
straw. Handbag embellishments range from tassels
to jewels, and from fur to feathers. Their hardware
is limitless and their styling and shapes include
everything from fantasy fun to architectural. This
is a huge industry within an industry and is an
excellent avenue to explore if you are serious about
illustrating fashion for a career. Within this chapter
you will find many of the challenges and issues you
will encounter in this genre and the answers for
solving some of the questions that may arise.

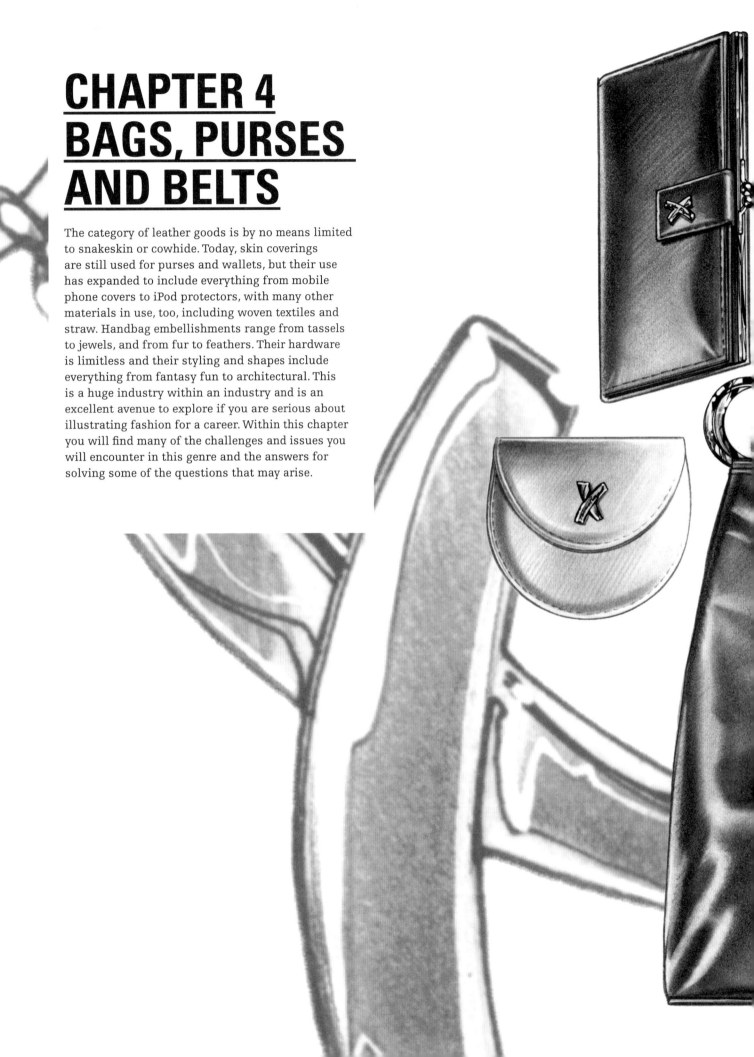

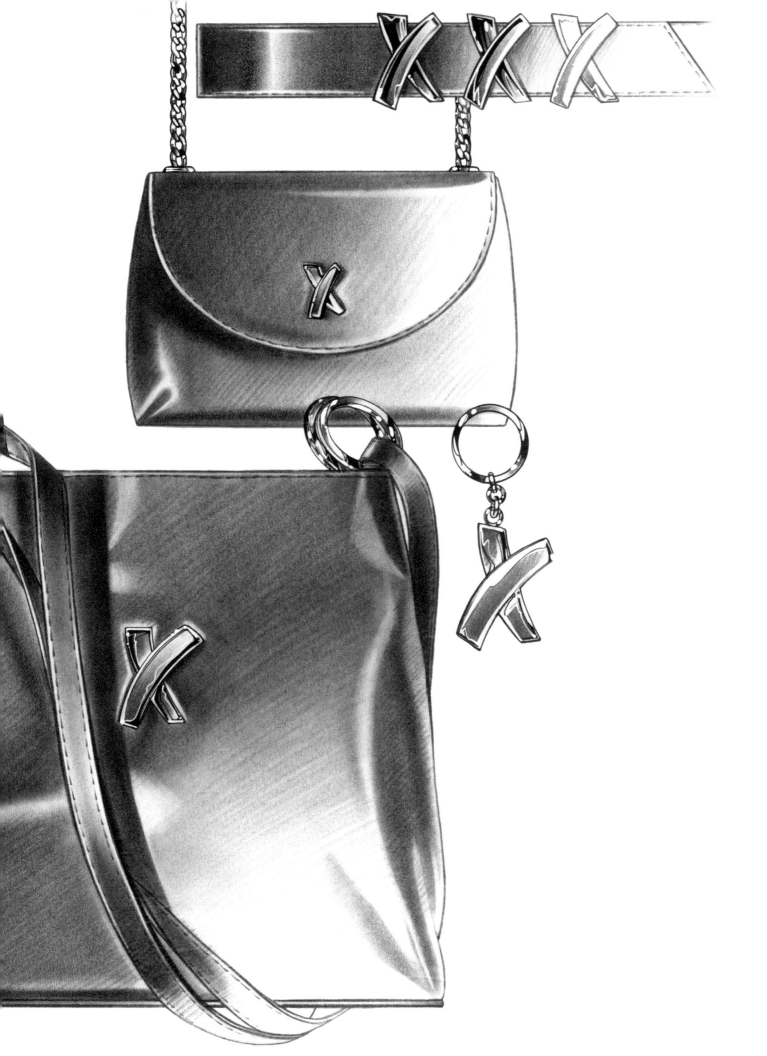

INTRODUCTION TO DRAWING HANDBAGS

Handbags can be hard-shelled forms or soft, unstructured shapes with innumerable expressions of textures. When drawing a handbag, consider what gives your particular bag life and then live it large. This casual bag by Ootra will help us gain understanding of all the basics involved in illustrating handbags.

STEP 1

This photo depicts the natural state of the bag and shows the challenge of giving it shape and life. When illustrating handbags, they should appear in their 'full' glory, not empty or limp. Consider the side; if a side shape and form is not easily presumed with a front view, then a three-quarter view will be necessary to show its specific character. You will also need to display any handles or straps in a way that expresses their function with character.

STEP 2

Even with a softer-shaped bag, it is wise to establish a symmetrical underdrawing, represented here by the orange lines. This first sketch is used to figure out view, proportion and balance.

STEP 3

This bag has three very distinct surfaces to render: the body is crushed velvet, and the strapping is black nylon with brushed silver hardware and black chain. The body of the bag is sketched with a pastel pencil to express its soft texture. The straps are drawn with coloured pencil to give a cleaner edge, and the hardware and chains are drawn with a fine-line black marker to contrast colour and surface.

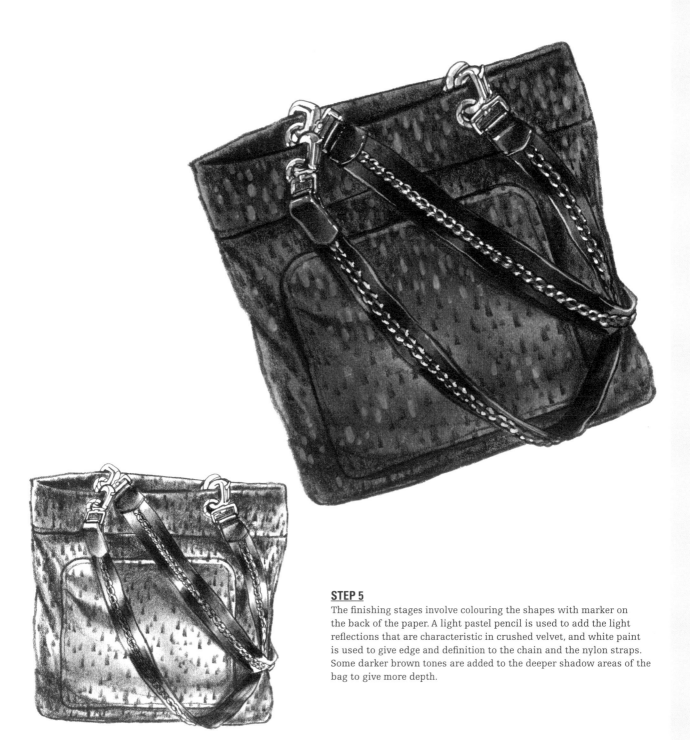

STEP 5

The finishing stages involve colouring the shapes with marker on the back of the paper. A light pastel pencil is used to add the light reflections that are characteristic in crushed velvet, and white paint is used to give edge and definition to the chain and the nylon straps. Some darker brown tones are added to the deeper shadow areas of the bag to give more depth.

STEP 4

The velvet is rendered with pastel pencil, leaving the areas of local colour untouched. The straps are rendered with coloured pencil to give them a smoother feel. The chain will be primarily marker. This is also the time to lay in the dark reflective pattern that is pressed (crushed) into the velvet.

DRAWING AN EVENING BAG

Evening bags and clutches are a popular accessory for formal events. The iridescent silk bag with fox fur trim by Ootra, shown below, is a perfect example of the luxurious materials from which such bags are usually made.

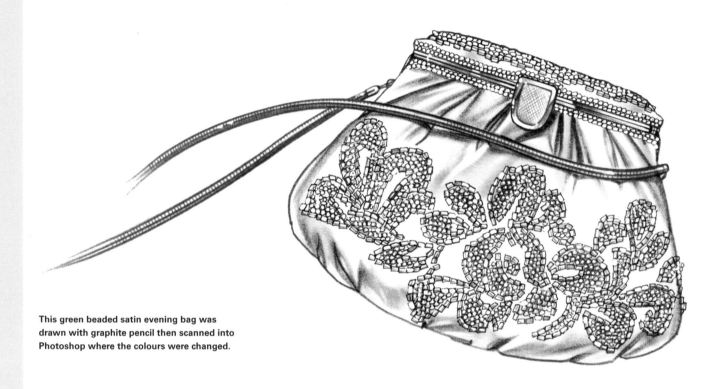

This green beaded satin evening bag was drawn with graphite pencil then scanned into Photoshop where the colours were changed.

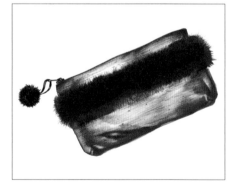

STEP 1
After drawing a light outline with a hard pencil, draw in your primary colour shadows using a water-based pen. Then take a wet watercolour brush and bring the colour across the bag, leaving the area for the fur accent unpainted.

STEP 2
Once the first layer has dried, put clean water down in the section where the fur texture will be, using a wide, flat watercolour brush. Before the water can soak into the paper, apply a saturated line of concentrated watercolour in the centre of the wet area; the paint will automatically bleed outward to the edges, creating a natural fur effect. Use the same technique for the small fur ball on the zip.

STEP 3
Once the paint has completely dried, add some darker hair details on the edge of the fur using a very sharp coloured pencil. You should also add some white reflection on the fur with white coloured pencil, since fox fur has guard hairs that glisten. To finish the bag and achieve the iridescent effect, use a violet coloured pencil and add some weave lines together with some silk slubs to finish the texture.

This Modoki handbag, illustrated by Yumicki, was drawn with black fine-line marker and shadowed using warm grey art markers. The bunny character, graphic stripes, floral pattern and ink splotches were all added in Photoshop after scanning.

DRAWING A STRAW BAG

Straw bags can be made from many different kinds of grasses with many different weave patterns. The step-by-step below demonstrates tips for simplifying the complicated overall pattern of woven straw.

This Dior straw bag with embroidered flowers was drawn with water-based pens; then the drawing was dissolved with water and a soft brush. Black line was added with a permanent pen to bring out some of the details and add contrast to the metal fittings. The embroidered flowers and leaves were drawn with a stitch-like stroke and then highlights were added to create a raised effect.

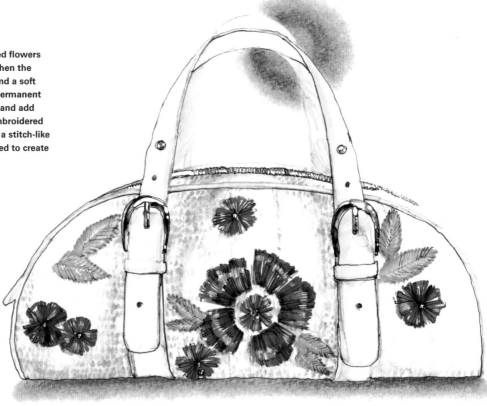

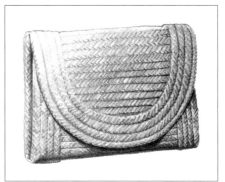

STEP 1

First establish the bag shape and weave direction using a light graphite pencil. This clutch was drawn with pastel pencils to match the bright summer colour. This particular three-quarter view allows you to see both front and side at the same time for better definition.

STEP 2

Render in your local colour, overlapping different colours to add interest. A directional hatch line will keep the bag solid in structure while helping to create the woven pattern. As you complete the fill-in, start to define the straw pattern. Notice how the repetition of the size and spacing of the weave assists in giving a fresh look to the straw. By gradating your value you can simplify the texture by burning out the pattern in the highlighted area or fading it into the darks.

STEP 3

To finish, punch in some dark values along the weave crevices and their individual edges. Erase out some highlights on a few of the straw sections in the shadow area, and push the shadows under the flap to add form. Some highlights can be added with white paint to show the reflected surface that most grasses have.

DRAWING A QUILTED BAG

Many kinds of fabric can be quilted. This step-by-step demonstrates the easiest way to gain the dimension of the quilting together with the softness the surface seeks to create.

This orange quilted Chanel bag was drawn with a fine-line pen and completed using pastels. Marker strokes were used at the edges to ground the bag to the page.

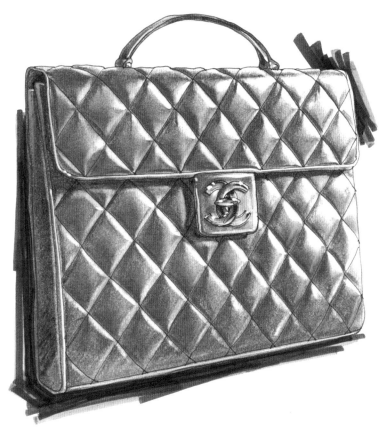

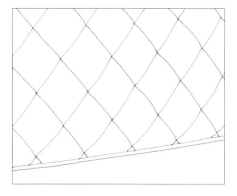

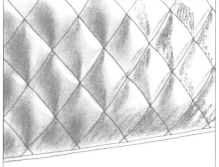

STEP 1

Draw light guidelines using hard graphite pencil. Keep the pattern even in size and centred on a vertical and horizontal axis. At the crossing points, arch your line a bit as though you were looking over a slight dome. The quilted shapes should narrow as they wrap around the edges of the object. Go over the pencil line with a fine-line marker. Draw freehand, allowing the subtle irregularity of the line to add to the soft feeling of the quilting.

STEP 2

Choose a light source and sketch in the shadows, concentrating them on one side of each raised area, intensifying your tones at the vertical crossing points. As you soften the shadows, focus the darker tones from corner to corner, not around the quilted areas. Leave the highlight side completely unrendered.

STEP 3

For added depth, choose a darker tone and accentuate one shadow edge together with a corresponding corner. Clean up your highlight shapes if necessary or add white highlights using coloured pencil or white paint.

DRAWING A MONOGRAMMED BAG

Branding or monogramming fashion accessories is common practice today. There are a couple of tricks demonstrated here that will simplify your task.

The bags featured here were drawn for a newspaper advertisement in graphite with an art marker base. Notice that some of the initialling is inverted; this is intentional by the designer and must be carefully observed and matched when illustrating.

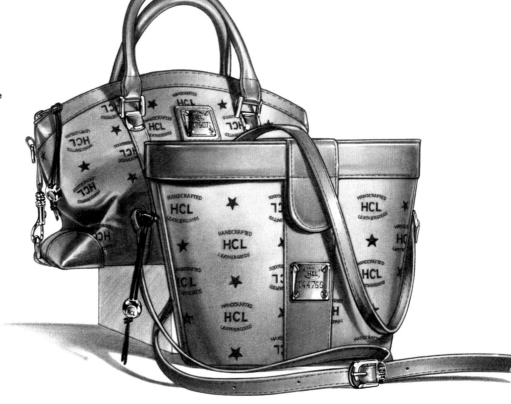

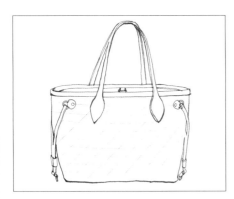

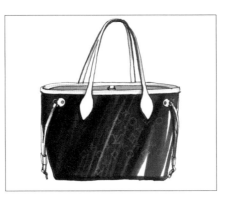

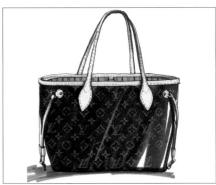

STEP 1

After drawing the initial bag structure, lay in guidelines that follow the form of the bag and also create the proportion and placing of the monogramming. Some branding will be horizontal and vertical; others will follow a diagonal pattern.

STEP 2

Using art markers, loosely render in your shadows and local colours. In this particular style the highlights were left as the white of the paper. Lay in your monogram design with coloured pencil, keeping the placement and proportion of the markings as consistent as possible.

STEP 3

Continue to define the monogram shapes. To add interest and save time, you can fade the design into the shadow areas or dissolve them as they wrap around the edges. Burning out the print in the highlights is another way to counter the flatness that an overall pattern can cause. White paint was added for the reflections on the hardware, and top-stitching was added on the trim for detail.

DRAWING RHINESTONE AND BEADED BAGS

Beading and bejewelling has always been an important characteristic of evening bags.

The bugle-bead encrusted purse featured here was drawn and rendered in graphite, then tinted after scanning to create the subtle gold tone of the beads. Notice that the highlights as well as the darks were rendered in an oblong shape to correspond to the bugle beads' specific character. A few quasars were added digitally to express the highly reflective surface.

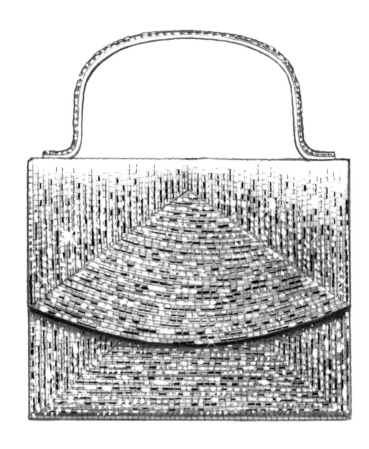

STEP 1
This cupcake minaudière was sketched with guidelines for the rhinestone colour patterns. Notice that the gold metal lip and closer are drawn with fine-line black pen for bolder separation. A centre line was used to keep the base symmetrical even though the top was not.

STEP 2
Using the small rounded point of an art marker, lay in the local colours of the rhinestones, beginning with the lighter colours and adding darker reflective colours next. There is no reason to draw the side stones in detail; fade them out as they start to wrap around the edges. This will keep the focus on the centre of the bag.

STEP 3
To strengthen and finish the rhinestone effect, add some coloured line with a fine-line marker using a circle guide. Then add some facet indication to some of the stones – do not over-render the stones or it will cause too much detail and darken the value of the true colour. Add highlights with white paint and a small brush.

DRAWING A HARD-SHELL BAG

Some handbags come in unique shapes that are hard shells. Described here is a simple way of illustrating bags that allows easy colour adjusting if the same bag comes in various colours, or if a designer wants to experiment with their colour choices before going into production.

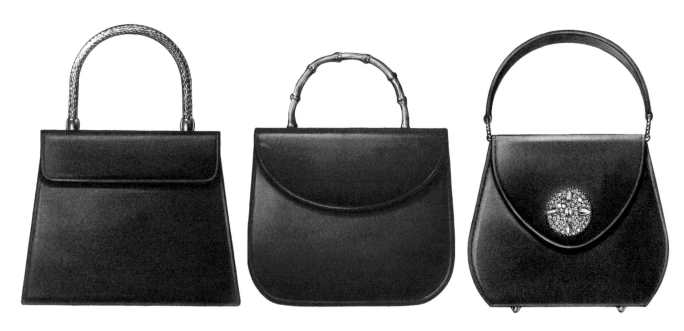

These satin handbags were all drawn with graphite pencil and then scanned into Photoshop to tint them their individual colours.

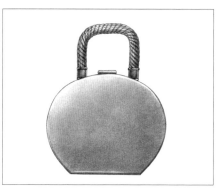

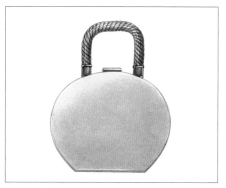

STEP 1
Since the bag is symmetrical, it is best to begin with a centre line with a perpendicular bottom line. The handle was first drawn with straight-edge lines, then divided into sections. The sections were then divided into braided partitions that created the wrapping effect.

STEP 2
Using a 2B graphite pencil, darken the outside line of the bag and handle. Lay in a soft gradation from bottom to top to capture the glow of the satin. Note the strong dark reflection shadows on the metal handle. Next, add a grey marker behind the drawing to reduce texture and blend the piece together. Finally, add the highlights to the middle of the handle with white paint, to help communicate a rounded feel.

STEP 3
To finish the bag in colour, scan the art into Photoshop and isolate the pieces using the masking tool. Once you have separated the handle from the handbag body, you can adjust the colour hue to the appropriate colours. By creating the art in this way you can now change the colour of the bag to any shade or tone the designer wants to see or that a store has available to sell.

DRAWING A METALLIC BAG

Metallic finishes have two basic characteristics. The first is the sparkling effect shown below on the featured silver bag. The second is a more liquid reflection similar to patent leather, shown in the step-by-step. It is worth noting that, as fun as they might be to draw with, a metallic coloured marker does not give you the same effect visually when it is reproduced. The steps below explain how to achieve a successful metallic look every time, without a metallic marker.

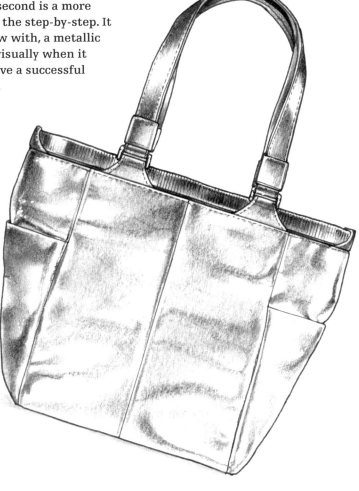

This silver bag is rendered with a sparkling effect. Notice the dots of highlight added with white paint.

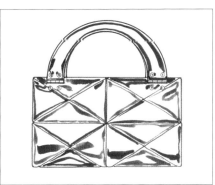

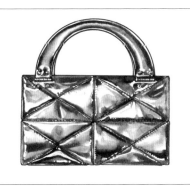

STEP 1
Because this handbag is very structured, it is important to begin with a symmetrical underdrawing. Note how guidelines were even used to ensure proper placing of the handle rivets.

STEP 2
Using black and copper tone water-soluble markers, draw the outline shape as well as interior shadow shapes. Because this bag is quilted the darks are focused along the seam lines.

STEP 3
With a wet watercolour brush, begin to dissolve the marker one section at a time, pulling the tone towards the centre of each quilted shape. In some areas, indicate the stitching, which emphasizes both the thick leather material and the quilting technique. Remember, the more reflective a surface is, the higher degree of light and dark it will reflect. Liquid-looking white highlights were added with paint after the surface had completely dried to give the tones more contrast.

RENDERING TOOLED AND EMBOSSED FINISHES

Tooled or embossed leather has a pattern pressed or cut into its surface to create a relief effect. Because of its three-dimensional effect, it needs to have a definite light source to capture its form.

This bag was rendered in watercolour; white paint was applied to accentuate the highlighted ridges.

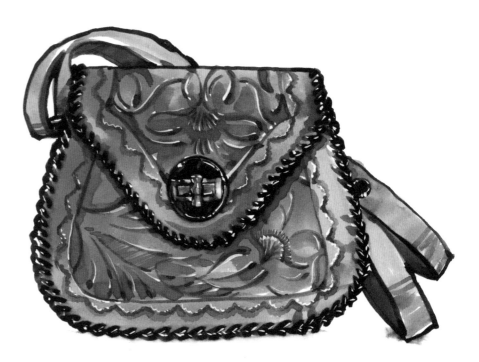

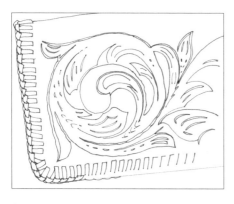

STEP 1

To give this chequebook cover more defined edges, draw over a pencil guideline with a fine-line black marker. Only draw the major pattern areas, leaving some of the more minor shapes for coloured pencil later.

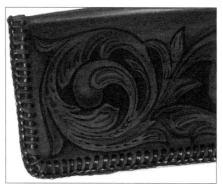

STEP 2

Use two different marker tones over the line drawing, one for the local colour and another, darker tone, for the deeper valleys and the edge stitching. Then add some deep red tints using coloured pencil and a dark warm grey marker for the punch-hole effect. The stitching was rendered from the ends inward, leaving the natural white paper highlight in the centre. You may also outline some of the pattern edges with a darker brown marker to add more depth.

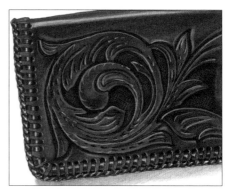

STEP 3

To finish, use a sharp white coloured pencil to capture the edges of the raised design. Make sure you keep your highlights consistently on the same side throughout the entire piece. For maximum depth, add a blue or green reflected light on the opposite side. Touch up highlights on the stitches and add in more design details with a brown coloured pencil if necessary.

Even though this satchel by Tina Berning is rendered
in a loose style, the top-stitching was drawn
with an even, mechanical feel, which adds
structure and strength to the bag.

DRAWING WALLETS AND COVERS

Leather goods have taken on a whole new meaning with technology making new items available daily that need covers both for aesthetics and protection.

This featured men's accessory collection contains alligator wallets and billfolds together with a sliver-trimmed flask and cufflink caddy. It was drawn with graphite pencil and then scanned so it could be coloured electronically. Not only does the colour distinguish the items from the background but so do the differences in texture.

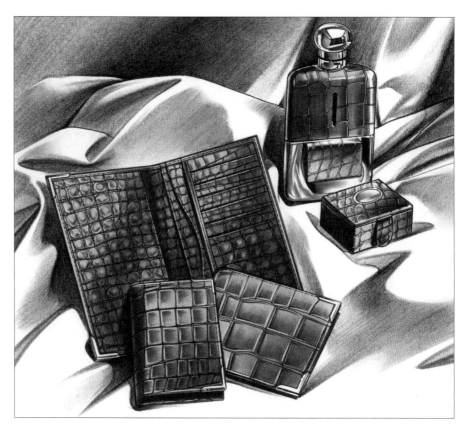

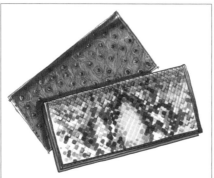

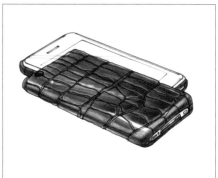

BUSINESS CARD CASE
This lizard business card holder was drawn with coloured pencils and then markered on the back to add local colour. It is mostly the small edge highlights that give its scales texture.

CHEQUEBOOK COVERS
Both covers here began with a fine-line pen and were then filled in on top of the line drawing with markers. The ostrich cover has a fine-line brown marker added to capture the wrinkled feel of the skin. Highlights were added to raise the feather bumps. The python pattern was added over a grid-like scale drawing following the light, medium and dark tones in the snake's natural pattern. Highlights were applied only to the edges of the scales to keep them simple and clean.

MOBILE PHONE COVER
This mobile phone cover was drawn to show the textured back, with only a partial section of the front drawn behind it to show how it fits. It was illustrated with a fine-line black pen on vellum, then marker was applied to the back of the image. Coloured pencil was added for tinting the darks as well as highlighting. Vellum allows you to see the image clearly from both sides, making rendering easy.

RENDERING CLOTH BAGS

Fabric or cloth handbags must show their soft, drapey nature without looking too puckered or modelled.

VELVET AND SUEDE

Velvet and suede are common for both evening bags and jewellery totes. When a bag is soft in nature, it should not be drawn limp or shapeless. Stuffing your bag with paper when illustrating it will give it healthy buoyancy. To add impact, you might also try putting a textured bag against a contrasting surface, as with this leather glove next to the suede bag. This piece was drawn in graphite and then the hue was changed in Photoshop.

WOVEN OR TWEED

Woven or tweed-type fabrics should have a feeling of 'threads' making up their colour. This tweed clutch by Ootra was drawn with pastels on black paper, giving it a rich colour with a sense of strong lighting. Allowing the shadow side of the bag to dissolve into the paper brings more attention to the button details and the plaid print.

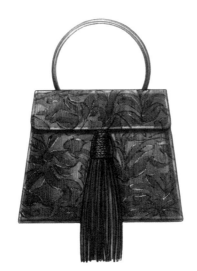

TAPESTRY FABRIC

Tapestry fabric can be drawn as a coloured pattern or as solid shapes, with the thread marks added last to enhance the effect.

CLOTH

Cloth bags can be drawn with pastel pencils on white paper, leaving the white of the paper exposed for soft highlights.

RENDERING OTHER TEXTURES

Additional textures you may encounter include: pleated fabrics, alligator skin, woven leather, nylon and patent leather. You will find step-by-steps elsewhere in the book that demonstrate specific formulas for rendering similar materials, but here are a few tips for rendering these bags.

WOVEN LEATHER BAG

The detailing of a woven leather handbag can be overwhelming to draw. This Dior bag was drawn with a fine-line marker on vellum paper and then rendered with watercolour to give it a looser, painterly look. Notice that the woven strips are not matched exactly. By following basic vertical and horizontal guidelines and curving some of their edges, the strips have the illusion of moving over and under each other. Highlights were added with coloured pencil and focused from one continuous direction. This helped communicate the form of the weave.

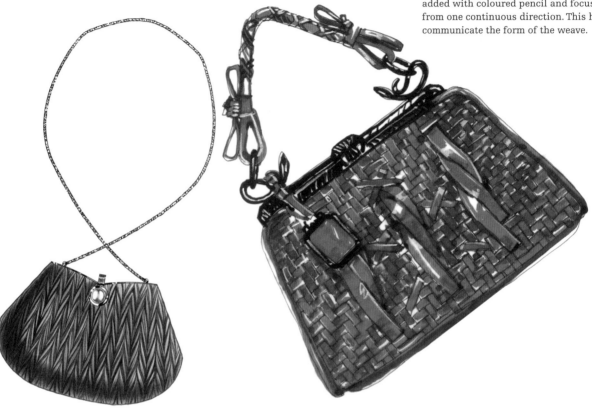

PLEATED BAG

This evening bag was drawn with graphite pencil using marker behind it for the local colour. Pleating is a specific pulling together of fabric. Unlike draped gathering, which is more sporadic in nature, pleating has a regimented pattern. The 'tuck point' of each pleat should be the darkest spot of the gather. Note that highlights are focused only on the highest area of the bag's bulge; this ensures that the bag remains strong in form despite the intense patterning.

ALLIGATOR SKIN BAG

This bag was drawn with graphite pencil, which makes it easy to render both the pattern and the value contrast. Once finished, the bag was scanned and then coloured in a photo-editing program. This particular view makes it easy to see both the design and the width and depth. Notice how the clean lines and smoother rendering help to emphasize the firm nature of the skin.

PATENT LEATHER BAG

Patent leather has the highest degree of reflection of all the leathers. It needs to communicate the darkest dark of whatever colour it is to the whitest highlight. It should have very liquid reflections that relate to the object's construction. When rendering black patents it is best to use a black medium so you can achieve maximum darks. The bag, wallet and belt here were all rendered with black charcoal pencils. Using black markers for black objects will hinder you being able to have gradations on your piece unless you render outwardly with lights. The light gradations on these pieces were achieved by letting the white of the paper come through.

NYLON BAG

Nylon and softer slick fabric bags present unique challenges to illustrate. They must be structured enough to clearly communicate their shape and usage, but not be so hard-edged as to lose their suppleness. Notice that the fabric drapes and wrinkles have been simplified and angled a little to communicate a crisp yet very pliable feel. These nylon bags were rendered in coloured pencil with some pastel used to add soft gradations. Marker tone was then added on the back of the paper for the local colour. The subtle grid of the fabric and strapping were added with a sharp coloured pencil to follow the movement of the material. Highlights were added on the cloth and strapping with coloured pencil to keep them on the softer side. All the hardware was drawn with fine-line black pen to give it a high contrast from the fabric. White paint was used to draw the labels and added to the metal pieces and zips to make them stand out.

DRAWING CHAIN MAIL

Chain mail is back in fashion and showing up in everything from belts to blouses.

This large collar piece was first drawn with pencil in a loose spiral design. Then, using a fine-line black marker together with a circle template, it was detailed to define some of the 'ring' shapes for more structure. The initial pencil underneath provided its grey metal colouring. Notice how the highlights are consistent in shape and placement, which helps create the overall mesh feeling.

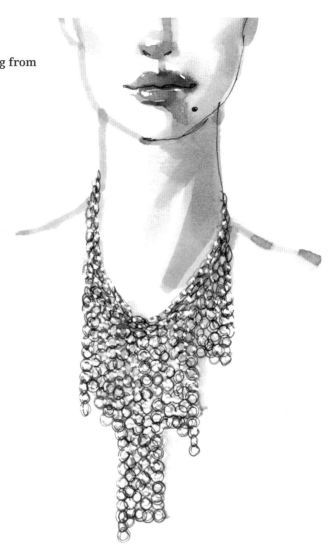

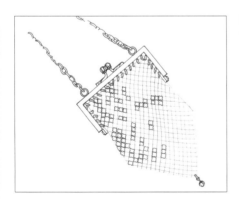

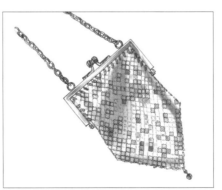

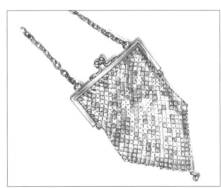

STEP 1
A symmetrical underdrawing was established for the bag shape, frame and closure. Hand-drawn flowing guidelines were laid down for the metal links to give a feeling of softer mesh. Using a fine-line black pen, outline the more solid pieces of the bag such as the handle and closures.

STEP 2
Draw enough of the links to establish a firm silhouette. Notice how some of the details are left in pencil to give an appearance of light reflecting across the surface. By rendering in larger dark tones before you start to detail the piece you will give it a more connected feeling.

STEP 3
To add reflection and finish the piece, use white paint with a small brush and cover over some of the link shapes in the shadow area. Also highlight some of the link edges consistent with a light source coming from one direction. A shadow to one side of a piece can be used to communicate the thickness of a straight-on view.

DRAWING BELTS AND BUCKLES

Belts should always be drawn as if they have life. Curves should be soft and twisting and look comfortable. Make sure you express the thickness of the belt's material on turned edges so the belt does not appear to be paper-thin. The step-by-step below specifically deals with rendering the metal studding or conches found on many wild west or punk-style belts.

The featured belt was drawn with black pen line, then rendered using graphite pencil with marker for the local colour. By scanning it into a photo-editing program it is easy to manipulate the colour into any variation.

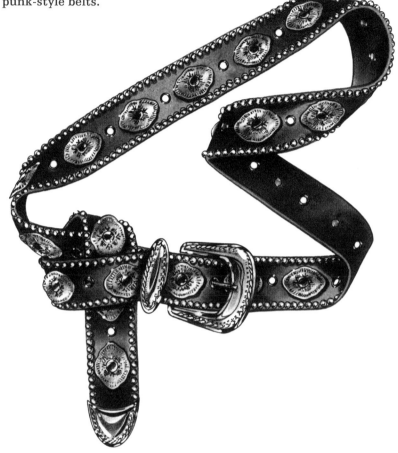

STEP 1
Establish a line drawing that is symmetrical and outline it using black pen line. This will communicate a hard metal surface as well as keeping it separated visually from the belt or host object. As with any accessory, shadow and light should move from one side to the other to create form.

STEP 2
Rendering should be from solid black to pure white to emphasize metal reflection. Smudge in a soft gradation to give a feeling of atmosphere and provide a tone into which highlights can be added.

STEP 3
To finish, add some reflected colour with a light-tone marker or coloured pencil. Highlights should be kept repetitious on the high points and focused as if coming from one light source. Note that the reflections are dot-like rather than painted strokes.

GLOSSARY OF BAG SILHOUETTES

Bags come in a huge assortment of sizes and shapes. The silhouettes below represent some of the more common family names to help you categorize the bags you are working with.

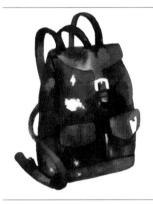

BACKPACK or BOOK BAG: This bag has shoulder straps and multiple compartments designed to hold all that a student needs.

CLUTCH or EVENING BAG: A handheld bag sometimes containing a hidden shoulder strap inside.

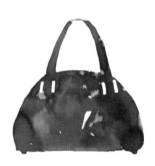

BOWLER BAG: A dome-shaped bag named for its similarity to bags used for carrying bowling balls.

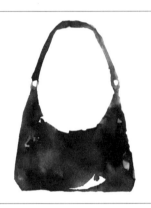

CRESCENT BAG: A bag with a half-moon or semicircle shape on top collapsing upward into the handles.

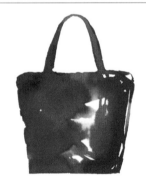

BUCKET BAG: A silhouette resembling a bucket shape (wider at the top) that typically has a rounded bottom.

CYLINDER BAG: A tube-shaped bag commonly used for storing cosmetics.

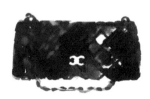

CHANEL BAG: Typically is quilted and has a chain shoulder strap.

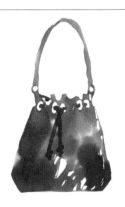

DRAWSTRING BAG: A bag that closes at the top with a chain, cord or rope laced through grommets or eyelets and then cinched.

DUFFLE BAG: A large rectangular bag with two top handles and a zip closure on top.

MESSENGER or COURIER BAG: A rectangular bag with a large flap-top closure and a long adjustable strap designed to be worn over the shoulder and across the chest.

FIELD BAG: A small rectangular bag with flap-top closure and long shoulder strap.

SATCHEL: A medium rectangular bag sometimes having strapped compartments on the sides. It has a short carrying handle and is reminiscent of a doctor's bag.

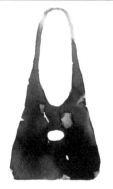

HOBO BAG: A small to large bag with a soft-cornered trapezoid shape and a shoulder strap.

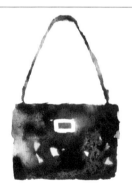

SHOULDER BAG: Variable shaped bags with a medium-length strap for carrying over the shoulder and hanging down around elbow height.

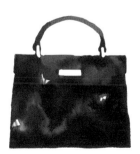

KELLY BAG: A classic handbag or purse with a slight trapezoid shape and a hard handle.

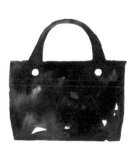

TOTE: A medium to large square or rectangular bag with open or closured top for carrying everything.

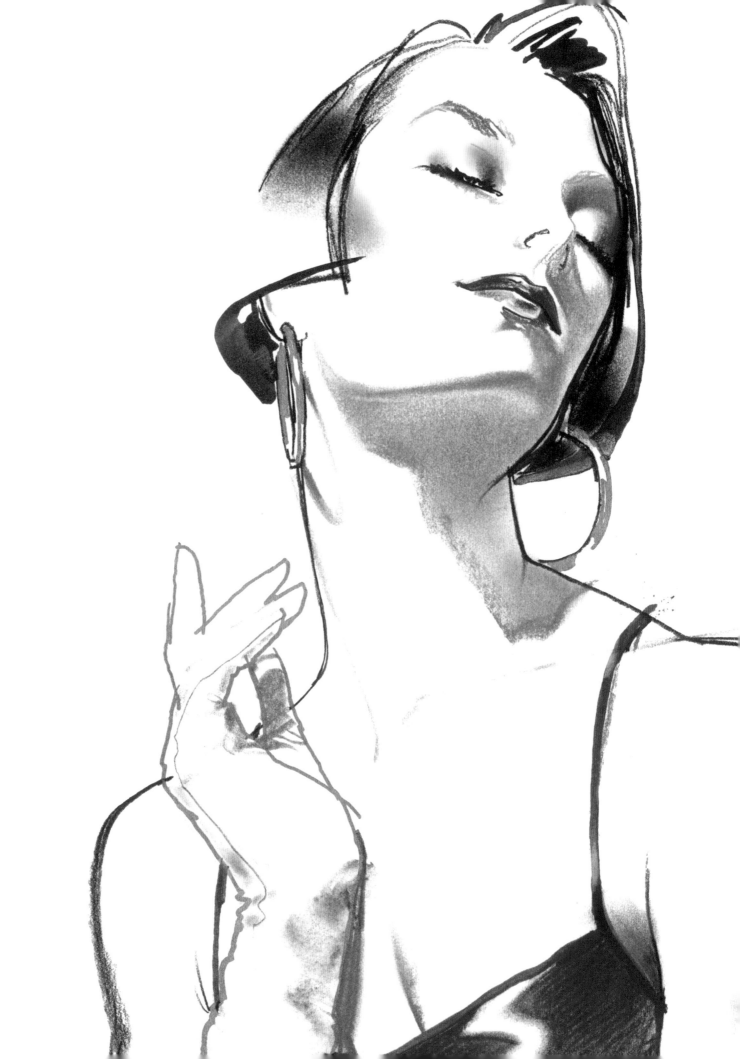

CHAPTER 5
THE BEAUTY
HEAD AND
COSMETICS

The cosmetics industry is a large branch of the
fashion illustration tree. There are multiple uses for
illustrations including in-house promotion, point-of-
purchase display, post-production product design,
hair cutting guides and beauty heads with make-up
application. Because of the expense involved and the
specifics of individual branding by each designer/
company, cosmetic illustration tends to dictate a
more realistic style than other accessories in the
fashion world. It does not allow for extreme
stylization or abstraction. You will notice the
illustrations represented in this chapter all capture
a more literal definition, no matter the medium in
which they are executed.

INTRODUCTION TO FACE SHAPES

Head drawing begins with understanding the face shape. Illustrated below are the four major face shapes identified in the cosmetic or hair-care industry. These illustrations were drawn for Vidal Sassoon's website and were used to show interested clients a recommended hairstyle based on their face shape and hair type. They were drawn with a single-colour brush-point pen and then scanned into Photoshop and coloured using only four tones each.

LONG FACE

A long face can have almost any angle to its jaw and chin. Its main characteristic is a longer proportion through the nose area. It will usually tend to make a person appear thinner.

ROUND FACE

The round face is characterized by a softer jaw angle and fuller cheeks. This is the head shape to use when illustrating full-figured women's sizes, usually considered size 16 and up.

SQUARE FACE

The square face is mostly emphasized in the chin and jaw area. Square features tend to look more masculine, so it is important when drawing a square-faced woman to keep her features on the softer, more curved side to balance the harshness of the angles.

HEART OVAL FACE

The heart oval face is the most commonly used beauty face shape. It lends itself easily to any subtle face characters and works for male or female heads.

DRAWING THE BEAUTY HEAD

Whether you are working in a more realistic or stylized form when illustrating beauty heads, the features of the human head need to remain true to reality. The following pages are not meant to teach you the way to draw a face as much as to give you the tools to check your art as you develop your own style and interpretations.

DRAWING TIP

If you sense something odd with your drawing, there is a way you can identify the problem more easily. Look at your drawing in a mirror (backwards) or, if your paper allows it, look through your drawing from the back. This will help you see the illustration from a different perspective and make the areas for correction more obvious.

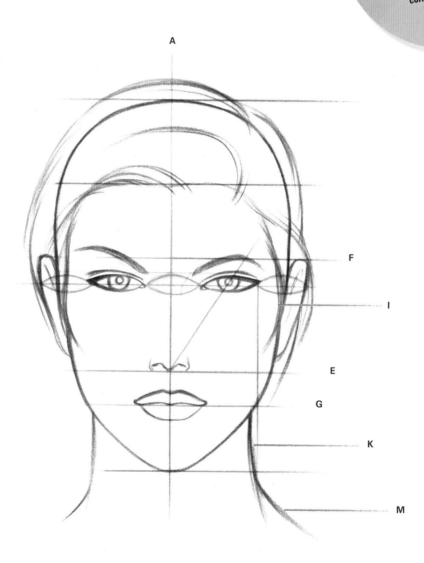

- For any straight-on beauty head, start with a centre front line (A) to assure a symmetrical face.

- The eye line sits in the middle of the head (D) – about halfway between the crown of the head (hair not included) (B) and the chin (C). A realistic eye proportion is equal to about five eyes across the head with the two outside eyes including the ears.

- The nose line (bottom of the nose) (E) is halfway between the eye line and the chin.

If you draw noses longer, measure from the eyebrow line instead (F).

- The mouth line (mouth opening) (G) falls one-third down between the nose and the chin. The closer the mouth is to the nose, the younger the person will appear.

- Ear placement is from the brow line to the bottom of the nose. Keep a female's ears closer to her head; a male's ears can be more pronounced, adding to his masculine feel.

- Hairlines (H) change with age to some degree on all men, but a hairline typically starts halfway between the eye line and the crown of the head. From the starting point, take the hairline down towards the eyebrow arch or temple area and then curve it behind the cheekbone/in front of the ear. Avoid a solid, continuous curve, which can make the hairline look helmet-like. The shortest hair will add at least 12 millimetres proportionally to a head. Note: on this male head example, the right-side hairline is more indicative of a younger

Both male and female heads use the same basic placements for their features – the difference comes in the character. As a rule, think more curved and refined when drawing a woman's features and more angular and bulky when drawing men. If you reverse the guidelines for the sexes the results will be an androgyny in the gender of your faces. Also, because the placement and the proportion of the facial features can affect the age of the face, keep true to these guidelines for an ideal 20-something-year-old.

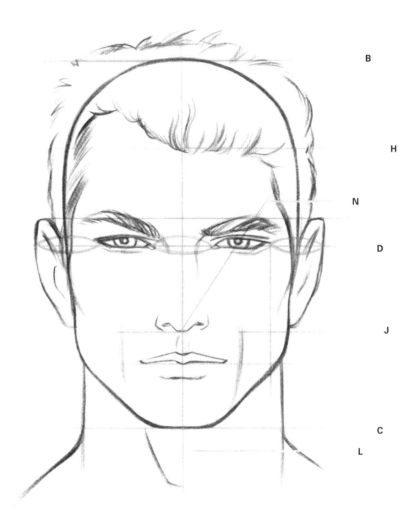

B

H

N

D

J

C

L

(18–24-year-old) male, while the left side indicates a more mature (30-year-old) hairline. The hairline plays an important part in ageing a male face when a more sophisticated look is required. A female's hairline doesn't change.

- Cheekbones (I) drop from the top connection of the ear towards the bottom of the nose. On a male head, do not emphasize the cheekbone line as much but rather the vertical jowl muscle, which is a more masculine feature (J).

- Necks (K) should drop down from the outside of the eyes on a female. The thinner a neck, the more feminine it will appear. Male necks should be closer to the ears/jaw line to make them more muscular. You can even bow a man's neck out a bit for a more athletic-looking figure. Male necks will also feature an Adam's apple (L) or thicker throat area. A woman's neck should be kept smooth on the throat. Also note that the neck tapers into the shoulders with a slight angle (the trapezius muscle) (M). This is essential to avoid the shoulders looking rigid.

- To find the correct point of the eyebrow arch (N), take a line from the bottom of the nose up through the pupil of the eye. A centred arch will give you an undesirable 'surprised' look.

DRAWING EYES

The following guidelines will help you draw fashion-head features with gender-specific characteristics. They are meant to help you draw heads with more accuracy, not to lock you into one way to draw a face. It is much more interesting to draw the diversity of ethnic features available around the world. We will begin with the feature that offers the most insight into the soul: the eyes.

FEMALE EYES

Generally, female eyes should be almond-shaped with a slight upward angle to the outside. This will give the eyes a bright rather than a depressed appearance. Draw a female eye with three sections in mind: the eye shape (A), the eyelid (B) and the eyebrow area (C). This opens the eye up more and allows for maximum make-up expression.

In a straight-on view the iris should be centred in the eye, resting on the bottom eyelid and covered by the upper eyelid by up

to a quarter or a third to give a relaxed look. If you show the whole iris, the eye expression will look shocked. The more you cover the iris, the more attitude or glamour the eye will have. If you cover more than half of the iris, the eyes will appear sleepy.

Add lashes with a down-then-up motion, creating the most density towards the outside of the eye (D). Consider the lashes as a solid

shape rather than as individual hairs, to give a more solid eye outline rather than just an anatomical explanation. Leave a slight space between the bottom lashes and the bottom eyelid to help give the eyelid some depth. Finish by rendering some dense tones on the outer edges to indicate the eye socket depth. Note that the highlight of the eyelid stays centred on the pupil (the highest point of the eye).

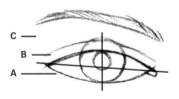 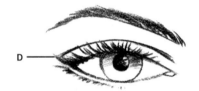 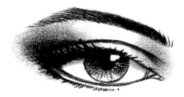

MALE EYES

Male eyes have the same basic shape as female eyes, but are more compressed. To make men's eyes more masculine, angle them on the inner and outer upper lid as well as flattening the bottom lid slightly. The male eye should be viewed more as one unit than as three sections. This is because males typically have a more pronounced brow bone/line that compresses their eyes.

The male's lashes should be kept shorter and more streamlined to the eye shape. The iris should still be partially covered to avoid a 'shocked' look.

A man's eyebrows are typically twice as thick as a female's and do not arch as much, since males do not typically shape their eyebrows. Notice also that you can indicate the lower lid bag on a male's eye (E); this will add a rugged

look to his face. This line on a female will only make her look older and more run down, so it should be avoided.

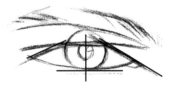 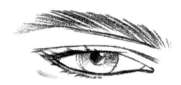 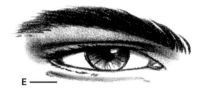

THREE-QUARTER VIEW

If a head is turned even slightly away it is considered a three-quarter view, and you must consider the foreshortening that takes place. In a three-quarter eye view make sure you ellipse the iris and pupils. Also notice that the eye sits on a slight back angle (F). To emphasize a three-quarter view look for the long and short side of each feature (G). It is the same effect as with the centre front of a turned figure. The eyelids and eyebrow will curve more severely around from the front of the eye (H).

FEMALE EYES – THREE-QUARTER VIEW

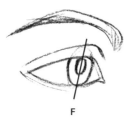

F

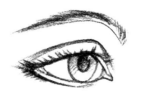

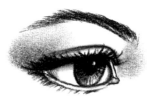

MALE EYES – THREE-QUARTER VIEW

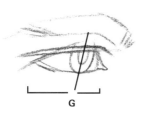

G

H

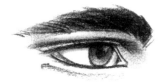

PROFILE VIEW

When drawing profile views keep the upper lid more horizontal (A) and add more angle to the bottom lid. This will help keep the eyes relaxed-looking. Remember to angle the iris back slightly and ellipse the shape (B). Include the tear duct at the corner of the eye (C) to help the eyelid appear to wrap around. Keep the eyeball behind the eyelids to avoid flattening the eye (D).

The eyebrow will curve more intensely around the eye and will not appear to arch as much (E). The more the head is turned away from you, the closer the eye and eyebrow will be to the bridge of the nose. For a straight-on profile view, as shown here, set the eye a good distance back from the bridge.

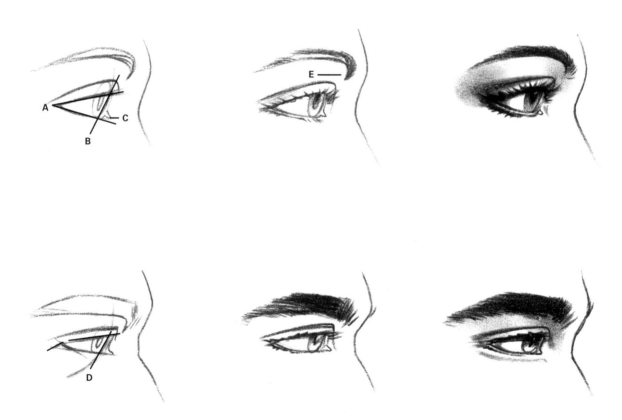

EYEBROW EXPRESSION

Eyebrows are one of the easiest ways to create attitude or expression. You can make them stylized and inquisitive (A) or give the face an air of sophistication and boldness (B). The pensive look (C) can also be read as naivety, which is useful with younger faces. All these eyebrow expressions are illustrated on the same set of eyes.

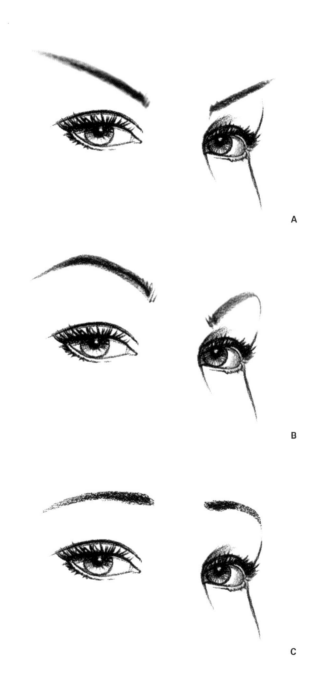

A

B

C

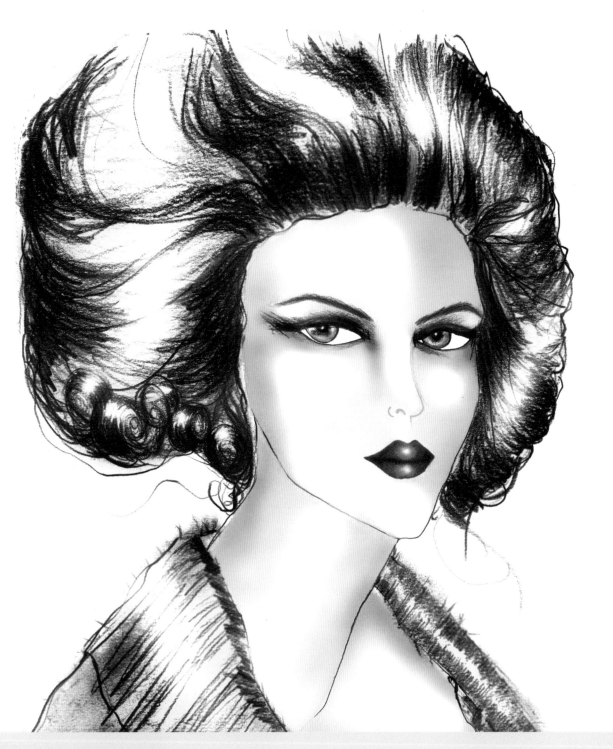

This beauty head by Cha Peralta-Martinez uses a combination of drawing skills and Photoshop rendering. The style is effective in combining texture and smooth gradations, both of which are necessary in drawing a beauty head.

DRAWING MOUTHS

If the eyes are the most communicative feature on the face, the lips come a close second. Throughout history, lips have been painted to emphasize them as objects of expression and sensuality. Mouths come in all shapes and sizes, and even make-up trends have dictated their style. Here are some guidelines to help you draw mouths with substance and character.

FEMALE MOUTHS

When drawing a straight-on mouth, it is good to begin by thinking of the three main muscle structures. Start with an almond shape divided in half horizontally and vertically. Stack three balls together and cut a '10 to 2' wedge out of the top ball (A). Draw a line between the centre of the stacked balls as if paper were being rolled through a press (B). Then draw a line under the bottom of the rollers to create a subtle bottom curve (C).

Bring lines down to the corners of the mouth from the peaks of the wedge shape (D). You need to create an outward arch to the upper lips. Inward curves will pinch the corners of the mouth and deform the lips' natural, full feeling. Connect the centre mouth line to the corners and to the bottom lip line. The bottom lip should be just slightly inside and under the top lip at the corners to assure a relaxed, pleasant look (E). The bottom lip is typically slightly larger then the top lip.

When rendering the lip shadows, establish tones that give them a soft, smooth form. Since the upper lip heads back towards the centre of the mouth, it makes a stronger shadow than the bottom lip. Do not draw the multitude of muscle striations (lines) that make our mouth so flexible, or you will end up with a 'mummy mouth'. Keep the highlights simple and focused on the breaking points of the lip curves (F).

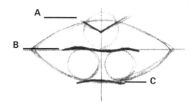

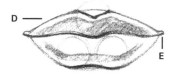

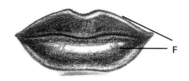

MALE MOUTHS

Although the structure of men's mouths is the same as women's, a male mouth tends to be wider. Men also do not typically have the fullness in their lips that women do. Just like with their eyes, it is more masculine in appearance to angle a man's lip shape (G). When you begin to render the lips, keep things on the lighter side and do not draw a line all the way around a man's lips (H); it will make him appear to be wearing lip liner.

If you find the mouth still looking a bit feminine, you can add a beard tone or emphasize the structure around the mouth a little more (I).

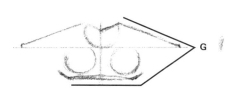

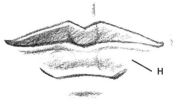

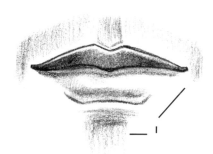

THREE-QUARTER MOUTHS

The most important aspect of a three-quarter, or turned, mouth view is to capture the differences the sides have, not their similarities. As with any turned feature, emphasizing the long side (I) and the short side (J) will automatically help turn the head. Notice that as the mouth turns away from you, the back of the upper lip actually starts to curve back to the centre line of the mouth (K). When drawing a direct-profile mouth, keep the lower lip set back a bit from the upper lip (L). This will keep the mouth structure looking healthy.

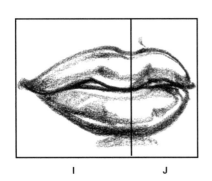

I J

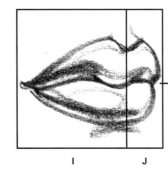

I J K

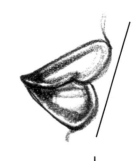

L

I J

I J K

L

OPEN MOUTHS

To draw an open mouth, start by drawing the lip shape in an open gesture. In a smile, the upper lip will commonly stay level while the lower lip drops down. Start with a centre line to keep everything symmetrical. After establishing the lip shape, draw the shape of the teeth, beginning with the upper gum line. Keep the teeth symmetrical and one solid shape. Do not draw a line around every tooth; that would cause the teeth to look separated and be overemphasized. The gum colour should be kept a light tone, similar to the facial colour.

The lips and tongue can be darker. Do not draw attention to the inside of the mouth with too much detailing.

For the three-quarter view, watch for the long (A) and short (B) side so you can easily establish the turning of the mouth. Notice that the centre front of the teeth falls slightly back from the centre front of the lips. For a profile view it is important to keep the chin and bottom lip back behind the upper lip because it is the jaw that drops down (C).

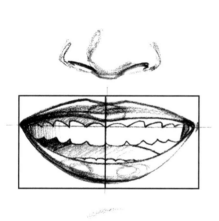

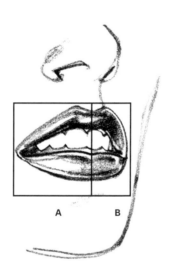

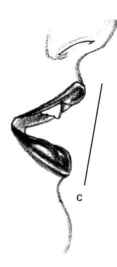

DRAWING NOSES

There is little difference when drawing the structure of the female versus the male nose, except in size. Typically men have broader and more pronounced noses. As for their variety and beauty, noses are the features to emphasize least on the face; no one wants to have their nose be the centre of attention, and the same is true of drawing.

At its simplest, a nose can be rendered by drawing only the nostril direction and length (A). When this technique is used, draw the edge of the nostrils, observing their curve and length. Do not draw two black 'holes' in the head. Indicate the ball of the nose (B) to give it structure. When drawing the bridge of the nose on a straight-on view, you should only shadow or indicate one side (C), not both. Too strong a rendering of the side planes will give you a 'lion' nose effect. For a three-quarter view nose, you should draw the outer edge (D) to structure and give the nose character. Make sure your profile noses have a structure that includes out, down and back angles (E).

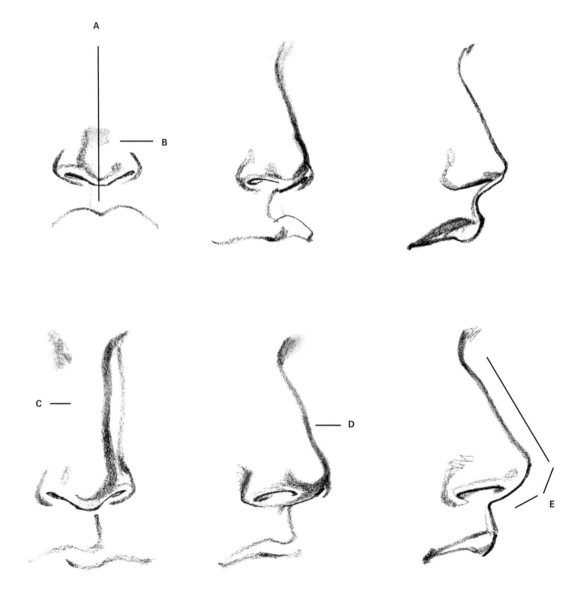

DRAWING EARS

Ears are necessary, but should not be overemphasized. They will be a more important element if earrings are the featured accessory.

FRONT VIEW

Notice how the cheekbone starts at the top of the ear and curves right in front of it. The ear should be a soft, curved shape kept close to the head, especially on females. Do not over-draw the inside details or make the ear too bumpy in texture. If an earring is featured in this view it will also ellipse or have perspective as it dangles down (A).

PROFILE VIEW

The hairline typically comes from the front of the ear and curves up over it. Ears sit about halfway in the middle of the skull and typically have a slight angle to them (B). Some shadow is necessary to create depth inside the ear, but do not over-render. This view is ideal for showing an earring.

BACK VIEW

This view shows off the structure of the ear. Notice how the organization of the ear is flatter, showing more thickness at the back and little inner ear detail.

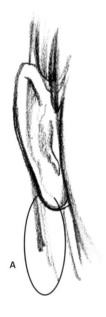

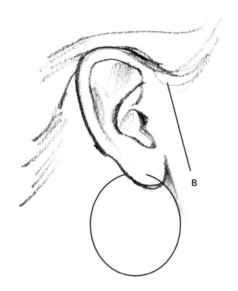

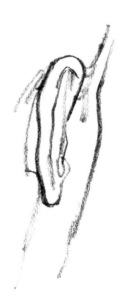

DRAWING HAIR

To finish your beauty head, it is essential to avoid detracting from it with sloppy execution of the hair. Hairstyles change continually and, therefore, can make or break your piece when it comes to style statement. Be aware and watch what hairstylists are doing. The easiest way to achieve comfortable, full, glamorous hair is first to consider its shape. Do not think of it as billions of lines, but rather a shape of tones that are broken up by major tonal divisions with some linear detail.

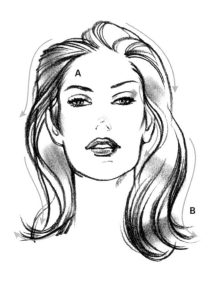

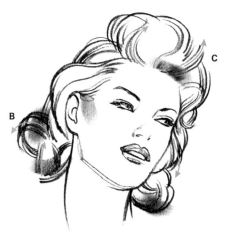

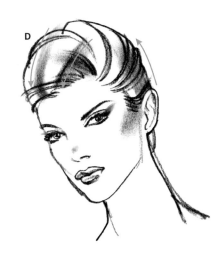

LONG, FLOWING HAIR
Hair will add at least two and a half centimetres to the thickness of the head; flattening the head by lack of hair volume is the most common problem when drawing hair. Make sure you keep your hairline soft against the face; a slight feathering will keep it from looking like a helmet (A).

WAVY HAIR
This illustrates the direction lines needed to break up the hair into pattern shapes (B). Drawing with curved lines will give the hair bounce and life. For curlier hair, work with patches of shorter lines that move in the same directions (C). Do not feel it is necessary to draw all the lines of the hair – you only need enough line to indicate fullness and direction.

SHORT HAIR OR AN UPDO
To bring a solid fullness to the hair, render in shadows and highlights with patterns (D). These should move across the direction of the hair, bringing unity and form. Finish by adding highlights with a white medium or erasing out directional lines.

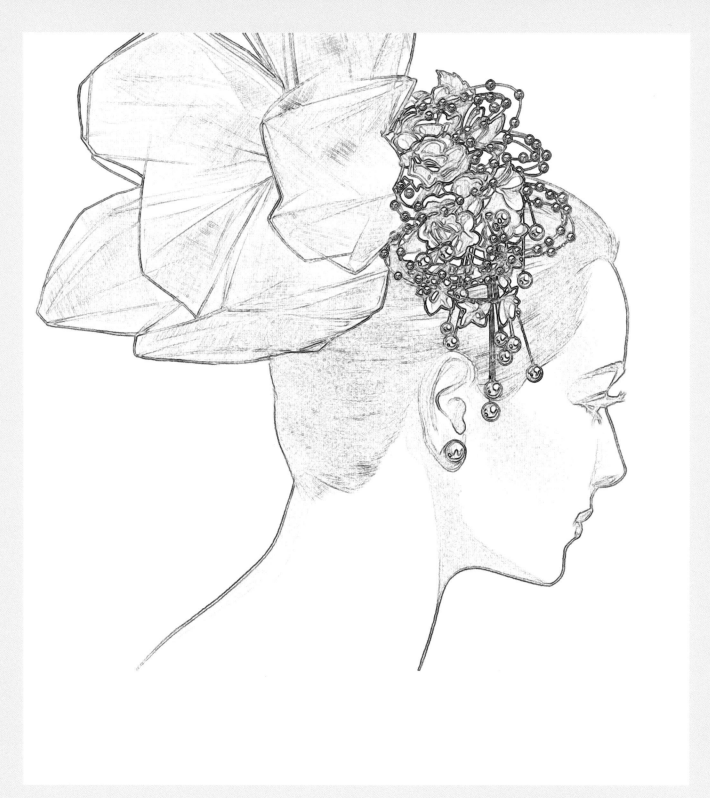

This bridal veil with beading and tulle was drawn with an outline using fine-line marker, as was the earring, and then rendered with graphite. An edge tool in Photoshop was applied after scanning; this gives the accessory the focus as the black line holds its edge with more intensity than the graphite. This trick can be useful to separate complicated areas of a drawing, even when the edge tool is not used.

DRAWING PROFILES

The profile head, or complete side view, is easier to draw if you observe the angles and how the facial features relate to each other, rather than thinking about them individually. The feature placement stays the same as on the frontal view, but their shapes will appear very different. The following notes will help you distinguish some gender characteristics more quickly. These are very general observations and will differ depending on your style or the actual person you are observing.

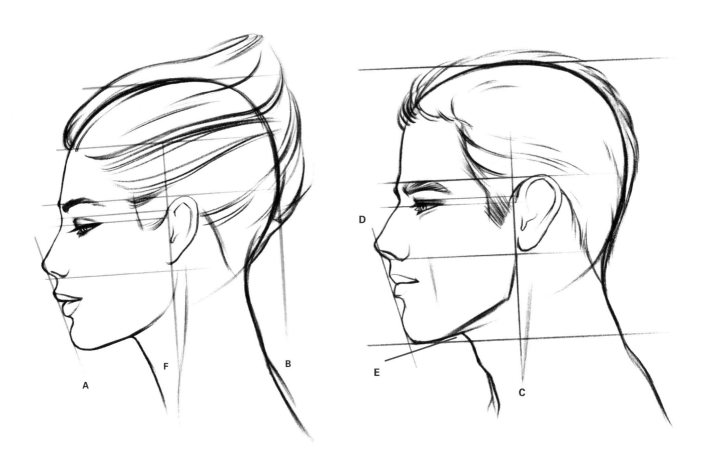

In terms of similarities, both heads have a slight egg shape to them and sit at an angle on the neck so that the front face angle is almost vertical (A). Notice that the neck comes out forward from the shoulders, not straight up out of the top (B). The ear sits about halfway back in the head (C). There is a slight back angle from the nose to the chin on most heads (D); this will vary if a person has a more pronounced chin or lips. Both figures have a sight upturned jaw line (E), a good length for their chins (F), and long necks, which help to give them a youthful, fashionable appearance.

The female head has a softer forehead, brow line and nose angle. Her features will tend to look more refined, as with her ear. Because of a smaller bone mass there is also a more open feeling to her eye socket. The space between her nose and mouth will have a more curved, upturned look to it. Her lips will tend to be fuller and more rounded than the male's, and her chin will be softer and not as thick. Her neck will be smooth and narrow in comparison to a man's.

As for their differences, note that the male head is more angular and also has larger features overall. Male foreheads tend to be more vertical than female's, with a more pronounced brow bone. The male nose is larger, both in bone mass and nostril length. The space between the nose and mouth will be straighter and his lips more squared. The male chin is more pronounced and thicker, and his neck will have an obvious Adam's apple and be thicker in appearance.

DRAWING THREE-QUARTER HEADS

Three-quarter-view heads can be the most challenging to draw and yet have the most obvious observation points to check. Two basic rules will help you keep your heads looking symmetrical and straight. One is to use a centre front line as you would when drawing a full body garment; the second is to note that the horizontal guidelines that arch around the face line up with the tops and bottoms of the features.

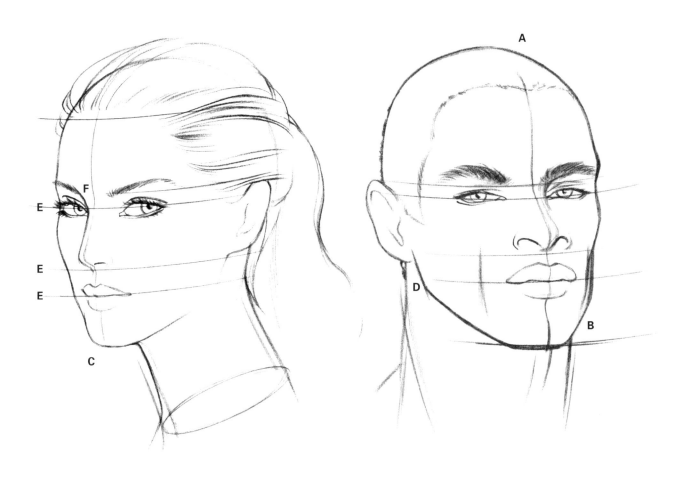

Notice the slight egg shape both heads have apart from the necks. Observe that the necks will almost always have an angle back towards the shoulders with this view. Once you have established this basic structure, draw a centre line from the middle of the forehead to the middle of the chin (A). As with any three-quarter view, there will be a long or wide side and a short or narrow side (B). This is true of the head itself as well as the individual features. Being consistent with this proportional characteristic will enhance the turning of the head.

The head will have two angles to watch for: The angle of the cheekbone to the chin (C), which has a slight back angle to it, and the angle of the chin to the ear (jawbone D), which typically has a slight upward angle as it heads towards the front of the ear.

Depending on the angle of the head, the horizontal guidelines (E) may curve up or down. Whichever way they go, you must stay consistent with their angle and match up their contact points from side to side of the head, such as right eye bottom to left eye

bottom or right nostril to left. Also watch for the difference in spacing from the centre line (or nose) to each eye. Since the nose protrudes outward as it comes down and the eyes sink back into their sockets, the nose will somewhat cover the back eye (F).

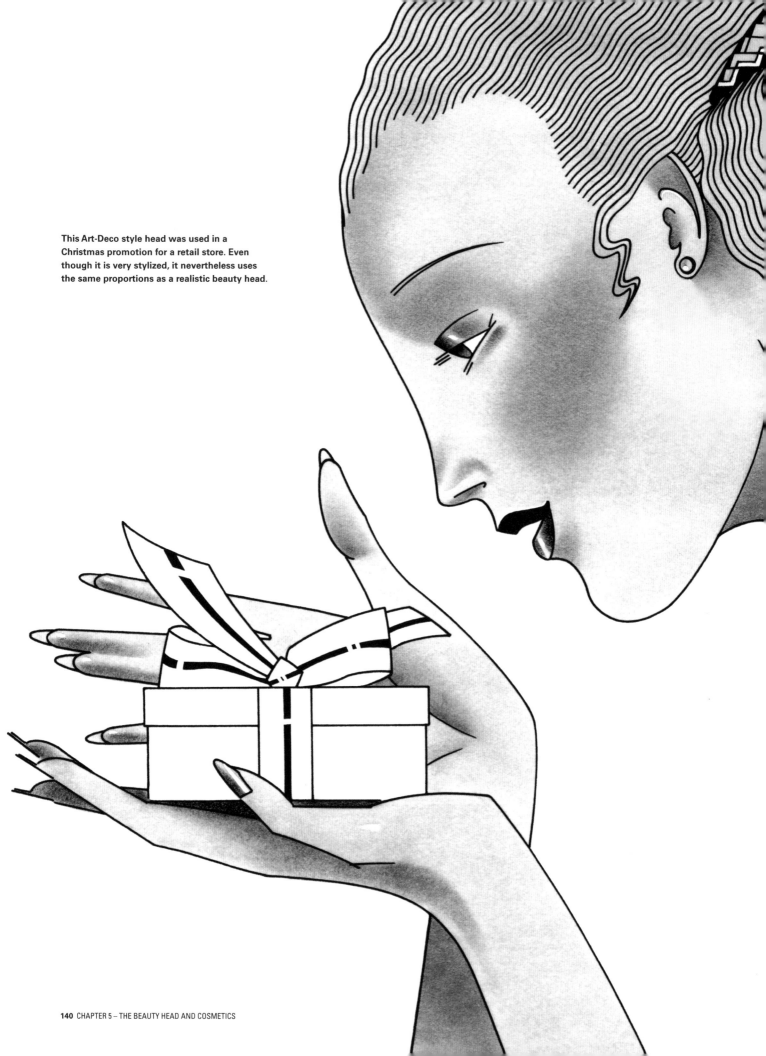

This Art-Deco style head was used in a
Christmas promotion for a retail store. Even
though it is very stylized, it nevertheless uses
the same proportions as a realistic beauty head.

DRAWING ANGLED HEADS

Drawing a fashion head at an alternative angle is a way to exaggerate drama and character. The trick is to watch for the feature foreshortening and placement changes. In an upward or downturned head, for example, the features will be much more compressed from their normal relationship. The mouth will be closer to the nose and the ears will move higher or lower, depending on the pose. The head templates below will point out these feature changes as well as giving you guidelines to help you keep your heads in the proper perspective.

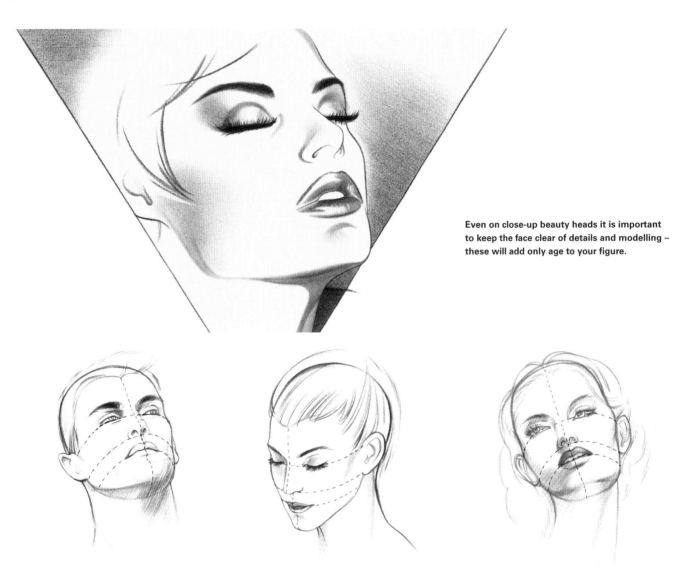

Even on close-up beauty heads it is important to keep the face clear of details and modelling – these will add only age to your figure.

LEANING BACK
Here the top of the head shortens and the eye line is no longer halfway between the top of the head and the chin. The ball of the nose is close to the eyes and the mouth has a downward curve. By using guidelines, all the features will automatically be placed correctly and the perspective kept consistent. Use a centre front line to remind you of the long and short sides of the face. To handle an upturned neck, establish a strong jaw profile line and then render softer tones on the inside of the throat and chin.

DOWNWARD ANGLE
In a downward angle, the perspective lines of the features curve upward around the head. This will also cause the features to curve more. The mouth will tend to have a larger bottom lip and a very narrow upper lip. The neck will also appear shorter as the chin overlaps it. There is more top of head, or crown, showing and the ears sit above the eyebrow line on a horizontal.

UPTURNED
On this straight-on upward-turned head, notice how the features become more compressed and flat. The bottom lip and the bottom of the eyes both have a more flattened feel, while the curves of the top lip and eyelids become more exaggerated. The nostrils should still be drawn with a line rather than being dark holes. Also notice how low the ears sit in relationship to the eyes. The jaw line also has a straighter front.

DRAWING PERFUME BOTTLES

Perfume bottles come in all shapes, sizes and fabrications. They are developed specifically, and at great cost in most cases, for each individual scent. It is important that any personal art style or interpretation does not distort the product's design aesthetic. The bottles featured here were both drawn for retail sales promotion and are very detailed to avoid any doubt of what the designer had in mind.

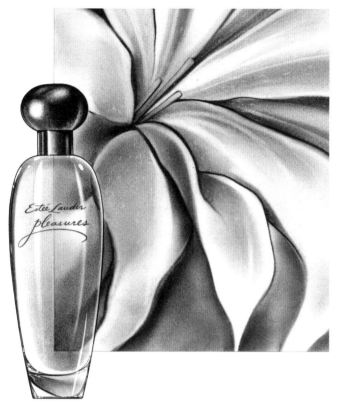

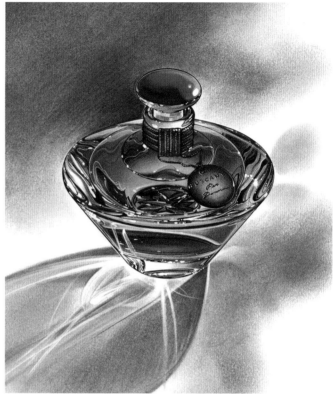

The Estée Lauder bottle was drawn with a black fine-line pen and then rendered using pastel pencils. Emphasizing a gradation inside the bottle gives a sense of depth and density to the liquid. Coloured pencils were used in the thicker base area to add interest and give a feeling of weight to the bottom. The top, which was a soft brushed metal, was rendered entirely with coloured pencils. Notice that even though the reflections are soft they still have a distinct shape and direction. For the soft white highlights some of the pastel was erased. White paint was

used for the hot highlights. The lettering was hand-drawn with a hard graphite pencil (2H). A background image was incorporated to communicate the transparent character of the crystal. There is no art marker colouring on this piece; it is all dry media.

Because the Tuscany bottle is a thicker crystal, it needed to have more black reflections to emphasize the density of the glass. Have fun swirling the lines on the inside, but keep the outside silhouette clean and crisp. After completing the linework,

coloured pencils were used to add variations of colour to the crystal and perfume. The bottle top, braided cord, liquid and medallion all have art marker behind them for their local colour, while the crystal does not. More hot highlights were used on this piece to push the hard, thick nature of this bottle. A soft pastel background was also used to contrast this feeling.

DRAWING FROSTED GLASS AND CRYSTAL BOTTLES

When drawing cosmetic bottles you will encounter two main materials: crystal and frosted glass. The media you use may vary, but the results must communicate the differences.

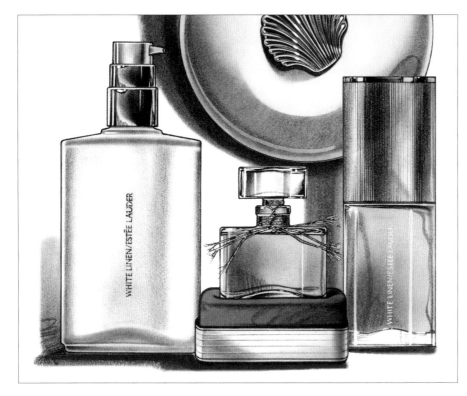

This illustration includes both frosted glass (left) and crystal (right). It was executed using ink, graphite and art marker. The finish was then scanned and some of the colours were enhanced.

STEP 1

Begin with an ink line drawing over your preliminary pencil sketch using a .8 fine-line marker for the outside silhouette and a .005 for inside detail and reflections. Notice that the crystal bottle has strong black lines and reflections, while the frosted bottle is left open for softer tones.

STEP 2

For rendering the frosted bottle, use a tortillon with graphite so the shadows have large soft edges and are lighter in contrast. The black of the cap was accomplished with charcoal and black ink. The crystal bottle was also rendered using graphite, while fine lines were drawn inside to indicate reflections. Note the large soft gradation that gives a feeling of depth to the liquid in the crystal bottle.

STEP 3

To finish, add some art marker behind the crystal bottle and on the glass cap. Then add the highlights with a brush and white paint to the cap and crystal bottle. The crystal bottle is given strong highlights with white paint to push the surface reflection. The frosted bottle is only highlighted on the cap. When it is dry, scan it and enhance the colours on the marker areas and also tint the frosted bottle to create a soft colour.

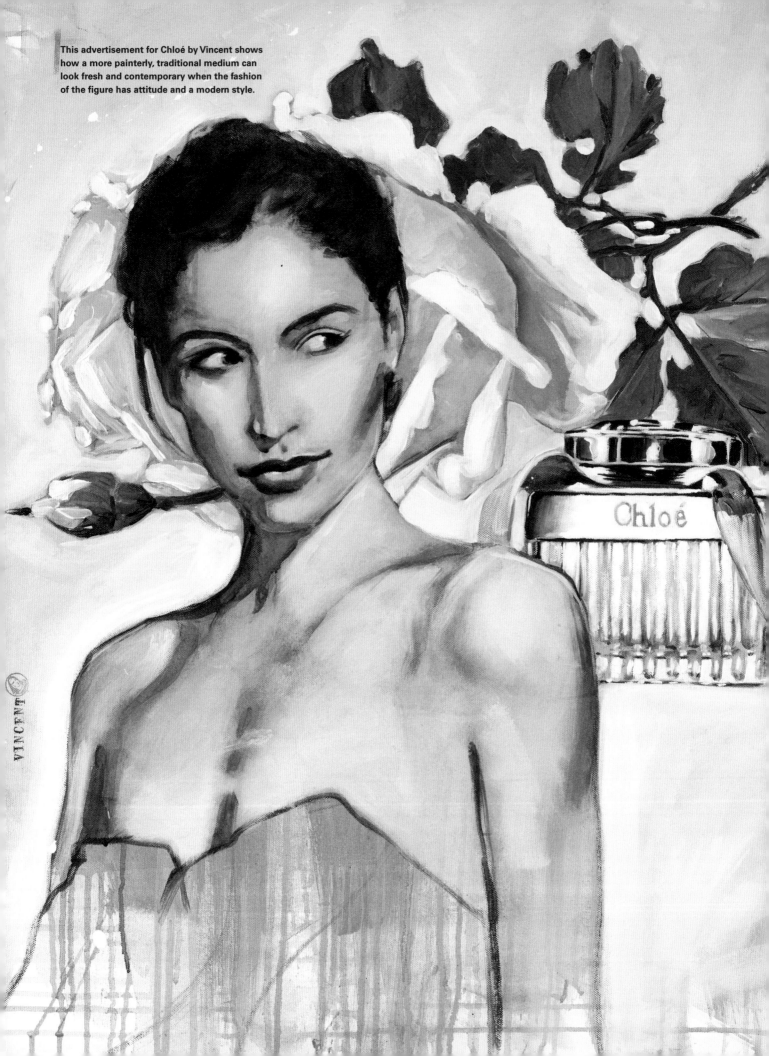

This advertisement for Chloé by Vincent shows how a more painterly, traditional medium can look fresh and contemporary when the fashion of the figure has attitude and a modern style.

DRAWING COSMETICS AND COSMETIC ACCESSORIES

There are multitudes of accessories within the cosmetic industry. These illustrations represent some of the challenges you may be faced with, and their solutions.

BRUSHES

When drawing brushes or wand applicators it is important to make them look luxurious. You should plush them up and play down the 'hairiness' of them. These blush brushes by Gillion Carrara are made with natural hair, horn, precious metals and woods, and are high-end art pieces. Remember in these cases that the ellipse increases in perspective as it moves away from your eye level. The mascara wand also gets a full brush feel. It was rendered on marker paper and then cut and pasted over the cylinder, which gives it its transparent art effect.

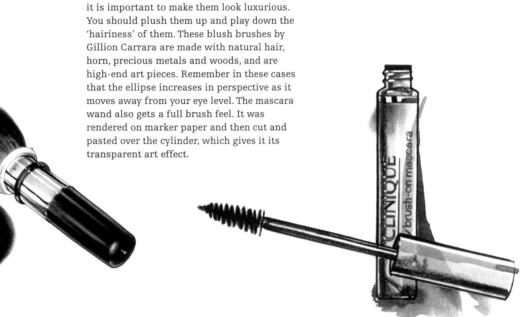

COMPACTS

When drawing compacts, it is best to show them open, for the obvious reason of displaying the choices the container holds. Colour matching is essential and in some cases you can, and should, use the actual eye shadow for your art medium. It will respond in a similar way to pastels.

LIPSTICK

All cosmetics need to be illustrated to look fresh and unused, but especially lipstick applicators. This stick is rendered in a looser style with charcoal and wash, and the colour was added in Photoshop to give it a cleaner, graphic feel.

LOTION TUBES

Lotion or make-up tubes should be drawn with a full, plump feeling. The looseness of this illustration was added in the rendering technique, while the outline was kept tight and controlled to keep the feeling of a brand-new product.

CHAPTER 6
JEWELLERY

The jewellery industry is a large and creative trade within the fashion accessory market. Everything from rings, necklaces, brooches, watches, pendants and bracelets, to royal crowns and sceptres falls under this heading. The textures and surfaces are extremely varied and fascinating to draw. Everything from crystal and organic stones to metals and rubber are used to stir up the senses of desire.

Although the uses for jewellery illustration are as varied as anywhere else in fashion, you will find the style most often used is one that is tight and very representational of the objects. The size and proportion of jewels dictates their price and wearability and this, combined with their hard physical nature, means that this area of illustration is not as open to exaggeration and stylization as others. For this reason you will notice that, although the media can be different and styles change, the samples here are all very realistic in execution. Jewellery designers and manufacturers tend to be even more concerned with accurate visual material description then clothing designers.

Illustrations are particularly helpful for post-production jewellery design because of the cost of the materials involved to execute a single piece. Drawings can also be used to better enhance a particularly detailed, or harder to photograph, piece. Flats or schematic drawings are also used to refine shape and proportions for manufacturing.

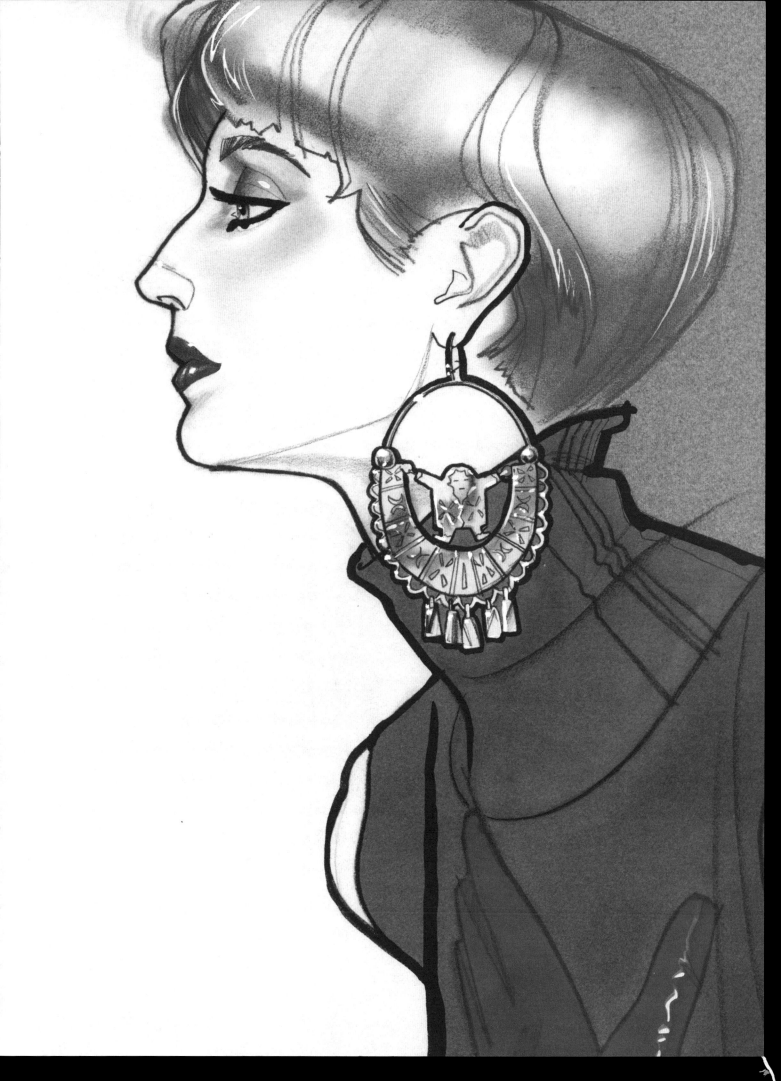

INTRODUCTION TO CUT STONE SHAPES

The cut stone shapes shown here are those most commonly used among jewellers. They are drawn with partial faceting to give you an idea of how to give the illusion of a cut pattern. They were drawn with straight edges and circle guides to keep their silhouettes crisp and hard. Most cut stones are basically cut with a centre point to optimize their reflective qualities.

The exceptions to this rule are the rectangular-cut stones such as the emerald, tycoon and baguette shapes. You will also notice a specific difference in how a square-cut stone is faceted. You will find that drawing with a solid outside edge and a more fragile, broken inside line helps create the depth and transparent look of clear stones.

Gems can also be drawn using a jewellery template (see p. 22).

Baguette Cuts

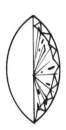

Marquise Cut

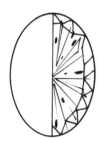

Oval Cut

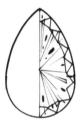

Pear Cut

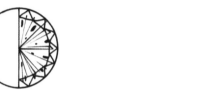

Round-Brilliant Cut

Square Cut

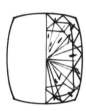

Cushion Cut

Emerald Cut

Heart Cut

Princess Cut

Tillion Cut

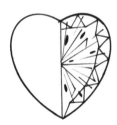

Tycoon Cut

DRAWING CUT STONES

When rendering cut stones it is imperative to capture the cut of the stone; for example, pear cut, square cut, brilliant cut. Obviously, the outside shape is most important, but the facet shapes also help describe the character of the cut. It is not necessary to illustrate every facet accurately unless you are working for a jeweller who is asking for a true diagram of the stone.

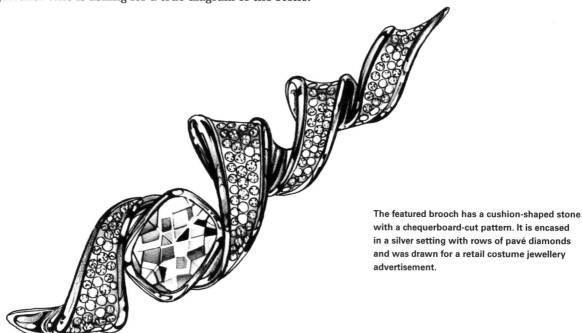

The featured brooch has a cushion-shaped stone with a chequerboard-cut pattern. It is encased in a silver setting with rows of pavé diamonds and was drawn for a retail costume jewellery advertisement.

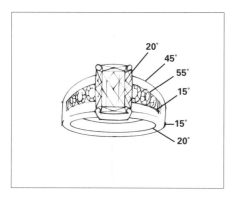

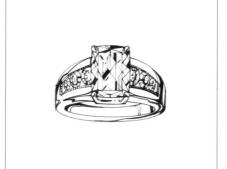

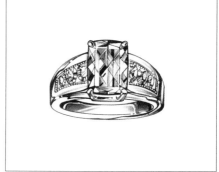

STEP 1

This step-cut emerald shows the perspective involved in drawing a commonly shown view of a ring. Begin with a pencil drawing on smooth layout bond paper. First draw a centre line for symmetry. The numbers indicate the different ellipse guides used to create proper curvature. French curves and triangles were also used to ensure the curves and edges were clean and straight. Notice that the facets are indicated and not exact and basically all head towards the centre point of the gem.

STEP 2

Draw over the pencil line with black ink. When you are rendering the gem facets, keep your lines straight, then when you use more expressive, flowing lines for the ring's reflective metal surface the difference will help separate the two. Once the inking is finished, erase the pencil lines of the preliminary drawing.

STEP 3

Add tone to the ring with a 2B graphite pencil and a tortillon, giving it gradations in the reflection and a feeling of depth. Fill in some facets completely and leave others soft. Erasing thin lines in some of the facets will give a feeling of shine. All this helps to express the way light moves through a cut stone. Add highlights using a small brush and white paint, filling in some facets with solid white to create a maximum sense of reflection and surface.

DRAWING COLOURED GEMSTONES

Coloured gemstones are a major part of fine and costume jewellery design. Keep in mind with any highly reflective item that you want to maintain a strong value contrast – black/darks to light/white.

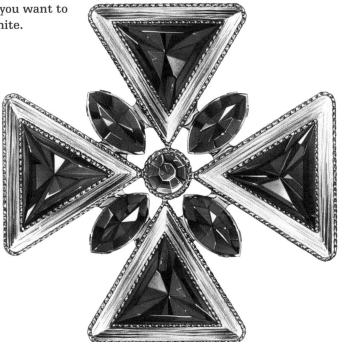

This large brooch was drawn for a costume jewellery promotion at a large department store. A fine-line black pen was used for the main outline and facet divisions. Coloured pencils were used for the rendering and gradations. Art markers were then used on the back of the paper to add the rich local colour. This piece is slightly more detailed than the step-by-step below because the original was used at a large size.

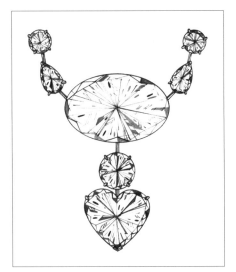

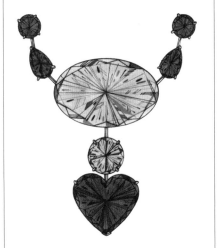

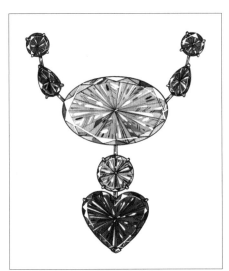

STEP 1

Begin by sketching out the gem shapes in pencil, paying attention to the symmetry of stone size and cut. You can draw the stone shapes and proportions on tracing paper first using templates and French curves to refine the shapes before copying them to the final paper. Outline all the gems with black ink. Then use coloured fine-line pens to help create the facets and reflections on the insides. Make sure the coloured lines are darker than the local colour of the marker you will be using, or your lines will wash out.

STEP 2

After finishing the facet lines and colouring in some smaller areas to indicate reflections, use art markers on the back of the paper to add local colour to the stones. The more gradation you add to the rendering, or create with the marker tones, the more depth your stones will appear to have.

STEP 3

Use a small amount of white coloured pencil to add some soft glowing highlights. Then add some hard-edged highlights with a small pointed brush and white paint. Keep most of the highlight lines running in the same direction as the facets. Make sure to fill in some solid white facet shapes on the top surface of the stone for surface reflection. If your edges get a bit sloppy with a brush, you can clean them up afterwards with a 6H (or harder) graphite pencil.

DRAWING PEARLS

Pearls are one of the more common and most fun objects to illustrate. They have a soft, glowing highlight and come in many colours and sizes. It is important to keep their shape, colour and size differences specific when illustrating them.

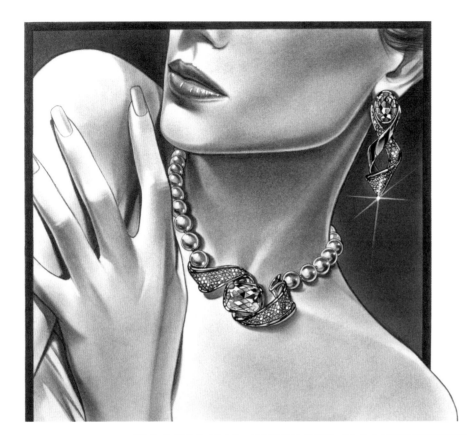

This necklace was featured in an advertisement for a large retailer. It was rendered on Bienfang Graphics 360 marker paper using a black fine-line pen with a 2B graphite pencil and a 40% warm grey art marker added to the background for contrast. Pro White paint was applied with a small brush for the highlights and the quasar, which is a good way to exaggerate the high reflection quality of a piece. Notice how the pearls diminish in size and overlap as they wrap around the neck – this is a common feature and needs to be carefully maintained in the drawing as it is a specific design characteristic.

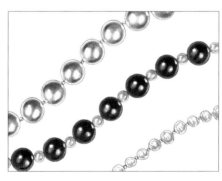

STEP 1

Begin with a light pencil guideline on which to centre your pearls. Then, using a circle template, draw the pearls lightly in place, ensuring that the spacing and overlapping areas look natural. Either draw directly on your illustration or do an underdrawing if your paper is translucent enough. Leave room in between the pearls for the knotting. Then outline the pearls with a 005 fine-line black pen. The freshwater pearls on the bottom were drawn by hand for a natural, uneven look.

STEP 2

A graphite pencil was used for the white pearls, focusing the darks more to one side and keeping the highlight edges soft. The pencil edge was blurred using a tortillon. The pink pearls were given form with a warm grey coloured pencil, as were the freshwater pearls.

STEP 3

Finishing was done by adding an art marker tone behind the black, pink and freshwater pearls for added unity of colour. A white coloured pencil was used for the highlights to keep them soft. Then, a spot of Pro White paint was added to bring out the reflection of the hard surface.

DRAWING PAVÉ

Pavé is a setting of gemstones where there is little to no metal showing in between the gems. It is a design element found throughout all categories of jewellery, including evening bags. The stones can be clear, as featured here, or coloured, set in a pattern similar to a mosaic in effect. The most obvious danger in drawing pavé is letting it become so confused with detail that it abstracts the accessory design. Although your choice of medium and style may vary, the principles given here for a successful illustration will always be true.

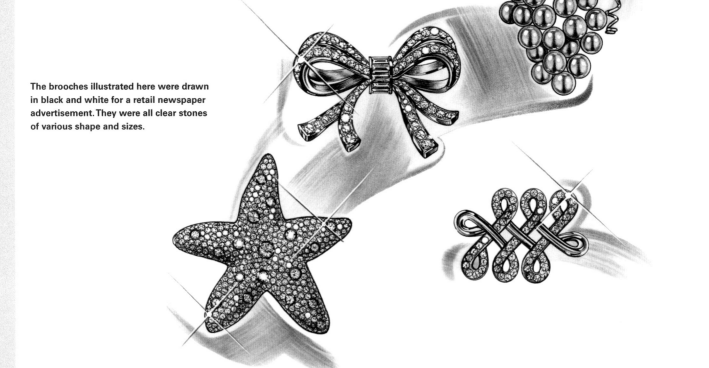

The brooches illustrated here were drawn in black and white for a retail newspaper advertisement. They were all clear stones of various shape and sizes.

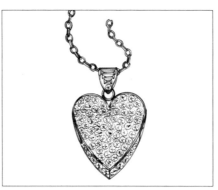

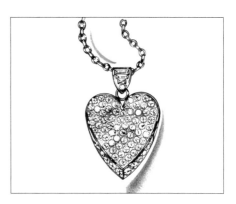

STEP 1
Draw your object on tracing paper, including the proportions of the stones. Then transfer the drawing to marker paper using a fine-line black pen with a circle guide so the edges of the gems are obvious and solid. Keep the stones as tight as possible to each other, making sure they do not overlap. On the visible sides of a piece, or a dimensional piece, ellipse the shapes of the stones so your perspective does not flatten.

STEP 2
Using hard graphite pencil (3H) add the prongs (small circle shapes) in between stones. Use a pencil rather than ink so it does not compete with the silhouettes of the stones or become over-rendered. Add small star shapes in the centres of each stone. Some are complete; some are just dash lines. Float the stars in the centre of the stone rather than touching the edges when possible. This will also help to keep the stone shapes more dominant in the drawing.

STEP 3
To finish the surface of the pavé texture, use white paint and add small dots of light inside various stones. Be careful not to break the edges of the stones. This will keep the surface from becoming too abstracted. To add more bling and reflection, white out a few tops of the stones. Note that you can also make more contrast by toning in a gradation between a few stones with pencil.

DRAWING RINGS

When drawing high-end accessories it is sometimes necessary to go to the client or store and photograph the objects because they are too valuable to be lent to you. Photography also comes in useful when the objects are unusual in shape or character – as with these rings by metalsmith Gillion Carrara.

When photographing objects to draw, use a contrasting background and watch your lighting and perspective. You will need to take several shots to make sure you get all the necessary details of each piece.

This illustration was used for a promotional booklet that the artist leaves behind with the client/buyer for future orders and presentations. The drawing style involves tight rendering because the artist does not want any misinterpretation of her designs by the viewer.

STEP 1
Begin by sketching out the rings in pencil. This can be done on a piece of tracing paper placed over a print or copy of the photograph you took. Using a circle or ellipse template, draw the outlines of the objects in black ink to give a strong and hard edge. Keep the connections between your lines clean. Begin to add some of the black reflections into your metal areas if applicable. Then start to block in your shadowing using a graphite pencil.

STEP 2
After completing your rendering, add art markers on the back of the paper to separate your pieces and add contrast. This is also the time to put any texture or print on your objects, such as the wood grain featured on these rings.

STEP 3
Finish the rings using Bleedproof White paint for the hot reflections and a white coloured pencil for the softer, glowing highlights.

If you look at the final illustration you will notice that some changes have been made to the upper right ring. An ebony wood peak was added with a cool grey marker to the back and it was moved up a bit to separate it from the other rings. This was done in Photoshop. You will also notice that the perspective on the T-bar ring was changed to give it a clearer reading. It is your job to find the best possible way to draw an object to enhance its appearance.

DRAWING FLAT GOLD AND SILVER NECKLACES

Gold and silver are the most common metals you will illustrate for jewellers. The more reflective the metal, the stronger contrast between lights and darks you will need to render. Brushed metals also have softer reflections.

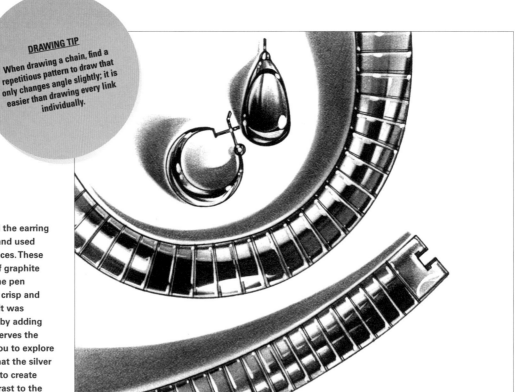

DRAWING TIP
When drawing a chain, find a repetitious pattern to draw that only changes angle slightly; it is easier than drawing every link individually.

These gold and silver necklaces and the earring set were drawn for a retail jeweler and used to promote large flat-banded necklaces. These pieces were rendered using a mix of graphite and charcoal pencils. A black fine-line pen outline was used to keep the edges crisp and hard. When the piece was finished, it was scanned into Photoshop and tinted by adding colour overlays. This technique preserves the original art design while allowing you to explore different colours or finishes. Note that the silver necklace has a touch of blue added to create the cool feeling of the silver in contrast to the warmth of gold.

STEP 1
Begin with a light pencil drawing of the shape. To get the proportion and pattern correct, scan or photocopy the necklace. Establish the pattern, and then begin to ink in your final lines. First draw your outer edge, then add the inside divisions. Use a plastic triangle to keep the lines clean and even, and an ellipse template to keep the curves and lengths even.

STEP 2
Using a soft graphite pencil, add your darks, keeping them flat and gradating softly. Notice the 'edge' feeling maintained using a thin line and an erased line. For the twisted and the chain-link necklaces, a pattern was drawn from dark to light, keeping the darks focused on one side of the link forms and pushed into the recesses. Some rendering patterns were added outside the objects to highlight the approach.

STEP 3
To finish the gold chains, add some warm yellow tones on the back of the paper using art markers. To add highlights and clean up any rough edges along with the chain-link negative spaces, use Pro White paint. Note the simple and repetitious highlight 'dot' patterns. This clean, simple way of applying highlights will ensure a hard, reflective surface without overworking the small details of a fine piece of jewellery.

DRAWING GOLD CHAIN NECKLACES

Chain necklaces present a challenge because of their intricate nature. The style demonstrated here is a more detailed way to approach them, which you can loosen up as you feel necessary. This style would be suitable for a production presentation or retail advertisement.

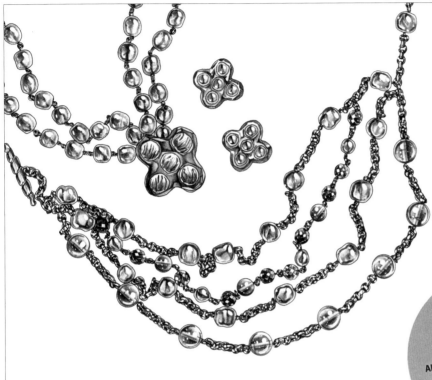

This necklace of chain, pearls and glass beads was used in a newspaper advertisement for a retail client. Like most jewellery art, it was necessary for it to be strictly representational. Because it is a free-standing necklace (not on a figure), it was photocopied. This method helps simplify and speed up the drawing of complicated items. A light table was then used to refine the underdrawing and transfer it to the final paper. It was drawn on Bienfang Graphics 360 marker paper using a fine-line black pen for the outline and then rendered with graphite pencil to add contrast. Highlights were added with white paint to give a sharp reflective surface.

DRAWING TIP
Always keep in mind a light source from one side of your object.

STEP 1
Make a preliminary drawing on marker paper using a medium-hard pencil (HB) with light hand pressure to see how the links twist and combine in proportion to one another. Erase the pencil line once the ink outline is complete. The top necklace was drawn using small ellipse guides. The other necklace samples were drawn freehand using a repetition of edge lines and shapes along a pencil guideline.

STEP 2
Use a fine-line pen to make the reflective darks on the insides of the links. Again, notice the repetitious nature of these marks. By creating a pattern of darks you will maintain clear definition within the details. Use a soft graphite pencil to add some tone to the links. Try to keep this rendering repetitious, and use it to produce a sense of gradation in the reflection.

STEP 3
To finish off the pieces, add some art marker on the back of the paper. With this technique it is easy to distinguish between gold, silver or copper. Once the marker is dry, use white paint to add the hot highlights that are characteristic of metal. Notice that the highlights are also done in a repetitious manner. This stops the piece from becoming abstracted with over-detailing or over-rendering.

DRAWING EARRINGS

Earrings come in all shapes, sizes and materials. One important feature to show when illustrating them is the clasp or ear attachment piece on the back. There are hooks, posts and a variety of clamp-style attachments, and at least one earring in a set should be drawn with a perspective clearly showing which kind is being used. The step-by-step below was drawn with coloured pencils on toned paper. This is a very popular technique with jewellery designers for presentation art. It allows you to work with both lights and darks at the same time, leaving the middle tone of the paper as your base. It also makes it easy to create dramatic highlights.

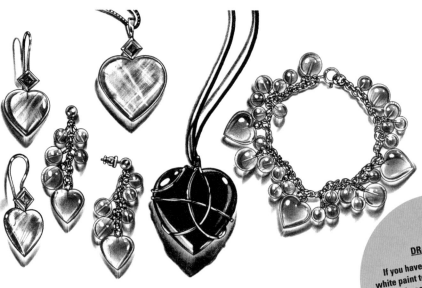

The pieces in this crystal set were rendered in black and white using graphite pencils. The art was scanned and the individual gradations changed into colour using the colour hue adjustment tool in Photoshop. By masking shapes in groups and locking all the surrounding shapes out you can adjust all matching colour shapes at the same time, as in the case of the gold chains.

DRAWING TIP
If you have trouble getting your white paint to stick to your coloured pencils because of wax build-up, try spraying your work with a workable fixative to give it a slight texture.

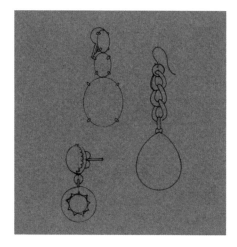

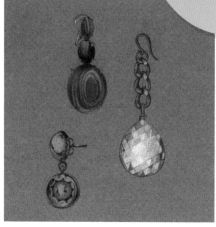

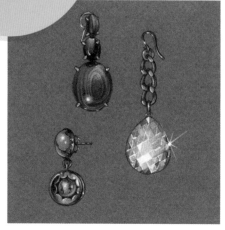

STEP 1

Begin with a line drawing on tracing paper. Use circle and ellipse guides on a centre line to keep the shapes symmetrical and edges hard. Photocopy the drawing onto a piece of medium grey drawing paper. This is a useful technique if the paper you are using is too thick to see through on a light table. Because the black lines are toner ink, they can usually be erased easily should you need to make adjustments.

STEP 2

Using soft-core coloured pencils, begin to add gradations and tones both in light and dark. Try to save the white colour until the very end. Always look for the 'colour' in the lights as well as the darks. Gold and silver coloured pencils are a fun novelty, but they will not reproduce as metal colour if your art is going to be printed. The gold colour here was created using various yellows, browns and oranges.

STEP 3

To finish the surfaces of the stones, burnish over the lighter areas with a white coloured pencil. This not only lightens reflective areas but also helps to blend colours together. The last thing to add is some white paint for the final 'points' of light. By adding a soft gradation with a white pencil first, you will achieve a soft, glowing effect to the highlights. Add a quasar to a stone to give it some bling.

DRAWING SUNGLASSES

To add drama or character, or to accentuate the summer season, sunglasses or glasses are fun accessories that communicate a style moment quickly. There are basically three important points to watch for when drawing glasses: the symmetry of the lens, the perspective and angle of the arms (especially if they are drawn on a face) and the fit or placement on the face.

The perspective examples below were all drawn with a water-soluble Tombow pen and then dissolved using clear water and a pointed watercolour brush. The colour was added with various coloured Tombows and then white paint was added for reflection. Finally, a fine-point pen was used to even out and refine some vague areas.

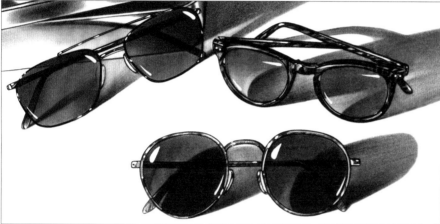

These glasses were drawn with graphite pencil and then tinted using Photoshop. They were for a Guess newspaper advertisement and needed to be very specific in detail.

DRAWING TIP

Profile views are usually impractical for eyewear because you cannot see the lens shape adequately.

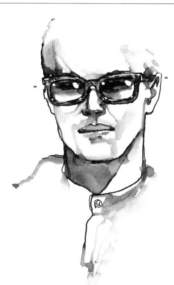

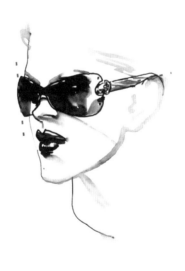

STRAIGHT-ON VIEW
The straight-on view is the most challenging pose to choose, both on and off the figure. It is important that the lenses are perfectly symmetrical, both in size and shape. Notice how the upper eye line is even with the temple line of the head. Most eyewear temples and the bridge sit evenly on this same line. The eyes usually sit in the upper quarter of the lens.

THREE-QUARTER VIEW
The three-quarter view enables you to look for the difference in the ellipse of the lenses, making them easier to compare and draw. Watch for the arm angle from the lens to the ear; typically the ear is level with the temple, but depending on the thickness of the arm and the height of the ears the arms may rise or fall. The arms should appear to 'rest' on top of the ear. There is usually a slight back angle to the lens as it moves lower on the face.

REFLECTION
No matter how clear the lenses are, it is important to finish with a sense of reflection. Notice the repetition of the white reflection, which helps to create symmetry as well as surface.

DRAWING WATCHES

Watches are one of the more intricate accessories you can be called upon to illustrate. The two most distinctive features of any watch are the face and the band.

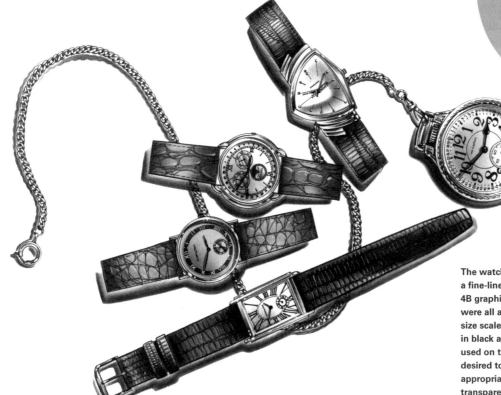

The watches featured here were all drawn with a fine-line black pen for the faces and 2B or 4B graphite pencils for the bands. The bands were all alligator skin, but showed different size scales. After the rendering was completed in black and white, a cool grey marker was used on the back of the paper to achieve the desired tone. The bands were then tinted the appropriate colour in Photoshop using the transparent fill tool.

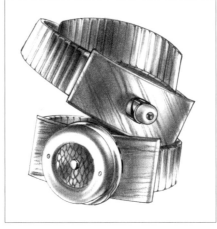

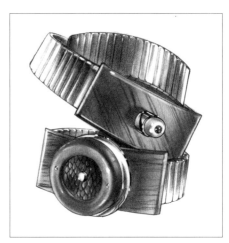

STEP 1
Begin with a loose sketch for proportion and layout. Notice the centre front crosshair lines used to keep the perspective centred. These contemporary watch band bracelets by Gillion Carrara were worked from a photograph to capture the right perspective.

STEP 2
After refining the underdrawing for accuracy, draw the outside line with a fine black pen, such as a Micron 00 or Prismacolour 005 pen. Once the linework is finished, begin to lay in the values.

STEP 3
Once the rendering is finished, add a 40% grey marker to the back of the illustration to deepen the wood tones. The final step to finishing involves adding highlights with Pro White paint and a small round brush. Highlights will give the metal a sense of surface and edge. Notice the dot-like character and repetition in the reflections; this adds to the symmetry of the watch band and is common with a single light source.

RENDERING CRYSTAL AND WOOD

On occasion there may be a need to illustrate crystal or wood as the primary materials on an accessory. These contemporary pieces are the work of metalsmith artist Gillion Carrara and posed the challenge of having to be very specific with values and textures to capture the unique character of the materials used. These pieces were commissioned for the artist's promotional booklet and were drawn using the marker and line technique described throughout this chapter.

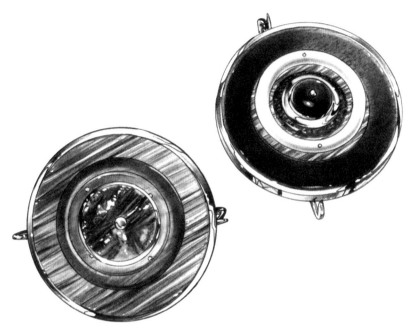

WOOD

The two brooches were a combination of silver, ebony wood, turtle shell, horn and briar root. The specific materials were described in the text of the booklet,
but the illustration still needed to express each material's individual identity. Notice the wood grain patterns (more linear) as well as the subtle turtle shell (more speckled).

CRYSTAL

The lead crystal pieces were drawn with a fine line black pen; then soft tones were added using a tortillon and graphite pencils. Notice the flow of the reflections. Try to avoid sharp, straight lines, which are more reminiscent of cut crystal. The transparent quality of the crystal cuff was emphasized at the point where you can see through the top to the right-hand side. The dark areas were also emphasized in this overlapped area to add as much form as possible. After all the rendering was finished, white paint and a small brush were used to add some free-flowing bright white reflections as well as some surface bling. Charcoal and a 60% cool grey marker tone on the back of the paper were used for the opaque glass rings to help give a smooth, non-textured finish.

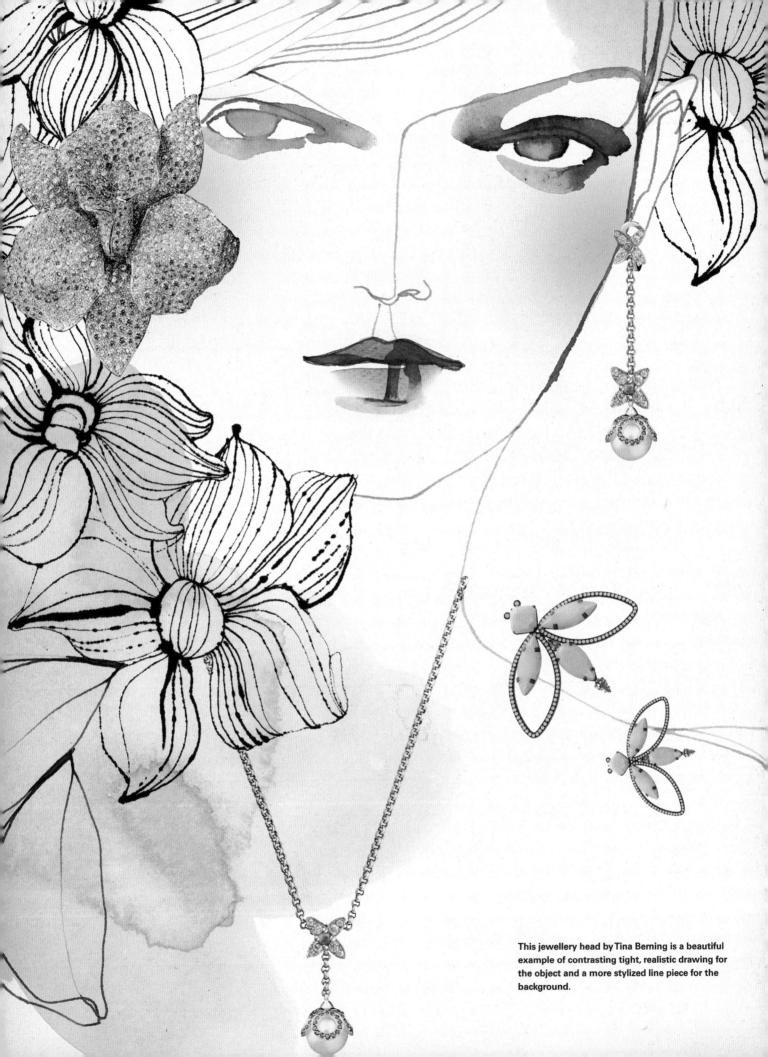

This jewellery head by Tina Berning is a beautiful example of contrasting tight, realistic drawing for the object and a more stylized line piece for the background.

GLOSSARY OF JEWELLERY TERMINOLOGY

There are endless names for jewellery settings and findings. This glossary is designed to give you a foundation in the vocabulary used to refer to some of these basic elements. The names of the most common gem shapes are listed on p. 148.

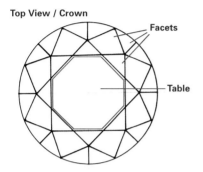

Top View / Crown — Facets, Table

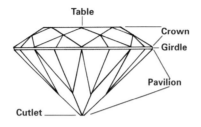

Side View / Brilliant Cut — Table, Crown, Girdle, Pavilion, Cutlet

Bottom View / Pavilion — Facets, Cutlets

A JOUR: The opening in a jewellery mounting that allows light to pass through the gem.

ALLOY: Two or more metals mixed together.

BANGLE: A non-flexible bracelet.

BRILLIANT CUT: A specific cutting style most often used for diamonds, consisting of 58 facets, also known as 'modern cut' or 'full cut'.

CABOCHON: A stone with a smooth carved surface, domed and unfaceted with a flat-sided base.

CAMEO: A stone with a positive relief carved into it.

CARAT: The unit of weight used for precious stones.

CASTING: The process of forming an object by pouring a molten metal into a mould until it solidifies and takes on the impression of the mould.

CHANNEL SETTING: A row of stones fitted into a metal channel.

CHASING: Working a design or pattern into a metal from the front using a hammer and/or punches.

CULTURED PEARL: A pearl created by human intervention when tissue is implanted in a host oyster.

FACET: The cut, ground and polished surface on the pavilion of a gemstone.

FAUX: An imitation of the real material, such as paste gemstones for costume jewellery.

FILIGREE: Wire twisted into patterns, then usually soldered to a base of metal or twisted to form an openwork pattern.

FINDINGS: Small tools and materials used in jewellery-making – wires, clasps, hooks, pins.

FRESHWATER PEARLS: Pearls found in freshwater sources that typically have oblong shapes.

GEM/GEMSTONE: A piece of attractive mineral or organic material used in jewellery-making.

INTAGLIO: A stone with a negative relief carved into it.

LAPIDARY: Gem cutting.

LOST WAX METHOD: A method of casting metal that uses a wax shape (ring) to make a plaster mould. The wax melts away or is 'lost' when the mould is filled with molten metal.

METALSMITH: A person involved in making metal objects such as jewellery or accessories.

NATURAL PEARL: A pearl that is formed naturally, without human intervention.

PAVILION: The lower part of a cut gemstone below the girdle.

PRONGS: The small metal arms or beads that hold a gemstone in its setting.

SHANK: The hoop part of a ring.

The parts of a cut gemstone are as follows:

CROWN: The faceted border of a cut stone.

CUTLET: The very bottom tip of a cut stone.

FACET: The cut, ground and polished angles on the pavilion of a gemstone.

GIRDLE: The widest part of a gemstone that divides the crown and the pavilion.

PAVILION: The bottom portion of a faceted stone.

TABLE: The flat top of a cut stone.

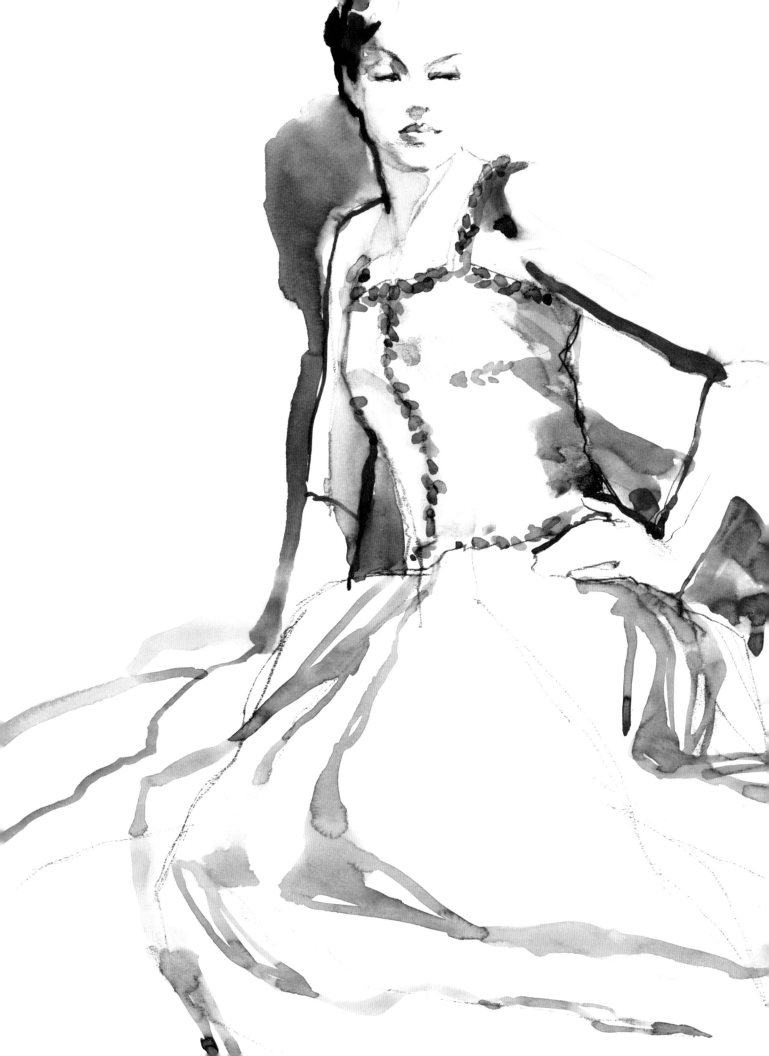

CHAPTER 7
FASHION
FIGURE
DRAWING

A fashion illustrator must be able to create the ideal figure for any given design or concept in clothing. Fashion accessories would not have much presence if it were not for the display stand of the fashion figure supporting them. This chapter will give you the principles for adjusting the human form to accentuate any fashion accessories you may be called upon to execute. Fashion illustration is one of the few areas of art where rules matter, because they communicate age, character and style, not to mention the designer's intent.

INTRODUCTION TO BASIC PROPORTION

Figure proportion should always be subject to the needs of the particular accessory, garment or action of the body. The following proportional breakdown will give you a starting point to create an ideal figure. In life drawing, the figure's proportion is commonly seven and a half heads tall. In fashion illustration we stretch the figure out to eight and a half heads, giving us a taller figure that is in tune with an ideal figure for fashion and accessories. Some illustrators stretch their figures to nine, ten or even twelve heads high. The proportion shown here is more conservative because accessory illustration is not as open to fantasy as garment illustration can be.

The proportional height sections of the female and male figures are basically the same, with only a few distinctive differences, listed below, that give them immediate gender recognition. The following proportions are meant to communicate a typical adult figure and are based on general body types. To draw your figures smaller in proportion will result in a different kind of figure, i.e. petite, junior or even a child. It is also usually necessary to thin your figures down a bit from a natural weight, or they will appear to be plus sizes, which is a separate fashion category.

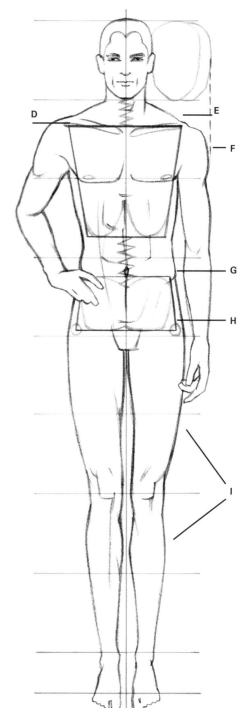

DIFFERENCES BETWEEN THE MALE AND FEMALE FIGURE PROPORTION

A female's shoulders will be about the width of a head or less. An adult male's shoulders will be a head and a quarter wide. Men's shoulder width should have a more triangular shape than females' (D), and a female's shoulders should always be kept narrow in relation to her hips.

Males will have more bulk as well as definition in their muscle tone, especially in the neck (E) and shoulder (F) area. They are generally bigger-boned and have a straighter, less curved waist area then a female (G). Because the male waist tapers right into the pelvis, there is not as much curve in the hips. A male's pelvic bone was not created to give birth, so it is narrower then the female's (H). A male's leg muscles should obviously be more bulky (I).

Although female hands and feet were typically small and delicate in the past, our culture now holds a different image of a woman. Hands, from the wrist to the tips, should be about the size of a head. Larger hands will communicate a stronger and more confident person. Smaller hands can seem frail or weak. Feet, when viewed from the side, should also be about a head size. Both hands and feet on males should be larger in size and angular. When drawing men and women together, you can lengthen the male's legs slightly to make him taller.

1 Begin with the head size (top of the skull to bottom of the chin); the head size is the standard for relating all figure sizes and ages.

2 Adding one head will bring you to the point where the underarms enter the upper torso. It is right above the nipple line of the female's breast. This head includes the neck (which is usually stretched a bit) and shoulder thickness.

3 The third head brings us to the waist of the figure, or the navel. It is also the first section where you begin stretching out the figure. Adding about a quarter of a head size will open up the mid-torso and add height to the upper figure. This is essential for a design area as well as visual comfort for the figure. You will also need to stretch your upper arms out a bit to bring the elbows even with the waist. If the arms are extended away from the body, use an axis line to maintain the right arm length.

4 The fourth head brings you to the crotch of the figure – the area where the legs enter the torso. All design really takes place within these first four heads; everything below the crotch is simply length – micro-mini, mini, mid-thigh, above the knee, below the knee, and so on. As long as you maintain the integrity of these four heads, you can lengthen the legs as much as you desire and your illustration will always seem to relate to an actual human figure. The crotch is also even with the wrist length (slightly above the thumb joint) (A).

5 Five heads down brings you to the mid-thigh, an important proportion when it comes to blazer and jacket length. It is also the proper location for the fingertips to hit.

6 Six heads should bring you to the knee.

7 The seventh head does not have as specific a marker as the others do, but comes to about the bottom of the calf muscle (B).

8 The eighth head takes you to the ankle. Note the inner ankle bone is higher then the outer ankle bone (C).

8.5 A half head brings you to the floor and includes the foot with a medium-heel shoe height.

The extra three-quarters of a head to stretch the figure to its eight and a half head height is added equally between the fourth and eighth head. If you draw a more exaggerated figure with longer legs, keep the bottom portion of the leg (knee to ankle) longer than the upper leg (crotch to knee). Because the ankle flows right into the foot, this section of the leg is longer and should always appear to be so.

GESTURING THE FEMALE FIGURE

Besides proportion, gesture is another powerful factor that an illustrator can manipulate to give a fashion figure visual impact. It is easily accomplished by breaking the figure down into two main box forms, to represent bone structures. The upper box (A), goes from the deltoid muscles down to the bottom of the ribcage. The lower box (B) is the pelvic bone. These two boxes cannot change their shape. They are joined together by the spine, which goes up into the back of the skull. The body moves by the boxes pivoting against each other as they swing on the spine.

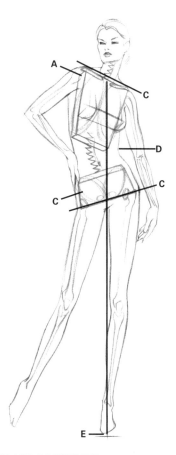
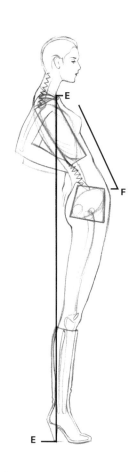
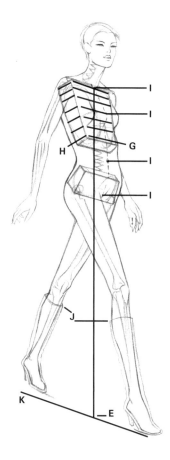

FRONT AND BACK POSES

In a frontal (or back) view, the gesture to watch for is the shoulder and hip juxtaposition (C). As the weight of the figure is transferred to a primary leg, it pushes the pelvic bone up while the shoulders bend downward to balance the weight. It also causes an equal and opposite reaction on the other side of the figure. There is also a crunching on one side of the figure (D), balanced by a stretching on the opposite side. It is important to establish the centre of gravity. On a standing figure this falls directly from the throat to the floor. Draw a plumb line along this line. The foot supporting the most weight of the figure (E) should be at its end.

SIDE POSE

Consider the depth of the boxes. The upper box is wider at the top from both front and side because it includes the shoulder blades and deltoid muscles. The pelvic box is the opposite, wider at the bottom, narrow at the top, especially for the female form. In a side view, look for the pelvic thrust forward (F). The upper torso continues to move outward under the breast towards the pelvic bone for both male and female figures. The plumb line is still under the throat, which means the legs need to come back under the neck to balance the figure (E).

THREE-QUARTER POSE

In a three-quarter view it is essential to consider the breadth of the boxes and think about two sides at once (G) and (H). Observe the centre front of the figure (I), which consists of the centre of the throat, centre of the breasts, navel and crotch. The upper box leans back because of the natural outward angle of the upper torso, while the lower box angles back to the crotch. Keep this in mind when considering how clothing wraps around the body, shown here by the boot tops that curve in different directions (J). As with any pose in perspective there will be a higher/lower foot. Keeping this perspective will ensure your figure moves comfortably in space. If you draw both feet as flat side views they will not be consistent with the hips and will look awkward (K).

GESTURING THE MALE FIGURE

Gesturing the male figure based on his box structure works very much the same as it does with the female. There are two obvious differences to keep in mind. First, the male's upper box is always broader in the shoulders than a female's. There is much more of a triangular shape to his upper body (A). Second, the male's pelvic box structure does not have the extreme width at his hip bones as the female (B). Notice also that all the figures have the same centre of gravity or plumb line from the centre of their throats straight down to the floor where the most weight is being distributed (C).

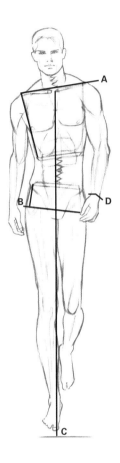

WALKING POSE

Watch for the natural juxtaposing angles of the shoulders and hips as the figure's weight shifts back and forth to the foot that has the most load on it. The weighted hip is pushed up while the corresponding shoulder is pushing down. The balancing foot will always be below the centre of the shoulders (C). As the arms swing with the motion of the strut, one will come more forward, the other back. Watch this perspective when drawing so their form keeps its proper perspective (D). The unweighted leg is lifted from the bottom of the knee and must be foreshortened. This will cause the foot to be seen as a top view, its length about one head size in proportion.

SIDE VIEW POSE

Make sure the neck comes forward out of the shoulders not straight up out of the top of them (E). This will keep your figures looking relaxed. The upper torso of a male angles forward as it moves down to the pelvis, just as for the female. Draw a male's torso outward to the top of the pelvic box bearing in mind that a male's gesture is typically not as extreme as a female's (F). Watch that the foot direction points the same way as the knee (G).

SEATED POSE

Keep your eye on the body proportion. It is easy to make the upper torso too short between the shoulders and crotch. Watch for the angles in the body as it sits or leans (H). Avoid drawing straight verticals and horizontals in your figures, as they will tend to make it look stiff. As the body leans back and the pelvis is pushed forward, you will see more of the bottom of both the top and bottom boxes (I). You should also note that this forward gesture pulls the buttocks under the figure (J) so they do not protrude at the back. Watch for the centre front of the figure (K).

DRAWING SHAPE

There is no greater tool to assist in drawing than the ability to see shape. It is a method of observation that will help you successfully approach and interpret even the most difficult subjects. This lesson will help you understand the process of observing and drawing shape.

Shape drawing is not merely contour drawing. It is not dealing only with edge, but with forms in space and how those forms relate to each other. It is a way of comparing angle, perspective, curves and volume to arrive at the accurate proportion and character of a subject.

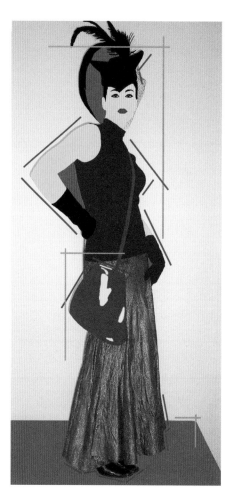

THE POSE

It does not matter if you have an accessory, a figure or a cityscape in front of you; seeing shape will allow you to see relationships in space and draw them with confidence and accuracy. Rather than looking at this figure as an abundance of details and textures, begin by breaking the figure down into graphic, coloured silhouettes.

GRAPHIC SHAPES

Imagine the shapes as solid colours, observing the specific characteristics of their edges – the smooth surface of the skin contrasting with the broken fluff of the feathers' edges, for example. Compare all edges, angles, curves and gesture (red lines) to the strict horizontal and vertical lines (green lines). Look at negative space shapes surrounding the figure (magenta areas). Negative shapes help with checking angles adjacent to areas like arms and legs. By focusing on an object's shape, you can

edit out all of the unnecessary gathering or wrinkling that will clutter the garment and distract from the designer's intent. Only draw shapes that are completely enclosed. Do not draw folds and wrinkles, but try describing the interior of the garment only by what you can observe on the exterior. Sometimes it is better to isolate shapes, like the foreground glove separated from the bodice; at other times you can combine shapes like the hair and hat.

DRAWING SHAPE

Begin at the top of your page so you can include as much of the figure as possible. Use a large enough pen size that you will not be tempted to sketch or get too detailed. Draw one solid shape – the hat or the hat and head together. This first shape will dictate the proportions of all the remaining shapes. As you draw, keep your eyes more on the object of study than on your work, only looking at your piece to check your progress and the relationships of the shapes. Remember, accurate observation is the goal – better shapes are more important then more shapes. After drawing your first shape, draw the next shape, comparing your angles, proportion and size to your first shape. Continue to draw down the figure, comparing its shapes, angles and proportion with horizontal and vertical lines. You should be drawing shape to shape. Do not fill in your shapes, as that will cause some shapes to dominate and overpower the form and unity of the line drawing. You do not have to draw a line around every shape, but combining some shapes as you draw down the figure will simplify the details while still producing a solid, powerful image. This technique can also be used to produce preliminary drawings for more elaborate works. Once your large shapes are completed, you may want to go back and draw some shapes within shapes using a smaller line weight, as shown here with the hat netting.

USING SHAPE

Once you have learned to see shapes in space, practise drawing them using your favourite media while concentrating on expressive line quality to enhance them. Try drawing the most extreme contrasts in value you can achieve with the medium as well as your hand pressure or gesture – light and fragile line versus bold and dark. It is still not necessary to draw a line around every shape, but by using shape your hand has the freedom to confidently bring life and emotion to your linework, while still maintaining solid form.

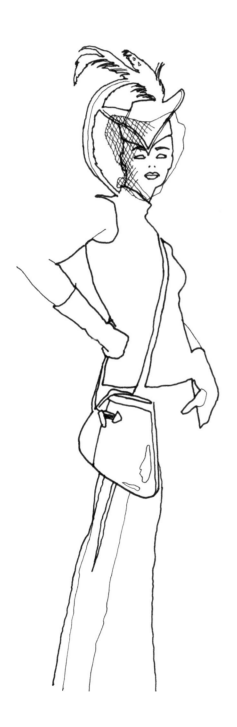

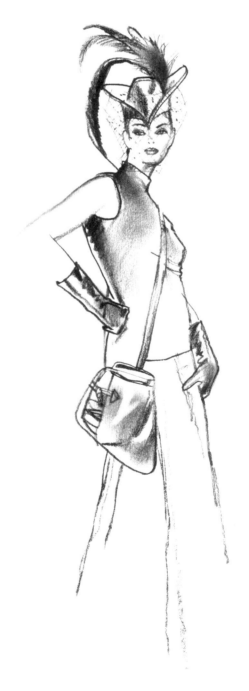

DRAWING THE SILHOUETTE

Fashion begins with silhouette, so it makes sense to begin your illustration with that same consideration. Illustrating fashion is not just about the basic clothing style, but the ideal image of what the designer had in mind. If you begin by studying the silhouette of the garment, it will give you the foundation upon which to build your exaggeration and fantasy styling, while still holding true to the designer's intent.

When having a model pose in a garment, encourage them to bring the character of the ideal wearer to life. It is your mission as an illustrator to perfect the image of the garment along with the character of its patron. Pin it, clip it, tuck it in and fluff it up to make it fit correctly and present its quintessential personality. Consider what features need to be focused on or emphasized in the garment. Be aware of hand gesture, foot perspective and overall body posture and pose, all of which can help or hinder in bringing the garment to life.

This silhouetted image was drawn on watercolour paper with a hard graphite pencil. The earring and martini glass were masked out with a masking fluid. Then a wash of clear water was put down over the entire surface of the paper to give the paint a vehicle to move around in and blend together. Immediately after the water had soaked into the paper but not dried, a wash of diluted paint was added. A little salt was sprinkled on the background while it was still wet to give the starburst effects. After the first layer of watercolour was completely dry, the solid silhouette of the figure was painted in with

slightly diluted watercolour. When the figure layer was dry, the defining detail shapes were added into the hair, cape and skirt with undiluted colour. When drawing a garment that is mid-calf in length or longer, it is wise to proportion your figure to nine or nine and a half heads tall, which will ensure it does not end up looking like a petite figure. After the surface was completely dry, the masking fluid was rubbed off to reveal the bright white paper. The background lines and shapes were added last to connect the figure to the page.

Silhouettes can be soft-edged, as with this feather-trimmed jacket. The face and gloves were protected by masking fluid, then the paint was added to a very wet surface. This technique of working wet into wet created the soft transitions of colour and draping in the garment. After the piece was dry, some black pastel was added with a cotton bud to make the blacks a deeper tone. Because pastels are basically dry pigment and go down with a matt finish, they are almost undetectable on watercolour. They can also be used for defining edges or punching up shadow tones so you do not overwork your painting with brushwork.

These small silhouette studies were painted directly on dry paper with a small brush and concentrated watercolour. The smaller a figure is, the more important it is to exaggerate gesture so it does not become a rigid form. This exercise is also a powerful tool for practising extreme gesture in your figures.

DRAWING SHADOW

Shadows are key to showing the form of any object or figure. Even when you are working in a looser style, it is important to indicate a light source to give dimension and movement to the garment. The more you accentuate the shadow contrasts and gradations, the more realistic your piece will become. There are basically two types of shadows: form and cast. The third element, which sometimes needs to be considered, is highlight. To achieve extreme structure it is necessary to exaggerate all three.

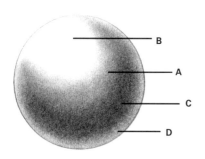

FORM SHADOWS

Form shadows are the shadows that happen as light moves across the surface of a form. Their main character is that they have soft edges. When starting, first establish what is shadow (A), and what is light, or local colour (B). Once you have established the shadow shape you can add depth and increase form by adding a core (C). The core of a shadow happens when light can no longer reach around a shape and can also not be reflected back around on it from the surfaces surrounding it. The core is the darkest area of a form shadow. The core also helps create a reflected light (D). A reflected light should never be as bright as the light area of the form. It is a secondary shadow tone.

CAST SHADOWS

Cast shadows occur when light is blocked from one object by another. It is the same principle as the shadow puppets you make with your hands by blocking the light cast on a wall. Cast shadows have more strict, harder edges. They are also darker at their base (E) or starting point. They soften slightly in shape and tone (F) as they move away from their source because of atmospheric light. They are a powerful tool to use for separating figures from a background or one object from another. The cast shadow intensifies the reflected light on the sphere.

HIGHLIGHTS

If you are drawing a reflective fabric like satin or patent leather, you will also need to consider a highlight. This sphere was finished by adding a warm #2 art marker to the back of the paper, which then became the local colour of the object. A highlight with white pastel was added, keeping it soft on the edges to give a glowing feel (G). This technique will give you ultimate form on your objects. Highlights should be focused primarily on the side of an object that is closest to the light source (H).

DRAWING SHADOW ON DRAPERY

STEP 1
Establish a light source and stay true to it (A). Build your form shadows on the most obvious drapes first. The drapes will immediately begin to have a feeling of a light side and a dark side.

STEP 2
Now work in the cores of the form shadows and also lay in your cast shadows. The angles of the cast shadows all follow the same perspective (B). Your drape will feel well formed but also very sterile. It is necessary to break the edges of the shadows with movement.

STEP 3
For a textured shadow edge, the light or local colour areas are primarily left white (or open (C)). The fabric's texture should be added to the shadow edges to avoid shadow spottiness all over your figure.

DRAWING SHADOW ON THE FIGURE

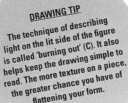

DRAWING TIP
The technique of describing light on the lit side of the figure is called 'burning out' (C). It also helps keep the drawing simple to read. The more texture on a piece, the greater chance you have of flattening your form.

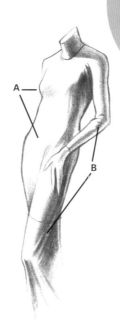

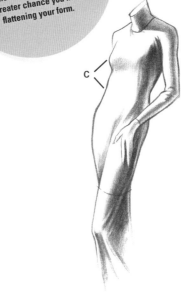

STEP 1
Establish your general shadow. Look for ways of connecting shadows into a continuous shape rather then small broken spots, which can look more like pattern on a garment than shadow. Illustrate form (soft-edge) and cast (hard-edge) shadows when possible.

STEP 2
Begin to add secondary shadows such as the breast plane and the pelvis area (A). Adjust your shadow edges to create the feeling of drape and gathering of the fabric as affected by the body (B).

STEP 3
Lastly, add any colour, pattern, texture or highlight that the textile requires. Here a subtle marker tone was added behind the garment and a highlight was added to the lit side of the form (C).

DRAWING GESTURE, MASS AND FORM

There are three more essentials to consider when approaching the fashion figure: gesture, mass and form.

DRAWING TIP

If you ever feel stiff or uninspired about the drawing in front of you, take a break and draw some gesture poses to warm things up. Use a live model whenever possible, or have a stack of fashion magazine reference in front of you to draw from. Do not forget to time yourself.

GESTURE

The figures on this page of gesture drawings were each drawn in one-minute intervals. This quick sketching technique will teach you to find the flow of the figure's movement and to exaggerate the angles caused by the boxes (see pp. 166–167), but without taking time to draw their shapes. Note that there is minimal detail. These figures were drawn with an art marker and are meant to capture movement, not body form. You must guard yourself against thinking about the body contour or specifics. Only add enough defining details to explain body perspective and direction.

It is best to stand up when doing such fast sketches, so you have maximum use of your drawing arm and do not lean on your pad. Begin with the figure's head to establish the proportional key, then challenge yourself to get from head to toe in one minute. If there is time remaining, begin to flesh out the figure's form. Note that the plumb line (green) and height proportion are still maintained, even at this speed.

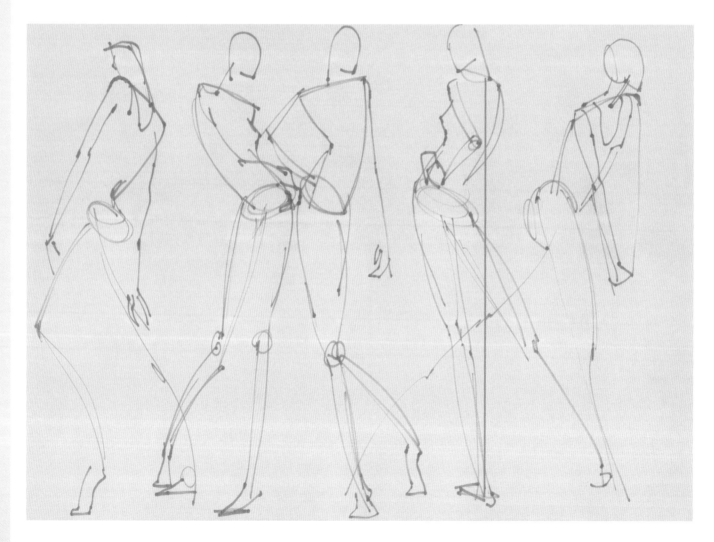

MASS

When a figure shape or form is hard to see as line, another way to approach the object is by drawing the mass of it from the inside out. Both the glove and male figure drawings were started from a centre point and then scribbled or hatched towards the outside edges of the shape. Do not become distracted by detail when trying this technique; squinting your eyes will cause the figure to go out of focus. Start with a continuous tone and, as you develop the shape of the mass and it becomes more and more representational of the form, begin to increase the value contrasts where necessary and define the edges. This sketching technique is also useful when it is necessary to draw quickly on location while maintaining a feeling of solid form in your figures.

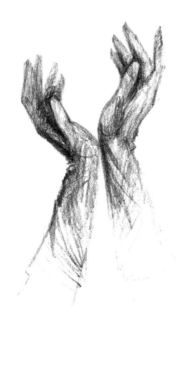

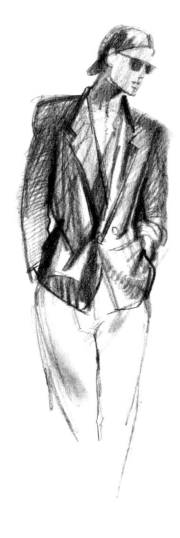

FORM

Form is established in two primary ways: first, when the overlapping of lines or shapes takes place (A), and second, when you draw the planes of a shape or around its edges while observing their perspective. Try to see a line map wrapping around the body, as shown here by the lavender lines on these figures. After drawing the figure's contour, begin to draw lines over the surface, which represent the direction of the forms as they head towards or away from you. Understanding these contour directions is paramount in bringing proper fit and perspective to garments on the body. This exercise teaches you to observe the directions of cuffs, hems and centre front contours, and explains the arm and leg perspectives (B). It is also important for understanding foreshortening, as with the raised leg of the seated figure. You can practise form drawing with any object or figure in life, as well as using photos.

DRAWING HANDS

Hands can add elegance and attitude to your accessory, or be totally distracting if you overemphasize their presence. When drawing any hand, keep your focus on the shape and contour structure, not on the nails, knuckles and veins. Rather than show the hundreds of ways a hand can gesture, some successful methods of observation are shown here so you can draw any hand in any position you desire. Keep in mind that larger hands will communicate power and confidence, whereas small or fragile hands can be unappealing in their message.

HAND PROPORTION

The basic shape of the hand can be seen as a diamond. The fingers and palm separate at the halfway point between the fingertips and the wrist (A). The knuckles' arc starts at the base of the fingers and continues through all the joints to the fingertips. Note the relationship of the thumb tip to the index finger's first joint as well as the pinky tip to the second knuckle of the third finger (B). The hand has a centre line that comes from the middle of the wrist proceeding through the centre finger (C). This centre line will assist you in seeing proportional differences when drawing three-quarter views.

HAND CHARACTER

Structurally, female and male hands work in the same way, but their characters should be drawn differently. The female hand commonly has more gesture than the male's. In general, draw her hand thinner but not gaunt to avoid her hands looking weak or claw-like. Her fingertips should taper slightly towards the points, whether you are giving her actual fingernails or not.

The male hand is beefier and more angular in appearance. The fingertips are more squared-off and the gesture will not typically be as arched as that of a female hand. For simplicity, fingers of both genders should be combined whenever possible. This will add to the overall stability of the hand. Try to position hands either in naturally relaxed poses or in some kind of action. Avoid flat or spread out stiff-looking hands in all cases.

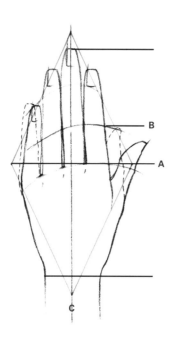

This fantasy illustration of ribbon gloves is a preliminary drawing done for an in-store display. The pencil drawing was scanned and then transformed with an edge filter tool in Corel Paint, before a black background was added for more drama.

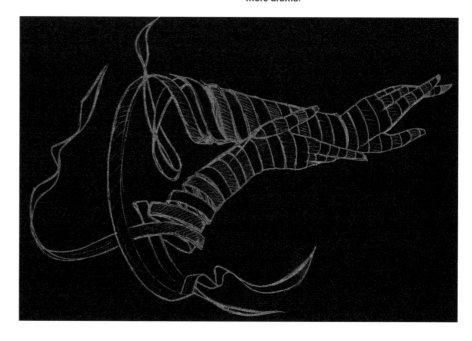

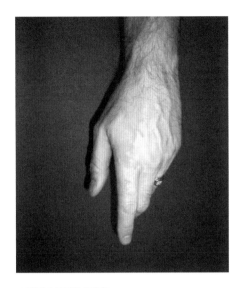

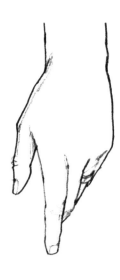

HAND SHAPE STEP 1

The easiest, most successful, way to draw any hands is to observe their shape. When looking at a hand, do not think of it as fingers, knuckles and details, which can throw you off and distract you.

HAND SHAPE STEP 2

As a drawing exercise, try to see the hand as a coloured shape or silhouette in space. As you draw, look for the angles and proportions within the shape. Begin by observing the general shape (D) and then start to break it down unto smaller increments of angle and curve (E). Compare these lines continually to horizontal and vertical axes.

HAND SHAPE STEP 3

When drawing the finished hand, keep the outside contour dominant over inside detail. It is always necessary to show bone structure when drawing the hands. This keeps the hands from looking limp or rubbery.

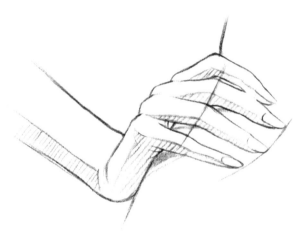

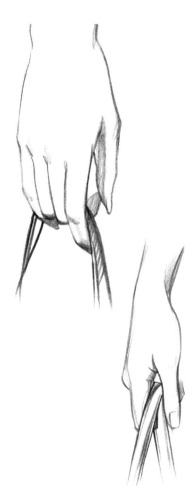

PLANE ANGLES

This hand-on-the-hip pose demonstrates drawing a hand while observing its planes. This is another method of observation that will give the hands good structure and keep them looking strong. Notice the arced relationship of the joints and the importance the side plane gives in adding perspective to the pose. The bone structure of the fingers should only be emphasized on one side: the top. If you accentuate the creasing underneath or fleshy part of the finger as well, your hands will have a skeletal look.

GRIPPING POSES

When drawing hands in action, as with these handbag poses, the hand is simply a support for the accessory. The straps in the hands should rest comfortably against the fingers. Do not overexaggerate the weight, or the effect on the fingers caused by the object, as this can warp the structure of the hands. Notice that the hand details are kept at a minimum and tone was added on the edges to keep the structure solid.

DRAWING FEET

Feet are more than just a supporting base for the figure. They can make or break your pose if their perspective goes awry or their shape is warped. Two common problems that occur are drawing feet too flat, in both side and frontal views, or giving them too much height so your model appears to be standing on her toes. Following here are some observational truths to watch for when drawing feet on your figures.

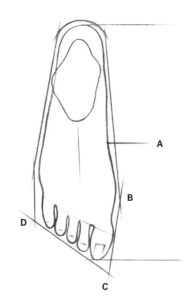

FOOT PROPORTION

The basic shape of the foot is a wedge. From the top, the foot divides in half in the middle of the inside arch, or instep (A). It tapers from the heel to its widest point at the ball joint of the big toe (B). From the ball of the foot the toes begin to angle inward again (C). The toes themselves have a progressive angle also, increasing from smallest to largest (D). Notice that the orange outline mimics the general shape of the sole of a shoe.

SIDE VIEW

The wedge shape of the foot is most obviously seen in the side view. When drawing a shoe on a foot you should always draw the foot from this outside angle. Notice that the foot is basically flat to the ground, unless it is inside a shoe with a heel. In this position, the ankle and leg will be at a right angle to the floor. The heel bone area of the foot makes an outward extension, highlighted here by a ball shape (E).

When a heel is added, and also a slight perspective that is a more common view for a standing figure, notice that there is a centre front line just as on the figure (F). Make certain that you draw the front curve of the toes (G), which shows their height and depth; this is necessary to create structure and stability for the foot (H). These angles are essential when drawing any type of shoe on the foot.

When a higher heel is worn, observe how the top arch becomes more pronounced (I) as the foot becomes more extended. The ankle perspective will also begin to increase (J).

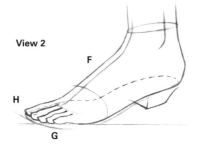

View 1

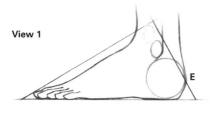

View 2

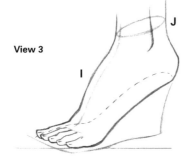

View 3

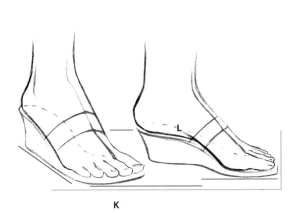

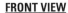

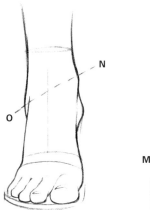

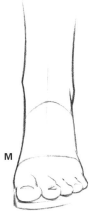

THREE-QUARTER VIEWS

In every three-quarter view there will be a higher and lower foot. Check this perspective by comparing the angles by using horizontal and vertical lines (K). You can also see the inside arch (L) in this view and how it affects the foot and shoe sole shape. It is best to not overemphasize this arch. Strapping has been added across the upper foot to give you an idea of form as well as the centre front of the foot. The toenails are just indicated so they do not distract.

FRONT VIEW

When drawing front-view feet, special attention should be given to defining the top plane of the foot (M). The big toe will angle in slightly and the entire toe area should have height as well as width. Notice that the inside ankle bone (tibia – N) is higher than the outer (fibula – O). These feet have been drawn standing in a medium heel height.

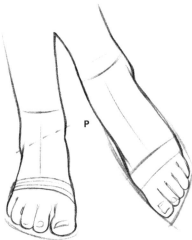

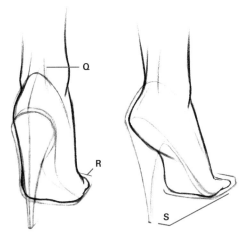

FRONT AND TOP VIEW

This foot has a slightly higher viewpoint than the front view. Notice that as the foot is extended out and down, the upper arch becomes more pronounced (P). An extended foot will be about one head size in length.

BACK VIEW

The heel takes centre stage and should be narrowed as it moves up the leg (Achilles tendon – Q). The foot will spread out as it moves forward to the toes. Draw the toes behind the ball of the foot whenever possible (R) to create form. Note the perspective of the foot as it goes away from you. The heel of a shoe will be lower than the toes in a back view (S).

DRAWING PARTIAL FIGURES

Because you will always want the accessory to remain the focus of your illustration, you should sometimes consider featuring your items on a partial figure. By cropping in with a tighter view you can direct the viewer's eyes wherever you choose. When cropping a figure or body part, it is recommended that you do not cut the figure at the joints – ankles, elbows or at the neck. This can create an uncomfortable visual that may make your figure appear to have been amputated in some way. Always crop the figure at a midway point, such as mid-thigh, mid-face or mid-arm. You may choose to put a border or window around the partial figure, as shown in the leg and skirt vignettes opposite, or you can fade the figure, as shown in the illustration of the face. If you take the latter approach, beware of cropping the figure symmetrically, especially on the legs as it can make the figure appear to be standing in water. It is better to use an asymmetrical fade in most cases.

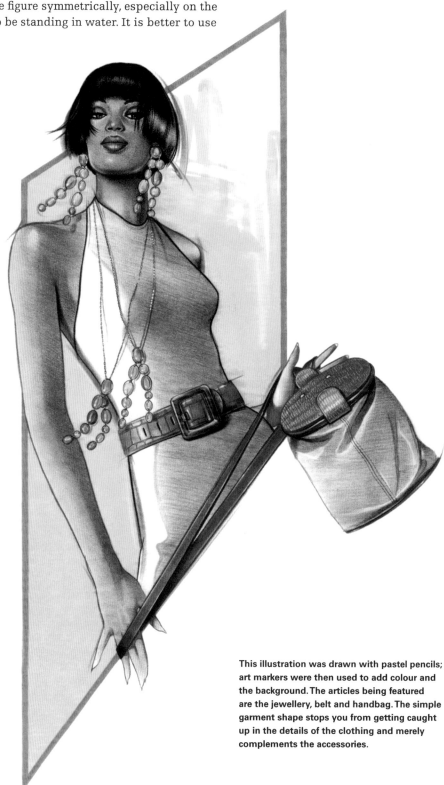

This illustration was drawn with pastel pencils; art markers were then used to add colour and the background. The articles being featured are the jewellery, belt and handbag. The simple garment shape stops you from getting caught up in the details of the clothing and merely complements the accessories.

THE HANDS

Gloves should be drawn as if they are a second skin on the hand. Do not express too much bulk at the bends or flange and keep the wrinkling clean, with firm shapes. For female gloves, taper the fingertips upward to the nail as you would for the hand. Men's gloves should have a more square, boxy look to the fingers. A lively hand gesture will help bring life to the gloves.

THE LEGS

These legs were used for a hosiery advertisement. They were drawn in graphite and then toned in a photo-editing program. It is important when working in such a tight style to have anatomical correctness, but not to overemphasize the muscle contours or wrinkles.

THE FACE

These hatpins needed to be drawn in black and white for use in a newspaper advertisement. The pins were drawn with a black pen outline to make them pop out from the hat. The face was drawn in graphite to keep it a softer tone so the attention would be on the pins and not the character of the face.

THE HIPS

To make sure the chain belt didn't get lost against the skirt texture, the highlights were burned out to give a pure white background to show the details. The fade-out technique supplied a soft contrast to the hard edge of the chain.

GLOSSARY OF WOMENSWEAR

EVENINGWEAR

Eveningwear can be anything from a little black dress to a ball gown. It is perhaps the most sought-after category to illustrate. It calls for drama and attitude from the figure while offering more exciting fabric textures and clothing silhouettes. Creating the perfect character for an evening frock is every bit as important as the outfit itself.

SPORTSWEAR

Sportswear is another huge category in fashion. It includes all casual forms of separates as well as some dress and athletic wear. The poses for such clothing are usually more active and the drawing styles can be more energetic and loose.

This vintage Korshak dress with multiple pleating around the hips was done in watercolour over a 6B graphite pencil line drawing. The length of the figure was exaggerated to emphasize the drama of the full trumpet skirt bottom with train.

These linen capri pants with pleated top were done with markers on a slick marker paper. The ink lines were done first with a water-based pen so that the art markers, which were alcohol-based, did not dissolve them. After the ink line dries, the marker can be put directly over the top of it. This piece was done for retail in-store display and was supposed to be a loose, designer-like sketch. The final display was enlarged to be two and a half metres feet high.

The green tulle dress was rendered using art markers on marker paper. It is a good example of illustrating transparent fabrics. The tulle skirt was done by layering the transparent markers in three different coloured tones. This fabric has a crisp linear quality to it so the marker edge is left more obvious. Notice how an impression of the legs comes through the skirt to give strength to the pose. The legs were drawn first, the left with a light skin tone, the right with a light green tone, and then the skirt colours were layered over them. The bodice was achieved by first laying down a skin tone and then a medium green tone over it. The beading and highlights were the final touches, done with fine-line pen and white paint.

This graphic print sundress with a pink crinoline was done with a confident and fun pose. It was drawn with coloured pencil on the front of marker paper; then marker was applied on the back for skin tone and shadow depth. The highlights were created by not colouring the paper from behind on those areas. The pattern was added last to the shadow areas with coloured pencil, appearing to 'burn out' in the highlights. This approach helps create a sense of bright summer energy and reflection. The hair, head wrap and lifting of the skirt all help create a more sporty atmosphere.

SEPARATES

Separates are a huge part of the fashion world. They are items that can be mixed and matched in multiple combinations. Shown here are two different techniques that demonstrate the diversity of approach and attitude possible when illustrating the same category of clothing.

This strikingly realistic marker rendering was done by Dijana Granov. She started with a line drawing in grey coloured pencil on a bleedproof marker paper. She then used multiple layers of transparent alcohol-based art markers to create rich values and form. After touching up the details with coloured pencils, she gave it a final outline with a fine-line pen and then pushed the highlights and reflections with a white gel pen. Also notice the powerful leather handbag rendering.

This quick sketch was done as an art marker demonstration. It started with a water-based, fine-line pen drawing. Then transparent alcohol-based art markers were put down over the top of the linework. For each garment piece there are three marker tones used; the local colour, the shadow colour and the dark detail shapes within the shadows. The highlights on this piece were created by leaving the paper area untouched by the markers. Note the exaggerated walking pose to add a lively, active feeling to the illustration.

GLOSSARY OF MENSWEAR

MEN'S SUITS

Formalwear is an area of fashion illustration that demands a clean, structured style. The poses tend to be basic, even static-looking. Tailored suits and dinner jackets should have smoother lines and even lapels – this is not a place to have a lot of organic lines or gestured exaggeration. The shoulders of a suit jacket will tend to look squared-off and give a broader feel to the male silhouette since they are formed by shoulder pads and interfacing. The number of buttons a suit has is very specific, so stay true to the quantity, spacing and size.

CASUALWEAR

The casual male tends to be a younger, more active figure. He can be posed any number of ways, including in an action pose. Clothing style may be loose or tight, layered or minimal, but most likely it will be comfortable in manner.

On this double-breasted suit, notice that the centre front line falls from the point at which the lapels overlap, not the button line; this is true on all suits. On a formal suit there should be 12 millimetres of 'linen' or cuff showing out of the jacket sleeve and a dimple in the centre of the tie under the knot. This suit was drawn with markers and coloured pencils, then cut out and mounted onto a board with watercolour strokes. The unfinished marker side gives the art style a looser feel. It can be used as a design presentation sketch or retail sales advertisement.

This skater was drawn with a combination of watercolour and charcoal pencil. The paint was handled in a very shape-oriented way and with a limited palette of only three colours. A pastel gesture shape was added to the background for a gritty urban feel. This piece is more geared towards an editorial publication.

This unstructured suit or sportswear illustration has a much more relaxed pose and attitude in the drawing. Areas of contrast with a formal suit include things like turned-up lapels, softer shoulders and the open-front jacket. Rather than draw in the shadows with coloured pencil, this piece was shadowed using a warm grey marker over the top of the jacket colour. The jeans were shadowed with a blue marker colour. Then coloured pencil was sketched on, giving a textured feeling as well as a washed-out look.

This punk figure was drawn with black and white charcoal pencil and made more dynamic by drawing it on a bold coloured paper.

This young urban guy started as a pencil line drawing that was scanned into a photo-editing program. After capturing the linework as individual shapes, the illustrator filled the figure with solid colour. The whole figure was then grabbed as a shape and dropped on top of a cityscape that had been photographed and turned into line-art.

GLOSSARY OF RENDERING FABRIC

The following fabric rendering samples show some basic techniques for approaching some of the more common fabrics you may be asked to illustrate. Although they are done primarily in marker with coloured pencil and pen line, the principles for rendering remain the same in any medium.

DENIM STEP 1
The colour character of the fabric was first achieved by saturating the drawing with three blue marker tones and then blending them together using a blending marker.

DENIM STEP 2
To finish, use a medium-blue coloured pencil along with a white pencil or pastel. Notice the detail and focus added to the seam lines that are so common on thicker fabrics like denim.

HERRINGBONE STEP 1
When rendering shadows on white clothing it is best to use a warm or French grey for warmer whites and a cool grey or sapphire blue marker for cooler whites.

HERRINGBONE STEP 2
Lightly draw guidelines vertically on the garment with a hard graphite pencil following the fabric draping. Begin by drawing all the downward slash marks in every other row. Repeat the same technique with the upward slashes until there is enough pattern to indicate total coverage. Observe that patterns tend to get narrow as they wrap over an edge.

HOUNDSTOOTH STEP 1
Lay down the shadow form first. A warm grey was used here and gave a soft lavender tint to the shadows.

HOUNDSTOOTH STEP 2
After laying down some light guidelines, draw the main square shapes at even intervals. Add the cross lines in a repetitious order, along the long corner-to-corner lines, then the left side slash, then the right. This will keep proportions consistent. Add some soft highlights over the pattern with white coloured pencil or pastel if the fabric is reflective.

LACE STEP 1

After using a pigment pen to draw the main outline, establish the shadow tones using three values of marker: light, medium and dark. Flesh tones were used here to indicate a see-through effect behind the lace.

LACE STEP 2

Use a warm grey marker over the dress area. Lay down the lace pattern. Watch for the repetition of the pattern. Start with the biggest shapes, then work your way down to the smaller ones. Finally, indicate the netting if necessary.

LAMÉ STEP 1

Begin with the shadow tones, keeping the drawing fluid in character; the more reflective the surface, the higher the contrast of light to dark. Three tones were used to create the form on both the figure and the dress.

LAMÉ STEP 2

Highlights are key to making a reflective surface come to life. White paint was used to add fabric depth and detail. The reflections are fluid and gradate from harsh to soft. Dots of white were used to indicate the sparkling fabric.

PLAID STEP 1

Keep the shadows simple and primarily on one side of the figure. Avoid spotty or harsh value contrasts.

PLAID STEP 2

First establish your guideline colours – the blue grid lines. Then draw the pale colour lines that intersect vertically and horizontally. Add the white lines with white paint or coloured pencil. Keep them softer in the shadows and ensure they follow the movement of the fabric.

SATIN AND SHEERS STEP 1

Establish the figure outline, then render the skin tone, including the part to be exposed under the sheer fabric.

SATIN AND SHEERS STEP 2

Use a medium-blue marker to render the satin's local colour. Add darks and lights with a dark blue marker and white coloured pencil. Keep the reflections soft-edged and glowing. Use a lighter blue marker to colour over the skin tone representing the sheer fabric. Add some shadow with the medium blue from the dress and some soft highlights with blue pastel to look like reflection under the sheer.

SEQUINS STEP 1

Draw the shadow forms of the garment. You will need light, medium and dark values to create the reflections of the sequins. If the sequins are the same colour as the fabric, use the shadow colour for the medium reflection sequins. Then add the dark reflections with a darker marker from the same colour family.

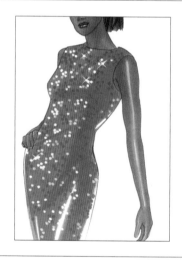

SEQUINS STEP 2

Add highlights with white paint in both medium and bright values keeping some reflections close together. Keep the majority of the highlights in the lighter areas of the garment. A few quasars will help to emphasize the sparkling quality of the surface.

VINYL STEP 1

Vinyls come in dull and high-gloss textures. For a duller finish, do not leave the white spaces when rendering in marker. Add them later with white coloured pencil. Keep the reflection tones very fluid-looking when laying down the initial reflections. Using dark greys for black at first rather than pure black allows you to use black as your darkest shadow tone.

VINYL STEP 2

To finish glossy vinyl, push the blacks with a 90% grey marker or darker. Soften the edges of the reflections with a blender marker. Paint the highlights with white paint, gradating them from hot white to grey. The blue reflected light added with coloured pencil adds secondary form.

FURTHER READING

Bina Abling, *Fashion Sketchbook* (5th edition), Fairchild 2008

Bina Abling, *Marker Rendering: For Fashion, Accessories, and Home Fashio*ns, Fairchild 2006

Cally Blackman, *100 Years of Fashion Illustration*, Laurence King Publishing 2007

Martin Dawber, *Big Book of Fashion Illustration: A Sourcebook of Contemporary Illustration*, Batsford 2008

Martin Dawber, *New Fashion Illustration* (New Illustration Series), Batsford 2006

Delicatessen, *Fashionize: The Art of Fashion Illustration*, Happy Books srl 2004

Bil Donovan, *Advanced Fashion Drawing: Lifestyle Illustration*, Laurence King Publishing 2010

David Downton, *Masters of Fashion Illustration*, Laurence King Publishing 2010

Kathryn Hagen, *Fashion Illustration for Designers*, Pearson Prentice Hall 2004

Susan Mulcahy, *Drawing Fashion: The Art of Kenneth Paul Block*, Pointed Leaf Press 2008

Nancy Riegelman, *9 Heads: A Guide to Drawing Fashion* (3rd edition), Prentice Hall 2006

Stephen Stipelman, *Illustrating Fashion: Concept to Creation* (3rd edition), Fairchild 2010

INDEX

PICTURE CREDITS

Vincent Bakkum 76, 144; Tina Berning www.tinaberning.
com / CWC International, Inc., www.cwc-i.com (USA) /
Cross World Connection, www.cwctokyo.com (Asia) /
2agenten, www.2agenten.com (Germany); 111, 160; Diana
Garrett 18 (top right); Dijana Granov 2, 183 (top left);
Colleen Kelly 39; Young Kim 16 (top left); Cha Peralta-
Martinez 130; Stina Persson/CWC International, Inc. 90;
Raymond Serna 34 (left), 60–61; Don Yoshida 55;
Yumicki 103

All other images by the author.

AUTHOR'S ACKNOWLEDGEMENTS

On his journey an artist encounters many influences and
inspirations that affect his art, and I am no different. I
thank my God for the talent He has given me and for a
mother who recognized it and set me on the path to be an
illustrator – thank you Mom (Dorine). Thanks also to Carol
Police for helping me to see shape and also eternity. To
Gregory Weir-Quiton who taught me to draw a line a day
and the many friends who refined my eye to see beauty
– Steve Bieck, Mia Carpenter, Rose Brantley and Andrea
Reynders – thank you all for sharing your lives with me.
A special thanks to Lee Ripley for the vision of this book
and to Anne Townley for pushing me through to the finish.
And, of course, to all my students who keep me growing
– thanks a bunch. Thank you to Leah, Rheanna and Ryan,
the three most inspiring models and children anyone could
ever have. And, most of all, thank you to my incredible wife
and art-mate Janice, who allows me to pursue my calling.
You are a constant source of love and encouragement to
me; my best critic and my best friend.